The Art of
SHIBATA ZESHIN

The Mr and Mrs James E O'Brien Collection
at the
Honolulu Academy of Arts

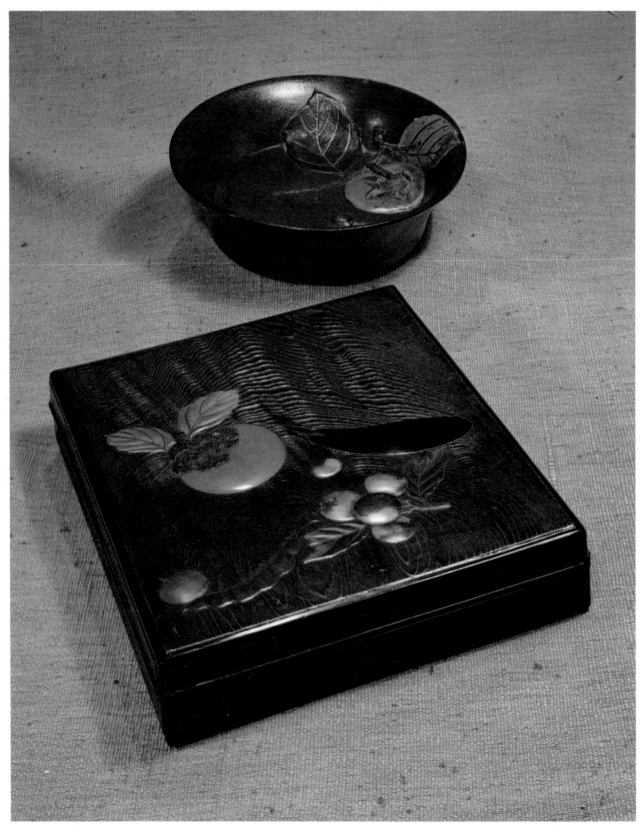

76 Bowl
84 Shikishi Bako (Box For Square-shaped Paper)

The Art of
SHIBATA ZESHIN

The Mr and Mrs James E O'Brien Collection
at the
Honolulu Academy of Arts

Essays by Mary Louise O'Brien
and Martin Foulds

Catalogue by Howard A Link

Robert G Sawers Publishing
in association with the Honolulu Academy of Arts

© Honolulu Academy of Arts 1979
Design and Production by Sonnie Howson
Published by Robert G. Sawers Publishing
Printed in Great Britain by Hillman Printers (Frome) Ltd.

Library of Congress Cataloging in Publication Data

Shibata, Zeshin, 1807-1891.
 The art of Shibata Zeshin.

 Bibliography: p.
 1. Shibata, Zeshin, 1807-1891 — Catalogs.
2. O'Brien, James E. — Art collections — Catalogs.
I. Honolulu Academy of Arts — Catalogs. I. Link,
Howard A. II. Title.
N7359.S46A4 1979 709'.2'4 79-24341
ISBN 0-903697-05-X

Dedication

This catalogue is dedicated in memory of Mary Louise O'Brien whose death in August 1978 has given deeply poignant meaning to our undertaking. The publication, as the collection itself, bears witness to her joy in the art of Shibata Zeshin and to the sensitivity and intelligence which informed her collecting activity. We had looked forward to sharing this event with her personally; certainly her vital interest lives on in the works themselves and in this document about them.

JAMES W. FOSTER

Table of Contents

LIST OF COLOUR ILLUSTRATIONS

PAINTINGS

CERAMICS AND LACQUER OBJECTS

Foreword

This catalogue is devoted to the work of an exceptional artist and reflects the discriminating taste of two collectors who pursued a passion both instinctive and cultivated.

The perfection in the art of Shibata Zeshin first aroused the interest of Mr and Mrs James E. O'Brien about twenty years ago. By 1970 they had systematically assembled at their home in California a collection representative of the lifework of this remarkably gifted artist. Undoubtedly a genius, Zeshin was a superlative craftsman whose talent touched on many aspects of Japanese tradition but whose art very playfully expresses his own individuality. The O'Brien Collection reveals his many facets in more than one hundred paintings, lacquer objects, tea ceramics and woodblock prints which compose one of the most significant assemblages of this master's art in the West.

A warmth of feeling for Hawaii and the Academy prompted Mr and Mrs O'Brien to promise their Zeshin collection to the museum on the occasion of its fiftieth anniversary in 1977, with a pair of six-fold screens as their initial donation. Within a year's time the gift in its entirety was completed, and concurrently with this publication we now open a gallery for the continuous showing of varied selections from the O'Brien Collection.

The Academy and the community are the beneficiaries of twenty-three years of dedicated effort resulting in a collection notable for its scope, richness and overall excellence. In the spirit of the donors the Academy, through its Curator of Asian Art, Howard A. Link, has endeavored to extend the O'Briens' research, involving examination of Zeshin's works in collections here in Hawaii and on the mainland as well as in Japan. Martin Foulds of Sophia University, Tokyo, was engaged to undertake a thorough study of Shibata Zeshin, working collaboratively with Professor Tadaomi Gōke, a noted Japanese authority on the artist; this has resulted in the first major monograph in English on this neglected master.

This publication has been a major project involving many people, with co-operation on an international level. Our warmest appreciation is extended to all participants.

The Zeshin Collection takes its place in the distinguished ensemble of Japanese art at the Honolulu Academy of Arts. Lasting gratitude is owing to Mr and Mrs O'Brien for their generosity in sharing their passion through the gift of their unique collection to Hawaii, thus allowing us and coming generations to experience the multifaceted delights of Shibata Zeshin's art.

JAMES W. FOSTER
Director

Acknowledgements

It is a very pleasant duty indeed to record my acknowledgements of the assistance I have received in the preparation of this catalogue from many friends and colleagues in this country, in England and in Japan.

My best thanks are due to Martin Foulds, a former student and associate of mine in Japan, whose fine essay on Zeshin's life and art adds distinction and significance to this publication. His research efforts on my behalf have been untiring and I am very grateful.

All students of the art of Shibata Zeshin are much indebted to the pioneering work of Professor Tadaomi Gōke, Head of Research, The National Museum of Modern Art, who made a thorough study of Zeshin's art and career, distinguished stylistic changes in his signature and collected authentic impressions of the numerous seals which Zeshin used, drawing attention to their possible periods of use and importance in attempting to date Zeshin's works. In addition, Professor Gōke has been most generous in his assistance by examining the O'Brien Collection works from photographs, indicating the still unresolved distinctions between Zeshin's individuality as an artist and those of his principal students.

Sadao Kikuchi of the Tokyo National Museum, Henry Trubner of the Seattle Art Museum, Masaharu Nagano of Tokyo and Bernard Hurtig of Honolulu generously permitted me to examine their holdings of Zeshin's works for comparative study.

It was Mr Hurtig who directed my attention to Miss Taeko Umezawa, granddaughter of Shibata Zeshin and a lacquer artist/connoisseur in her own right. Her insights into the life and work of one of Zeshin's sons published in her recent book *Shibata Shinsai* add a new dimension to our understanding of the Zeshin tradition.

I also wish to express my gratitude to Roger Keyes, Woodacre, California; Charles Mitchell, Tokyo; Neil Davey, London; Reiko Brandon, Honolulu; and George Lazarnick, Honolulu, for their careful reading of the manuscript. The valuable suggestions and corrections they provided are warmly acknowledged. A special thanks is also due Mr Lazarnick for his splendid photographic work of the lacquer and ceramic collection.

Among the many members of the staff of the Honolulu Academy of Arts who helped with this publication, primary recognition must go to James Jensen for his patient and skilful editing, often clarifying and expanding upon special points of interest. Both Joanne Tang and Gay Jefferson coped with typing the lengthy manuscript. Without their thoughtful co-operation my task would have been a great deal more difficult. Marshall Wu, Assistant Curator of Asian Art at the Academy (1975–78), gave diligent attention to the transcription of seals and signatures on works in the O'Brien Collection, and Raymond Sato applied his photographic skills with fine results. Finally, I wish to express my sincere thanks to James W. Foster, Director of the Honolulu Academy of Arts, for his thoughtful co-operation and support throughout the research, writing and preparation of this publication.

HOWARD A. LINK

Collector's Preface

In the continuing search for bridges between the Eastern and Western worlds, between the 18th and 20th centuries, between art as the province of churches and rulers and popular art of the comic strip and magazine illustrations, the 19th century interrupts orderly processes of study and thought. The 19th century was an explosion. The lids were blown off the pots – in science, in people's attitudes, in education, in government, in travel, in art and in human hope.

The lids were blown off many pots, especially in Japan. After living quietly for centuries on an isolated group of small islands, for more than two hundred of those years within firmly sealed boundaries, the Japanese had inevitably become culturally ingrown, and their art over-refined if not stagnant. The impact of the industrial revolution was tremendous, stimulating to some, frightening to others, but universally pervasive and inescapable. In the realm of art, new vistas were opened, sometimes in a blinding flash of light, more often slowly, cautiously, through hazy mists and intuitions.

Imagine, then, the excitement of living one half of a long lifetime in old Japan, the other half after the incursion of the Western world. Imagine the luxury of being born in the year 1807, developing as an artist of prodigious talent, situated conveniently for an early apprenticeship at court, and working successfully in two discrete fields of art throughout all the turbulent years until 1891. Shibata Zeshin had the genes and the stamina, the good luck and the persistence to achieve that life-span and to leave a distinctive mark upon his century.

Born, raised and trained in old Japan, Zeshin was all Japanese, heart and soul and mind. He studied classical Japanese painting and produced Japanese land-scapes true to that tradition. He worked diligently as apprentice to a skilled lacquer craftsman attached to the Imperial court and produced splendid examples of classical Japanese lacquer ware. He loved nature – especially its minutiae, depicting them in affectionate detail (a classical tradition in Japan) – and he loved the traditional household gods. And yet, a hundred years after the fact, in a warehouse full of 19th-century Japanese artifacts, a lacquer writing-box or a painting by Shibata Zeshin stands out clearly and distinctively from a wall of paintings of the same subject or a shelf of boxes for the same purpose. He wasted no energy protesting the world as he found it; he simply saw it in a different way, which he happened to prefer, and proceeded to develop his own style of reproducing it.

My introduction to Shibata Zeshin came about quite casually on a sleepy-hot August afternoon in a small California town not too far inland from San Francisco. The shoe repairman needed another half-hour to finish the job I had asked him to do, and to pass the time I climbed some creaky stairs to a curio shop where I had seen some attractive artifacts from time to time. (The year was 1955. In the spring I had paid my first visit to Japan. I had been infected, but hadn't yet realized that my love affair with Japan was to prove pervasive and permanent.)

The shopkeeper, recognizing me as a previous visitor, was unpacking a crate of gift-wares from Japan – some folk pottery rice bowls, a few small boxes of cherrywood bark, a chubby little brass incense-burner, and a stationery-box-size package wrapped in silk. When I had inspected each article in turn, he finally handed me the box wrapped in silk. 'You may open it,' he said.

Inside the silk and inside a protective kiri-wood box with its identifying black calligraphy, was a subtle brown wooden writing-box, its cover decorated with an exquisitely-placed persimmon and a few leaves. That was all, but I'd never seen anything in lacquer that looked like that, and I'd never seen such an appealing persimmon separated from a tree. I examined the box over and over for a long time.

The shopkeeper said it was the work of a Japanese artist named Shibata Zeshin, and I nodded (but the name meant nothing to me). Glancing at my watch, I thought that my shoes should be ready downstairs. I said thank you to the dealer and walked out into the glaring sun.

Next morning it was hot again. After a restless night, I telephoned the shopkeeper and told him I wanted the box (Cat. No. 84).

A few weeks later he phoned and said he had something to show me. When I dropped by the shop, he carefully unrolled the exquisite *Plum Branch and Mandarin Ducks* (Cat. No. 16). I wanted that too.

The next Zeshin work the shopkeeper produced for inspection, after some months, belongs at the other end of the spectrum among Zeshin's paintings – rough, sweeping brushstrokes in red and black ink, the head and tail of a slaughtered *tai* fish (Cat. No. 50), still very powerful and surprised by death.

As beginners we had had beautiful luck, but we waited two or three years for our next Zeshin discovery. Meanwhile, I had searched and asked in Japan, New York, London and San Francisco, to be met by blank stares or incredulous head-shaking.

I fell into the habit of checking the index of any newly-encountered book about Japanese art or artists. A reasonable number include the name Zeshin, about eighty per cent of them identifying him as a skilled 19th-century Japanese lacquer craftsman. They do not mention his painting. They ignore the fact that he recaptured the forgotten magic of a couple of extraordinary earlier artists and painted delicately, with precision and expressive clarity, as successfully in lacquer as in ink or pigment.

For an artist with such imaginative talent, Zeshin displayed surprisingly little curiosity about a world beyond that of his routine experience. Or perhaps he was only polite and did not wish to express his negative reactions to intrusion from the West.

'The world he lived in' clearly included the world of legend and fairy tale, of Shinto gods and folk heroes. He spent his life in cities – Tokyo and Kyoto; but the Japanese city-world of his day encompassed streams and rocks and quantities of green space populated by the living creatures he knew and understood best – crickets, ants and dragonflies, mice and rabbits, noble carp, butterflies, moths and innumerable birds. He was familiar with and respected their individuality; and because Zeshin's special eye was connected with his very special hand, his portrayals, while true to nature, tend to represent almost distinct sub-species of each type. (As a special gift, wouldn't you like to have a lacquered cageful of Zeshin fireflies?)

Somewhere not too far from Zeshin's home ran a sizeable stream or small river on whose bank he must have spent hundreds of hours, observing and sketching. His favorite perch was on the right-hand bank looking upstream, and the configuration of rocks, grasses and roots protruding from the overhanging soil of the riverbank becomes almost a trademark as one browses through Zeshin's works.

Small crabs and turtles scramble up that bank, birds perch above in contemplation, carp measure their strength exultantly against the tumbling water. The world Zeshin lived in was an active world, worth loving.

His eyes and ears were always open, and he was intensely aware of what other artists were doing, what patrons were buying. He reacted in his own way – often by ignoring rivals, often, one suspects, by shrugging, 'I can do that too!' and proving it. Some of his more relaxed prints – vignettes of village life and country people, are strongly reminiscent of Hokusai. His larger screen and *kakemono* paintings, his more 'traditional' works, most resemble the world as seen by Ogata Kōrin's eye.

But the jewels in Zeshin's crown, resembling the work of no other artist, before or after him, are his lacquer album paintings. His sons and several pupils worked diligently; some became good artists, even producing a few three-dimensional lacquer objects that were persuasively similar to works of their master. In lacquer album paintings, however, they had to concede, hands down, to the older man.

Soon after we discovered Zeshin's work we started wondering why it appealed so strongly to us, why his voice was so clear. Dozens or hundreds of Japanese and Chinese painters, over the centuries, have painted delightful insects and small animals and fish, have painted charming birds and flowers, have painted swashbuckling folk-heroes and gods of magical power. Hundreds of others have demonstrated dazzling skill and expertise in lacquer-craft. We still don't know the answer. But Zeshin, who knew only the Japanese language and never traveled outside his own country, speaks clearly with his own voice across the oceans to the world. He has not been classified by art historians as one of the great artists of the Orient, but he was a true artist, living in and projecting his own world. His hand presented that world so convincingly that anyone who sees must listen and believe his message.

For more than twenty years we have lived within the sound of Zeshin's buoyant voice speaking through his work. Now we want to share him with others able to appreciate him. And what more likely place for them to gather to listen and enjoy him than in the Hawaiian Islands, midway between the East and the West. (Who can say which is which?)

MARY LOUISE O'BRIEN

Zeshin's Life and Works

Zeshin's paternal ancestors came from Echigo (modern prefecture of Niigata). His grandfather, Izumi Chōbei, a skilled wood sculptor and carpenter, arrived in Edo about 1770. His professional care and diligence in the planning of his work soon attracted the attention of the Shogun's Chief Carpenter, the most influential man in his field and under whom he was commissioned to work.[1] Chōbei established himself as architect and roof carpenter for a number of shrines and temples in Asakusa. His sons, Junzō I (gō Ichigorō) and Chōbei II, both followed in the profession and, as specialists in the decorative carving of the important transom area between the top of the shrines' main doors and eaves, became master sculptors in their own right.[2] With established reputation and solid income, Ichigorō was an attractive marriage prospect, and at the turn of the century Chōbei arranged for his marriage to Shibata Masu, the only daughter of a local tobacco-pouch and bag merchant. The Shibata business concern, located at 2-chome, Tachibana-chō, Ryōgoku, had by then fallen on hard times, and the arrival of Ichigorō, who adopted the family name so as to ensure continuation of the family name, must have been welcome. Able to provide the family with a supplementary income, he could also assist in the store, and for a short period found time to study the *ukiyo-e* style of painting under Katsukawa Shunshō (1726–92).[3] Masu was a strong willed woman who was said to have been a geisha in the Yoshi-chō district of Nihonbashi before the arrival of Ichigorō. She was an attractive and witty person, and her songs, which she composed herself and sang to the accompaniment of a *samisen*, made her a popular entertainer. It is not at all likely that Ichigorō disinherited himself from his own family simply because he wished to care for Masu and make himself useful in the Shibata store. The title Maki-e Shi (master lacquer artist) for the name Kametarō (died 1828) that appears in the Shibata family death records[4] suggests that one member of the Shibata line was already successfully engaged in lacquer production. It may thus be speculated that an heir was required to succeed Kametarō.

Zeshin was born on the seventh day of the second month of Bunka 4 (1807). Kametarō II, his given name at birth, was later changed to Junzō II. His artistic talent soon became evident, and he may have taken part in Tani Bunchō's seminars while still quite young.[5] His first move toward a professional career, however, occurred as early as 1817 when he began an apprenticeship under Koma Kansai II (1766–1835),[6] the tenth generation of a family attached to the Shōgun's lacquer workshops since 1636.[7] Stories originating in Junzō's period of training with Kansai describe him as an ambitious student inclined to apply precious metals unsparingly in order to impress a customer. A local bathhouse commissioned him in 1826 to decorate the *zakuroguchi* (a wooden plank affixed across the entrance of the bath-house to reduce the escape of hot air). He carved the wood into a curling vine with bunches of grapes – a most interesting and unique idea – to which he applied gold lacquer. For his efforts he was paid two *ryō*, a handsome sum for a young student and one that gave impetus to a growing self-confidence.[8] While public attestation signified success to a certain degree, some critics thought his work lacked depth. Kansai attributed this shortcoming not to Junzō's technique – which was superb and surpassed that of many colleagues – but to his inexperience in preparatory design. Such criticism

for over-dependence on the sketches and designs of others impressed upon Junzō the need to improve his painting technique.

In 1822 Junzō was introduced to Suzuki Nanrei (1775–1844),[9] a local artist who had received instruction from Watanabe Nangaku (1763–1813)[10] and later from Okamoto Toyohiko (1773–1845).[11] Nangaku, one of Maruyama Ōkyo's ten best pupils, had come from Kyoto and spent three years in Edo teaching the methods of painting of the Maruyama School. Nanrei's mature 'uninhibited' style and his enterprising personality made him a popular teacher; having proved himself an artist open to new ideas, Nanrei was the logical choice of a master who would encourage a student's probings, and he accepted Junzō for instructions six times a month at his atelier. Junzō was given the pseudonym Reisai (the *rei* from Nanrei's name and the *sai* from Kansai's name).[12] Records show that in the same year of 1822 Junzō moved from Tachibana-chō to Shin-Uemon-chō, Asakusa. He then spent long hours in his father's new fan shop and there used the opportunity to put into practice the concepts of naturalism learned from his teacher. His skill aroused considerable local curiosity when Utagawa Kuniyoshi (1797–1861) – the well-known *ukiyo-e* artist – noticed his fan designs on display and, prompted by their technical expertise and good taste, asked Junzō if he might become his student. They collaborated on a number of works, and it is said that business in the fan shop flourished as a result.[13]

Junzō's ambition was further encouraged by suggestions that he go to study in Kyoto. Nanrei introduced him as a promising student to his own teacher, Okamoto Toyohiko, one of the greatest exponents of the Shijō style of art. Arriving in the spring of 1830, Junzō settled in the Kiyamachi district of western Kyoto,[14] and began work immediately. His sketchbooks, the earliest of which date from this time, testify to his methodic endeavor to analyse and digest his first-hand observations of nature. Extant paintings, signed *Reisai* and contained in the altar room of the Daiyū-in, Kyoto, tell of Junzō's progress.[15] The bold line of his *Chinese Figures* carries the impact of a lacquer design, and thus contrasts dramatically with the softer Shijō School approach used in the background, while vignettes of indoor utensils prefigure the everyday scenes common to Zeshin's later work.

Besides assimilating objective realism prescribed by the Maruyama tradition, Junzō's enquiring mind was attracted at the same time to fields of study offered by other noted Kyoto scholars. He met Rai Sanyō, the philosopher and author of important history texts,[16] and received instruction in *waka* poetry and litera-ture from Kagawa Kageki.[17] Of his many visits to temples and shrines containing paintings by famous masters most impressive was that to Sanseiji temple of Tōfukuji, where he saw a set of sixteen *Lohan* scrolls, and was permitted to make sketches of three of them.[18] In the following spring of 1832, Junzō set off on a sightseeing and sketching trip that was intended to take him as far as Nagasaki. He boarded a ship near Wakayama, hoping to visit first the lacquer-producing centers on the island of Shikoku, but contracted typhoid fever and had to abandon his journey while still at sea. He recovered on return to Kyoto but soon sought permission to return to Edo. Although he thus terminated his studies quite suddenly, Junzō's progress must have been impressive; in the autumn of 1832 Nanrei allowed him to adopt the *gō* (pseudonym) Zeshin and *azana* (alternative name) Tanzen.[19] In October of the same year, Zeshin moved to 11-banchi, Kami Heieimon-chō, Asakusa, his home for the rest of his life. It stood on the north bank of the Kanda River, a few hundred yards from its confluence with the Sumida River at Yanagibashi. The row of willow trees along

the opposite embankment persuaded him to call his new home *Tairyūkyo* (The House Opposite the Willows).

Zeshin now began to learn the tea ceremony from Yoshida Sōi,[20] and embarked on a life-long attachment to *haiku* poetry which he studied successively with Asuka-en Issō[21] and Kitta Shunkō[22] (*gō* Shōchiku-an). The directness of expression associated with *haiku* is evident in much of Zeshin's art and especially in his lacquer work. He treats small animals and insects (subject matter favored also by the *haiku* master Kobayashi Issa (1763-1827) with comparable sympathy and similar reliance on sharp juxtaposition of images and of textures for impact. When Koma Kansai II died in 1835, Zeshin was amply trained to step into his master's role and had an ever-increasing reservoir of knowledge and experience on which to draw.[23] To further sharpen his technical insights he began an intensive analysis of lacquer methods employed by such illustrious predecessors as Hon'ami Kōetsu (1558-1637), Ogata Kōrin (1658-1716), Shiomi Masanari (1647-1722), Ogawa Ritsuō (1633-1747), Tsuchida Soetsu (active 1688-1704), Yamada Jōkasai (active 1680-1705) and Hara Yōyūsai (1772-1845); accumulation of data on their personal lives in addition expounded his historical perspective on the development of the art of lacquering.[24]

Part of this latter undertaking included a trip to the Kyoto area for the opening of the Shōsōin in early February 1836. Kagawa Kageki introduced him to Hoida Tadatomo, an expert in Imperial Court customs and the official compiler of the Shōsōin inventory.[25] Hoida had access to other storehouses belonging to important shrines and temples in Nara, and owned a large collection of old books describing the designs and methods of producing raised lacquer. Zeshin was allowed to copy not only this unique set of illustrations but also sketches of old paintings Hoida had made himself. He not only guided Zeshin around shrines and temples in the district, advising him of their holdings, but in many cases procured special permission for Zeshin to sketch. It seems likely that but for Hoida, Zeshin should have gone home with far fewer tangible achievements.

In October, 1836, after seven months of research, Zeshin returned to Edo in a position to begin serious work as a lacquer artist. Honing his technical expertise in the production of trays, miscellaneous boxes and *inro*, he also received orders for ink paintings, and the two media seem to have received from him equal attention in time and thought. It was at this time that his relationship with the people of the *shitamachi* (downtown) district began to deepen, and he preferred to devote more energy toward their special orders than to his regular production. Zeshin's first major contribution to the entire community was a huge (more than 5 × 7 ft.) painting in ink, leaf-green, lavender and gold on paulownia wood entitled *Kijō-zu* ('Portrait of the Devil Woman').[26] Dated by inscription on its reverse side to Tempō 11 (1840), it was dedicated to the Ōji Inari shrine by the Edo Sumiyoshi Meitoku Kō (forerunner of the present Association of Tokyo Sugar Wholesalers) on the first Horse Day of 1840 (early February) and hung outside and above the main door of the shrine.[27] Upon recognition by the Japanese government as an Important Art Object on September 1, 1934, it was taken down and placed in a special museum on the shrine precincts. Zeshin's exquisite skill is revealed in the perfectly-balanced composition that is built up through free-moving lines and in the fitting atmosphere conveyed by the ominous countenance.[28]

In April of 1841 Zeshin set off with Ikeda Taishin to retrace Bashō's famous pilgrimage along the *Oku no Hosomichi* (the 'Narrow Road to the Deep North'),

a course which took them by way of Nikkō, Matsushima, Kinkazan, Ishimaki, and Hiraizumi (Chūsonji) to Akita. Calling at all the important historic and religious sites on the way, they copied paintings, statues and architecture, and made many sketches of the countryside through which they passed.[29]

Zeshin's technical proficiency in the lacquer medium was challenged in 1845 when Matsumoto Heijirō, a merchant under shogunal patronage, commissioned him to execute on his sword sheath a decorative effect termed *seigai-ha* (blue wave pattern). Since its inventor, said to be Seigai Kanshichi (active 1680–1705), had not recorded his methods, Zeshin had no prior training in its application.[30] After studying extant examples of Kanshichi's work and a long process of trial and error, Zeshin successfully produced the *seigai-ha* motif. Matsumoto's was one of the first requests in what was to be an ever-growing demand for the exquisiteness once the exclusive right of the samurai class, and Zeshin's successful revival of this technique elevated his standing considerably. With Maruya Ribei acting as his distributing agent, Zeshin began to improve his subtle simulations in lacquer of other materials from about 1849 onward. Especially popular were his renditions of *seidō-nuri*, in which a dark green lacquer was applied over a wrinkled pattern so as to look and feel like the patina of antique bronze work. Variations of this idea also of wide appeal included *tetsu-sabi-nuri*, a rust-colored decoration, and *shūmon-nuri*, an application that effected an earthenware surface. Zeshin catered as well to the more gaudy tastes among geisha entertainers and some collectors with *taka-maki-e* articles sprinkled with graded powders of gold and silver.

The year after his father's death in 1848, Zeshin married, and his first child, named Kametarō III and later called Reisai, was born in 1850. Zeshin's happiness was brief, however, for he suffered the first in a series of tragedies in 1854 when his mother, Masu, passed away after a long illness. His wife, Suma, also in poor health for some time and exhausted by the constant care of her mother-in-law, died two months later.[31] In the summer of 1854, in the midst of this emotional stress, Zeshin received news that the scrolls of the Sanseiji *Sixteen Lohans*, three of which he had copied in 1831, were to go on sale to cover debts resulting from fire damage. Zeshin parted with prized tea bowls to raise funds, and, with a promise to pay the remainder of what he owed later, acquired all sixteen pictures, as well as two paintings of *The Eighteen Guardians*, and one picture of the Buddha for 257 *ryo* 2 *bu* in February of 1855. All these he treasured as sources of inspiration for his own study: 'A master,' he would explain, 'will be born only after he has accumulated study material while in unusually extreme distress.'[32] Through most of the uncertain years when the government groped for solutions to the problems posed by the arrival of Perry's fleet of 'Black Ships' at Uraga (1853) and the consequences of the death of Shōgun Iemochi (1866), Zeshin contended with his own personal misfortune. The Great Earthquake, which brought destruction to the city of Edo, in October of 1855, and the cholera epidemic that decimated its population in December of 1858 adversely affected the lacquer market, and Zeshin was unable to repay his debts to the Sanseiji temple until 1861. His second marriage produced a son, Shinjirō (later called Shinsai), in June of 1858, but ended abruptly when his new wife died in November of 1863.[33]

When word came that Emperor Meiji had replaced the Shōgun, the populace of Edo, in their usual stubbornness, did not easily or quickly accept the change. Like most of them Zeshin resented the imposition of the new government and in 1872 showed his disapproval by refusing an order from the Emperor himself.

The *ukiyo-e* artist Kaburagi Kiyokata wrote in his *Kiyokata no Ki* that the Governor of Tokyo struggled to convince Zeshin that his decision was ill-advised. Zeshin's acceptance in October of the same year of a commission to paint in the Enryōkan implies that the governor was successful in convincing Zeshin to change his mind, and an invitation to represent Japan at the 1873 World Exposition in Vienna further suggests that his indiscretion was forgiven.[35] In mid-June of 1872 Zeshin climbed Mt Fuji with his sons and followers, and the sketchbook material collected on the way supplied the main ideas for his Vienna exhibit: a large framed lacquer work entitled *Fuji Tago no Ura* ('A View of Mt Fuji from Tago no Ura'[36], 131.5 × 178.5 cms). Unlike many views of this famous mountain, Zeshin's painting includes details of a country village with people at work in the fields. His refusal to deny the ordinary working man his rightful place at the foundation of this national symbol is typical of Zeshin's concern for different levels of society. The culmination of his initial experiments in lacquer, *Fuji Tago no Ura* is a key work in Zeshin's artistic life. Some contemporaries interpreted its exceptional technique of subdued and shaded colors as a Japanese effort to rival the effects of western oil-painting. Japanese circles were impressed by the unique technique, by the unusual presentation of the subject and by its frame, which gave it a western guise: European admirers were fascinated by this Japanese approach to what they called a western-style painting.[37]

Ever eager to view the nation's finest historic treasures, Zeshin made his second journey to Nara for the opening of the Shōsōin in the summer of 1875. With Reisai, Shinsai and Shōji Chikushin, he spent five weeks browsing among the great art works contained in that famous repository and in selected temples in the vicinity.

In a feud between opposing parties of a local art association over the appointment of a judge for the Fifth Kyoto Exposition in June 1876, Zeshin's growing reputation and virtuosity proved valuable. Although not a native of Kyoto, he was asked to accept the role of judge in a compromise between the two sides.[38] This decision by the Industrial Relations Board was highly significant: it reaffirmed the selection of Zeshin for the work in the Enryōkan (1872) and as one of Japan's representatives in Vienna (1873); by implication it authorized him to continue experiments of his choice.

During the 1870s Zeshin not only maintained high quality in his work but became innovative and prolific as well. In such important gatherings as the Philadelphia Centennial Exposition of 1876, the Nagoya Exhibition of 1878 and the Kyoto Exposition of 1879, his exhibits of framed lacquer paintings and hanging scrolls frequently won top honours. Success in these events stimulated interesting explorations into the application of colored lacquers to paper and silk rather than to a wooden base. An ingenious technician, Zeshin discovered how to prepare and apply a lacquer flexible and strong enough to withstand cracking when unrolled or fading when exposed to strong light. Few other artists had the skill or patience to use his methods, and the *urushi-e* (lacquer picture) of the Meiji period is now associated with Zeshin's name. By 1878 Zeshin's persistence had resulted in a type of composition on paper using the *togi-dashi-maki-e* method.

This type of painting is usually accomplished by first outlining the design on a wooden core, next covering the entire surface with lacquer, and then rubbing the lacquer away in areas to leave the finished composition. On paper, however, this process requires the utmost care since the lacquer base is extremely sensitive and liable to damage. Although the innovation brought satisfactory results, Zeshin decided to discontinue the technique in favor of the more efficient, direct

application of lacquer in *urushi-e*.

After the World Exposition in Vienna in 1873, Zeshin contributed in varying degrees to almost all the major functions and activities associated with traditional Japanese art until his death in 1891. He accepted an appointment to the position of overseer for the Industrial Arts Department of the Agency of Museums in 1879 and in this capacity was responsible for advising many important collections of art throughout the nation.[39] Zeshin also joined the Ryūchikai (Dragon Pond Society) soon after its founding and together with Sano Tsunetami, Kūki Ryūichi and, later, Ernest Fenollosa, helped in publicizing the society's intention to rehabilitate the floundering state of Japanese art.[40] Still an active and prolific artist, Zeshin frequently entered several works in exhibitions and only rarely was not awarded recognition of some kind. To the First Domestic Exhibition of Business and Industry[41] he submitted five works, among which his framed lacquer composition entitled *Uekishitsu-zu* (The Planthouse) gained the top Ryūmon Prize.[42] To the Second Domestic Exhibition he submitted two lacquer hanging scroll paintings, but it was his framed lacquer work *The Nagae Cormorant Boat* that commanded the bronze Myōgi Prize for technical skill. Zeshin prepared two exhibits for the First Exhibition of the Progressive Society of National Painting in 1882,[43] but on the day before the exhibition opened he was suddenly charged with duty as judge; in a hurried rearrangement of entries, works by his son Shinsai were used to fill his vacated spot. The first Paris exhibition of Japanese painting under the direct sponsorship of the Ryūchikai took place in 1883, and Zeshin fulfilled their request for a work representative of contemporary Japanese art. The Second Exhibition of the Progressive Society of National Painting which ran from April 1 to May 20, 1884, saw Zeshin gain another bronze Myōgi Prize for his *Sailing Ship Running before a Gale*. He served also as a committee member of the Oriental Painting Association from 1886 onwards, and this position served to complete and confirm his devotion to promoting the traditions of Japanese art.

Zeshin interrupted these official commitments and appointments in April of 1886 in order to participate in the interior decoration of the newly-constructed Imperial Palace. This tremendous project involved a work-force of several hundred professional experts in carpentry, furniture construction, *tatami*-making, wood sculpting and painting. Seventy painters representing all the major schools came from throughout the country; Zeshin was among the thirteen representing the Shijō School and one of the forty artists finally selected to make their contribution to the Emperor. None of the paintings are sealed or signed, but records in the Imperial Household Agency (Kunai-Chō) show that Zeshin was responsible for a four-panel sliding screen which partitioned a main corridor in the inner recesses of the palace. On one side of the doors he painted a work entitled *Night Herons and Water Hollyhocks*, and on the other *Irises*. The fresh colors – the warm blues being particularly attractive – recall the sumptuousness of traditional renditions of bird-and-flower themes; nevertheless, the bold freedom and expressive movement typical of Zeshin are missing, due perhaps to an effort on his part to conform to his official Shijō School listing.[44]

Once the work was finished, Zeshin was free to resume his own forceful expression, and at the meeting of the Society of Progressive Oriental Arts at Ueno Park in 1886 he won a silver prize for a painting entitled *Landscape on an Autumn Evening*. He was judge for the Seventh Meeting of the Society for the Appreciation of Old

Art in June of the same year and accepted a silver chalice for his labors. To an exhibition sponsored by the Tokyo Society of Progressive Industrial Art Works in 1887,[45] he submitted three works and won two silver prizes, while at the Art Exhibition of April 1888 his landscape painting in a traditional vein again won the silver prize.

Zeshin's artistic commitments to the seemingly irreconcilable goals of preserving tradition within innovation, of direct and forceful expression through elaborate technique, and of speaking to the West in a Japanese idiom were crowned in 1889 by two important honors: his appointment as temporary inspector for the Zenkoku Takaramono Torishirabe Kyoku (National Treasure Investigation Department) and his gold prize for a framed lacquer composition entitled *Tachinami Ebi Maki-e Gakumen* ('Lobster and Rising Waves') at the Paris Exposition.[46] The highest confirmation of Zeshin's mastery came on October 11, 1890 when the Emperor elevated him to Court Artist.[47]

To promote added interest in lacquer ware and the means whereby the public could voice fresh ideas in its evolvement, Zeshin established the Japan Lacquer Association in December 1890. Belying his 85 years, he devoted himself for six months to ensuring its successful operation, but then suddenly fell ill and died on July 13, 1891. In a ceremony in the following October, the Emperor paid tribute to Zeshin's career and presented to Reisai a commemorative set of silver chalices with an imperial citation:

'Junzō devoted his life to lacquer techniques in industrial arts. He rebelled against recent innovations which he considered rough and ill-conceived, and grieved for the fine, old, gold applications by means of which he strived to recapture the essence of pictorial art. Immaculate combing and sculpture flowed from his genius. He decorated his creations with copper-colored lacquer and made concentrated studies into unique ways of improving upon past techniques, in *tetsu-sabi-nuri*, *shitan-nuri*, *shūmon-nuri*, *usuginubari-nuri* and *seigai-ha* applications. He invented a method to paint directly onto paper with lacquer sap. He founded the Association of Raised Lacquer Artisans and the Japan Lacquer Association. He inspired his fellow and junior colleagues, and generally provided great encouragement to the technical field of industrial arts. He worked hard and had that admirable quality of assiduity and determination. In recognition of his contribution to the arts, Shibata Zeshin is hereby granted a set of silver chalices.

Signed and witnessed this 23 October 1891'[48]

Shibata Zeshin was the epitome of an *Edokko* (Edoite). A stubborn and energetic man, who gave eighty-five years to the continuation of an ideal in Japanese artistic expression, he rejoiced in the simple form. He explored the effects of novelty and wit and felt little obligation to be restrained by tradition. His line surges with magnanimity, his innovations a light cheerfulness that run counter to his bouts with personal grief. Disinclined to consider very deeply events beyond the houses and shops of downtown Edo, he rarely ventured, except on journeys that promised advantages to his art, far from his home opposite the willows. Zeshin was an idealist who immersed himself in the time-honored sentiments of the expert artisan and in the moral disposition of a local culture. While he deliberated on the state of traditional art at a national level – and could produce brilliant overtures when commissioned by the Emperor – themes in both his lacquer and painting suggest that his urban environment influenced his expressive sense. Stories recount Zeshin's deep sense of belonging to the people; he was a constituent of the streets of Edo with the disposition of a working man and, like the stage actor, cultivated such a relationship with his

audience that those who purchased his art stimulated the creation and development of his inspired touch. Zeshin's ability to respond to any taste or whim was intuitive, and as a master artist who sustained interest over two generations, he was that one genius who makes his appearance in Japanese art every century or so.

Martin Foulds

Reference Notes

1. Anonymous, 'Ō no Ie Sude-ni Yonketsu-o Idasu,' *Yomiuri Shimbun*, July 21, 1891, p.2 (one of a series of newspaper articles concerning Zeshin following his death on July 13).

2. Chōbei II inherited the Izumi business and had an outstanding career thanks to a gift in art and mathematics. He was Assistant Chief Carpenter (*Fuku Tōryō*) for the third reconstruction of Ōji Inari shrine, completed on the 22nd day of the 8th month of Bunsei 5 (1822).

3. Details of this relationship are lacking but Soeda Tatsumine ('Shibata Zeshin-Ō no Kotodomo,' *Toei*, Vol. 16, No. 9, Tokyo, 1940, p.24) suggests that Izumi Shunzan (杲春山) could well have been Ichigorō.

4. The *kako-chō* (record of deaths) for the Shibata family is kept in Shōfukuji temple, Imado, Asakusa, Tokyo.

5. Motoyama Tekishū ('Shibata Zeshin,' *Meijin Kijin*, Tokyo, 1971, pp.246–7) remarks that even among all his students and admirers, Tani Bunchō (1763–1840) had noticed Junzō's talents. Mori Taikyō ('Shibata Zeshin-Ō,' *Shin Shosetsu*, Vol. 10, Nos. 7–8, Tokyo, 1905, p.160) suggests that Zeshin may have been introduced through Koma Kansai's son, Bunsai, who was married to Bunchō's daughter.

6. Artisan families frequently hired child apprentices who were family relatives or whom people recommended. Kametarō I could have influenced the decision that Junzō work under a lacquerer. For some interesting notes on the apprentice system of the day, see Charles David Sheldon, *The Rise of the Merchant Class in Tokugawa Japan, 1600–1868* (New York, 1958), pp.52–3 and footnote 10 on p.66.

7. Although not a direct descendent, Koma Kansai I (?–1792) was granted use of the family name by his teacher Koma Kōryū and contributed greatly to the technical field of *chinkinbori* ('sunken gold carving') in particular and *maki-e* in general. The quantity and quality of lacquer production by his son Koma Kansai II, however, was limited and some critics argue that it was only on account of his association with Zeshin that his name became known at all. When Kansai II retired to become a priest in 1824 and his son Kansai III (died 1857) assumed his position, Zeshin continued work on a semi-independent basis. Zeshin himself reports the complete Koma lineage in 'Maki-e Shi no Ryakkei', *Kokka*, vol. 5, Tokyo, 1890, pp.16–19.

8. See Gōke Tadaomi, 'Shibata Zeshin,' *Nihon no Bijutsu*, No. 93, Shibundō Series, Tokyo, February 1974, p.20.

9. J. Hillier presents a good account of the art of Nanrei in his publication *The Uninhibited Brush* (Hugh Moss Publishing, London, 1974), pp.306–315. Nanrei frequently contributed illustrations to accompany *haiku* compositions as in *Asakusa Gusa* [published Bunsei 3 (1820)] and *Yuisō-an Shinchiku Kinen Kushū* [published Tempo 5 (1834)] with *haiku* by Yuisō. His book entitled *Musashi Yawa* [published Bunka 12 (1815)] is more well known. In four volumes it contains line illustrations of famous localities in and around the Kantō district, to accompany anecdotes written by Kakusō of the people who lived and worked there.

10. The vitality common to Ogata Kōrin's style, which Nangaku studied in his later years, is often evident in Nanrei's extant paintings. Zeshin (Junzō) himself made a direct copy of a *suzuribako* (inkstone box) by Kōrin entitled *Senmen Narihira Maki-e Suzuribako* in the autumn of 1863. The original, which once belonged to Koma Kansai II, and Zeshin's copy are illustrated together in Gōke, *op. cit.*, plates 39 and 40, p.38.

11. Toyohiko was a senior pupil of Matsumura Goshun (1752–1811), founder of the Shijō School in Kyoto. As an important teacher of the Shijō style in the early 19th century, Toyohiko displayed a versatility that extended over a wide range of subjects. He is most remembered for his landscape depictions, which are characterized by a strong hint of Chinese school mannerisms, apparently due to his association with Kuroda Ryōzan. (See Hillier, *op. cit.*, pp.136–145.)

12. *Sai*, 哉 , the final character of the name *Reisai* which Junzō adopted in deference to his teacher Kansai, reads *ya* only in a literary context at the end of rhetorical statements or exclamations. The name *Reiya* (and also *Shinya* instead of *Shinsai*) contained

in numerous non-Japanese publications would seem inappropriate.

13. Numerous accounts of this meeting attempt to trace Zeshin's rise to fame, but they are often reduced to anecdotes popularized and exaggerated by professional storytellers. Three sources maintain that Kuniyoshi, who may have been the first known disciple of Junzō, was given the name *Senshin* (仙眞). It was custom for followers to receive the character *shin* in their *gō* (pseudonyms) after 1832 when Junzō received the name *Zeshin* from Nanrei. Motoyama Tekishū (*op. cit.*, p.248), on the other hand, dates the meeting with Kuniyoshi to no later than 1827 when he writes that Junzō was still 'a handsome boy with a red face and not yet 20 years old'.

14. Junzō lodged at the home of Nōzaki Yōsuke, a close friend of the Shibata family, who ran an ironmongery business and did trade at stations along the Tōkaido highway. The relationship continued for many years and Zeshin always stopped at this house when in Kyoto.

15. Junzō's paintings on the *fusuma* (sliding screen doors) of the *butsuma* (altar room) of the Daiyū-in are entitled *Tōjinbutsu-zu* ('Chinese Figures'), *Chishō-zu* ('Pine Trees'), *Sansui-zu* ('Landscape'), and *Taki ni Saru-zu* ('Monkeys by a Waterfall').

16. Rai Sanyō (1780–1832) was also a gifted poet, calligrapher, and painter. His most important work, *Nihon Gaishi* (1827), written in Chinese, describes the fortunes of military families in Japan during the Middle Ages. Restoration of the Emperor constitutes its main theme, but tales of heroic deeds may account for its overall popularity (see Burton Watson, 'Historian and Master of Chinese Verse: Rai Sanyō', *Great Historical Figures of Japan*, Japan Culture Institute, Tokyo, 1978, p.240) and Zeshin's attraction to Sanyō. Okakura Tenshin later called the book 'an epic narrative'. (See *The Ideals of the East*, New York, E. P. Dutton and Co., 1904, p.210).

17. Kagawa Kageki (1768–1843), founder of the Keien School of *waka* poetry and author of *Keien Isshi* (1830), gave his poems about the countryside and its animals a conspicuous refinement. People came to accept this style, but in Edo Junzō was one of the few to respond to its cultural implications. Kageki gathered a large number of sympathetic followers in Kyoto, and in 1831, when Junzō met him, he had already become a national figure. The beautiful expressive strength of Kageki's poetry may have caused Junzō to reappraise his own style in painting and lacquer work. The artistic abbreviation partly derived from his poetic training and the urbane simplicity valued by the Edo people are two key factors that characterize Zeshin's art.

18. Most sources in the past have stated unequivocally that the *Rakan* of Tōfukuji were painted by Li Lung-mien (in Japanese, Ri Ryū-min), the last of the great Chinese figure painters who revived the plain, drawing (*pai-maio*) style of the T'ang Period. Recent comprehensive studies suggest that they are probably the work of Ryōzen, a Japanese painter active in the Kyoto area sometime in the early 14th century. (See Carla M. Zainie, 'Ryōzen: From Ebbushi to Ink Painter,' *Artibus Asiae*, XL (1978), 98.)

19. The name Reisai was not discarded; Zeshin continued to use it occasionally (see Appendices of seals and signatures). The names *Zeshin* and *Tanzen* appear in the Chinese classical work *Sōshi*. The author explains that the essential quality of truly individualistic painting is the expression of a humanitarian nature. He cites the example of the Sung Emperor who summoned all the painters in the land to give a demonstration of their abilities. Once assembled, the artists prepared their brushes and began to rub their ink sticks. As everyone was about to put brush to paper, however, a latecomer entered oblivious to the imperial presence. He stripped himself naked and sat with both legs outstretched. 'This,' announced the Emperor to the astonished onlookers, 'is the true painter who understands what real art is all about.' The name of the painter in Chinese used the same characters which in Japanese read *Zeshin*. *Tanzen* means *placid nature* or *oblivion*. The name *Chinryūtei* (literally, 'The House of the Silent Willows') dates from this time too, but its appearance on either lacquer or paintings is rare.

20. Sōhen School; *gō* Keisetsu-an.

21. The Asuka-en School of *haiku* extends over twelve generations from its founder Sugiyama Shōfū (1647–1732) to its present-day representative Watanabe Kōji (born 1901). Zeshin associated chiefly with Issō IV (1776–1857) but frequently met Issō V (1792–1858) also.

22. Kitta Shunkō (1814–1886), born in Kōfu, arrived in Edo in December 1854, and set up house in Naka-Saga-chō, Fukagawa. He left for a 21-month tour of Ise, Shikoku

and Kyūshu in the following February and became Zeshin's full-time associate from about 1857 soon after Issō's death. The *Kyōbushō* (forerunner of the present-day Ministry of Education) appointed Shunkō and five other *haiku* masters in May 1873 to organize *haiku* as a form of moral instruction in public education.

23. Although he had retired from the Shōgun's workshops in 1824 (see note 7), Kansai II remained an unofficial adviser to Zeshin until his death in 1835. Zeshin compiled an inventory of lacquer ware belonging to the Koami family (published in *Bijutsu Kenkyū*, No. 99, March 1940, p.36 – see note below); he signed himself Koma Zeshin and dated his copy Ansei 2 (1855). This suggests that he was already privileged to use the Koma family name before the death of Kansai III in 1857. Details of Kansai's family tomb in the cemetery of Seidō-in, Shitaya, Tokyo, are to be found in 'Sakanouchi Kansai Boiki,' *Bohi Shiseki Kenkyū*, No. 43, Tokyo, 1938, pp.547–552.

24. *Bijutsu Kenkyū* (Nos. 98, February, 1940, pp.17–31 and 99, March, 1940, pp.33–38) published one example of this dedication. For a short account of the ideal that guided Zeshin, see Tonomura Kichinōsuke, 'Shokunin-Katagi: The Spirit of the Artisan,' *The East*, Vol. XII, No. 4, pp.51–56.

25. Hoida Tadatomo (1792–1847), a priest at Ikutama shrine in Osaka until he transferred to the offices of the Nara Magistrate in about 1824, studied *tanka* and other forms of poetry under Kagawa Kageki from 1813.

26. The picture is intended to convey the story of Watanabe Tsuna, samurai of the Minamoto clan, who met a fox demon on his way across Modori Bridge in Omiya. Enraged by the mischief she had caused the locality, he immediately sliced off her arm. Six days later the demon appeared at Watanabe's house disguised as his aunt and retrieved her arm. The painting captures the moment she is about to fly into the air to make her final escape.

27. The relatively good condition of this work, exposed to the elements over a long time, may be attributed to the services of Arai Kampō (1878–1945), the well-known copyist of Indian and Central Asian paintings. He volunteered to insert adhesive between the flaking gold leaf and the wood base, a task he accomplished only after much trouble and without payment in 1905.

28. Zeshin rarely attempted depictions of apparitions. He reluctantly made one other entitled *Yūrei-zu* (see Gōke, *op. cit.*, plate 49) required by Kikugorō V, the famous kabuki actor, on an advertisement for a forthcoming stage performance, but this was done only as a special favor to a close friend. Zeshin usually recoiled from mysterious or gruesome depictions, which he left to his archrival Kawanabe Gyōsai. Genpuan Monto ('Shibata Zeshin to Kawanabe Gyōsai,' Bi no Kuni, August 1927, pp.91–98) describes the animosity between the two.

29. Zeshin followed the route taken between 1689 and 1691 by Matsuo Bashō (1644–1694), the greatest of Japan's *haiku* poets. This may suggest that Zeshin concurred with Bashō's view of the countryside and the *haiku* with which he reported his observations. Interesting discussions about Bashō's life are available in Yuasa Nobuyuki, *Bashō: The Narrow Road to the Deep North and Other Travel Sketches*, Penguin Classics, England, 1970.

30. The *seigai-ha* motif is an extremely delicate application of lacquer, carefully raked with a coarse brush before it has chance to solidify. Additional treatments result in an elegant rippling effect with an attractive blue sheen, a favorite among samurai warriors. Kanshichi monopolized the market and left his technique an unrecorded secret. For details of *seigai-ha-nuri* as it is known today, see Sawaguchi Goichi, *Nihon Shikkō no Kenkyū*, Maruzen Co., Tokyo, p.296.

31. The *kako-chō* (record of deaths) in Shōfukuji temple, Imado, Asakusa, shows that Ichigorō died on the 16th day of the 7th month of Kaei 1 (1848), Masu on the 28th day of the 8th month of Kaei 7 (1854) and Suma on the same day of the 10th month. They are buried together in the Shibata family tomb near the gate of the temple cemetery.

32. Zeshin aired his feelings about the importance of old treasures in 'Maki-e Shi Koma-shi no Ryakkei', *Kokka*, Vol. 5, pp.16–19. Soeda Tatsumine (*op. cit.*, pp.27–29) reports the complicated transaction of the pictures.

33. Utako (maiden name, Suzuki) born on the 21st day of the 12th month of Bunsei 7 (1824) and died on the 10th day of the 11th month of Bunkyū 3 (1863), aged 39 years (*kako-chō*, Shofukuji temple).

34. Kaburagi, *op. cit.*, p.66.

35. The Enryōkan was part of the Hama Rikyū Palace where Emperor Meiji spent his daily life. Once sited near the present-day Hamamatsu-chō Station in Tokyo, it was completely destroyed in the Great Kantō Earthquake of 1923. Only records that Zeshin painted there survive.

36. *Tago no Ura* is the name given to a stretch of coastline near Yoshiwara (the modern Fuji City), the 15th station on the Tōkaido highway. The view of Mt Fuji from here has been a favorite subject of many painters, including Suzuki Nanrei.

37. The work was awarded a Medal of Commendation for Progressive Technique at Vienna, and the Japanese Foreign Ministry ordered 20 copies on silk in 1875. (See Gōke, *op. cit.*, p.36.)

38. While the exhibition was in progress, Zeshin paid courtesy calls on *haiku* master Yagi Kinsha (*gō*: Hansui-en), 1805–1890, the most influential poet in Kyoto at the beginning of the Meiji Period, and tea master En-an.

39. The Agency of Museums (in Japanese, *Hakubutsu-Kyoku*) was the forerunner of the Imperial Museum which later changed its name to the present Tokyo National Museum.

40. The Ryūchikai, a society that grew out of the Society for the Appraisal of Art Objects (Bijutsuhin Hyōkai), held its first formal meeting on March 15, 1879 and proclaimed itself 'for the purpose of providing moral and financial support to artists working in the Japanese tradition'.

41. The First Domestic Exhibition of Business and Industry (in Japanese, *Dai Ikkai Naikoku Kangyō Tenrankai*) was held from August 21 to November 20, 1877 in Ueno Park, Tokyo. The second was held March 1 to June 30, 1881.

42. Zeshin won the *Ryūmon-shō* (Dragon Prize), Shibata Reisai won the second *Hō-shō* (Phoenix Prize), Shibata Shinsai and Zeshin disciple Ikeda Taishin shared the third *Hana-shō* (Flower Prize), and follower Shōji Chikushin won a Commendation.

43. The First Exhibition of the Progressive Society of National Painting (in Japanese, Dai Ikkai Naikoku Kaiga Kyōshinkai no Tenrankai) was held October 1 to November 20, 1882 in Ueno Park, Tokyo.

44. Seki Chiyo has made a study of all the door paintings, which were removed from the palace before it was destroyed in an air raid on May 25, 1940 and which are now stored in the Imperial Household Agency (Kunai-Chō). (See 'Kōkyo Sugito-e ni Tsuite', *Bijutsu Kenkyū*, No. 264, Tokyo, 1969, pp.41–72.)

45. The Tokyo Society of Progressive Industrial Art Works (in Japanese, Tokyu-fu Kōgeihin Kyōshinkai) was held from April 1 to May 9, 1887 in Ueno Park, Tokyo.

46. With number of exhibits exceeding 60,000 and attendance more than twice that of the 1876 Philadelphia Centennial Exposition, the Paris Exposition of 1889 was one of the greatest fairs of the 19th century. Nowhere in the eyes of the Japanese was a more prestigious place to exhibit.

47. Zeshin was one of ten artists elevated to the position, but the only one as lacquerer.

48. Translated by the author freely from the Japanese in Gōke, *op. cit.*, pp.40–41.

Catalogue Notes

TITLE

Japanese inscribed titles appearing on paintings and woodblock prints are transliterated, with a translation in parentheses. For art that is untitled, a descriptive name has been utilized which suggests the primary concept of each work's design content. For lacquer and ceramic objects, where appropriate, the Japanese name for the object has been given followed by its equivalent Western name in parentheses.

Iconographic notes on paintings, prints and lacquer objects are not claimed to be comprehensive. In the present stage of iconographical identification involving a plethora of legends and anecdotes, many sources need to be re-examined. Some legendary characters such as Okame involve complex problems which can only be summarized here. Many traditional identifications and legends, moreover, need to be more reliably documented from the original Japanese sources.

TECHNICAL INFORMATION

The exact measurements of each work of art is given in both inches and centimeters with height preceding width for paintings and prints; dimensions are clearly marked for three-dimensional objects. The medium is fully described.

DATING

Exact dates are used only when an accepted inscribed one occurs or can be deduced from an age seal. It should be noted that according to Japanese custom a person was considered one year old at birth, and I have taken this system into account in determining Zeshin's actual age and the date of inscribed works. As no paintings in the O'Brien Collection date from the first period, undated paintings without inscription have been grouped according to style and inference of signature and seal within the remaining two of the three main time periods of Zeshin's career:

1. early period (1817–1832)
2. middle period (1833–1872)
3. late period (1873–1891)

Lacquer objects are all dated to Zeshin's later period (1873–1891) and divided according to the method of signature (incised or lacquered). Neither method permits the same degree of control as the brush, and stylistic changes in the calligraphy, pertinent to a closer dating, are of less value than one would first suppose. Likewise, only a few lacquer objects bear an inscribed date, making stylistic dating most difficult. Woodblock prints are also dated to Zeshin's later years. The two ceramic items in the collection can be dated on the basis of seals and external evidence.

Very little is known about Zeshin's early life and few works are available for study. Throughout most of this period, he utilized the signature *Reisai* written in a distinctly elegant *gyōsho* style. None of these rare works are included in the O'Brien Collection.

Zeshin's middle period is represented by a number of works in the O'Brien Collection that ideally demonstrate the sophistication of Zeshin's art. This work is characterized by an urbane spirit that is all his own, born perhaps from the expressive brevity of *haiku*, and the delicious play on terms that so delighted the *Edokko* of the day. The long handscroll, *Episodes from Life in Edo* (Cat. No. 7), is a key work from this period in that it is the only painting in the collection firmly dated to the middle period by inscription. The work reveals Zeshin's clear, abbreviated approach in a lighthearted series of puns. Throughout this period, he utilized the signature *Zeshin* in combination with a number of other names and a variety of seals (see Appendices I and II, Signatures and Seals).

Zeshin's later years may be distinguished by a gradual softening of compositional elements and a dazzling range of innovations including the prolific production of *urushi-e* (lacquer painting) and framed lacquer work. The O'Brien Collection contains seven key paintings

and two lacquer objects dated by inscription from this culminating period of creativity. In addition, the collection boasts a large number of other works (paintings, prints and lacquer objects) assigned to this period on the basis of style comparisons.

Mr Raymond Bushell, at the 1979 INS conference, Honolulu, reports that some lacquer paintings actually use a mixture of glue and pigment to simulate lacquer; other paintings incorporate a combination of both techniques. The requisites of publication deadline, make it impossible to document this satisfactorily or to provide the necessary technical analysis.[1]

One final word is necessary on stylistic dating. Until a larger reliable body of work dated by inscription has been culled from Zeshin's total surviving output dispersed throughout the world, any attempt at stylistic dating must remain conjectural. Dating here is therefore only a tentative beginning.

SIGNATURES AND SEALS

All signatures and seals are transcribed and transliterated. Occasionally, both a transcription and translation of a longer inscription are included where appropriate. For comparative study purposes, enlargements of signatures and seals on paintings are reproduced in a separate section following the catalogue.

The study of Zeshin's seals and signatures, important as a subsidiary aid to dating and authenticating works reputedly from Zeshin's hand, is still very much in its infancy and a number of corrections or modifications to our present understanding seems necessary (see Appendix I and II, Signatures and Seals). For example, in the album of landscapes depicting the twelve months (Cat. No. 35), dated by inscription to 1881, one leaf bears a genuine seal reading *ze*. While seals with the character *shin* are not uncommon, the *ze* seal has not been recorded hitherto. Paintings bearing the *ze* seal should therefore not be eliminated from Zeshin's oeuvre on this account only.

An even more critical problem surrounds the use of the seal *Reisai*, not believed to have been used by Zeshin after his return from Kyoto to Edo in 1832. Genuine *Reisai* seals appear on three paintings signed and sealed *Zeshin* (Cat. No. 1, Cat. No. 2, and Cat. No. 8). The latter is executed superbly in lacquer. Up to this time, all of Zeshin's paintings in lacquer have been dated to 1872 or later. Only one piece of evidence, dating to 1848, has so far come to light to support earlier experiments in lacquer painting. If the early date of genuine *Reisai* seals can be trusted, the advent of Zeshin's experiments in lacquer could be extended back as far as the mid-1830s. The occurrence of this rare seal with the *Zeshin* signature may eventually point to a transitional group of works dating from the mid-1830s to the mid-1840s. Such speculation however, must wait future research, once a larger corpus has been determined. As with the *Reisai* signature, however, it is more likely that the master after assuming the name Zeshin in 1832 continued to use the *Reisai* seal on occasion.

CONDITION

Unless noted otherwise, all works are in good condition.

ATTRIBUTION

In Japanese art, the question of attribution is always a most difficult matter, for traditionally a gifted master would maintain an atelier for the production of art in his general style. A few examples from the O'Brien Collection, first noted by Mr Marshall Wu, illustrate some of the techniques utilized in distinguishing such productions as well as the true counterfeit. A Shijō style hanging scroll in ink and light color on paper titled *Long Life* bears a signature

[1] Mr. Bushell, in a subsequent letter dated March 19, 1979, describes the use of glue for coloring on *inrō* and painting as follows: 'GOFUN ENOGU The colors of the *inrō* in Figure 99 are not lacquer-based, nor do they exhibit the texture of lacquer. They are those often used by Japanese artists in painting *kakemono* in water colors and are known as *gofun enogu*. They are made by mixing *gofun* pulverized oyster shell, *nikawa* fish glue, and natural mineral colors. They are fairly thick colors somewhat similar to gouache and are sometimes mistaken for lacquer. Zeshin painted the design of the *inrō* with the colors and in the style of the colored *kakemono* painting known as *suisai ga*.'

which reads *Meiji ju yonnen shinjitsu shihitsu Zeshin*. This long inscription, which appears on first glance to be in the genuine hand of Zeshin, suggests that this was the first painting of the new year, a work of Meiji 14 or 1881. The seal accompanying this painting, however, reads *kon hachiju ni* or 82 years old. Since Zeshin was only 75 years old in Meiji 14, there is a discrepancy between the inscription and the age date of the seal. This problem, as well as the rather undistinguished brushwork of the painting suggests that the work may not be by Zeshin himself but rather a talented member of his atelier who carelessly sealed it incorrectly.

Another work of art, *Deer in the Forest*, a small lacquer painting, appears to be a counterfeit. The light outline of charcoal discernible around the body of the deer as well as some pressed lines along the roots of a tree suggest a tracing. The results are clumsy forms and muddy colors. The seal on this painting, moreover, was not truly stamped but was painted with a brush after one of Zeshin's authentic seals. There can be no question that this painting is a later fabrication.

Still a third work of art so deceptively well done that it was published as genuine in Professor Gōke's study of Zeshin (*Nihon no Bijutsu*, No. 93, Plate 91) reveals the same problems as the last example. The seal was not printed but recreated with brush; an obvious copy after a genuine impression of a seal.

Other works have been questioned because of the weakness of brushstroke or, as in the case of one example illustrated in the catalogue, *Pagoda and Flying Bird* (Cat. No. 42), because of weak brushwork and a difference in the quality of paper from the remainder of the accompanying set.

As with any collection developing over a span of time during which the connoisseurship of the collector grew with the collection, there are works of art of varying quality. It is possible that some of the lesser pieces could be the talented production of other artists. It is rumored in dealer circles, for example, that artisans copied the master's art for use as decoration in restaurants and inns. It should be added, however, that such counterfeiting was relatively limited. There is, moreover, no *hard* evidence to support the claim that Zeshin lent his own signature to student work as other artists often did, or that posthumous works in his style continued to be inscribed with his name. These are matters for future research once a larger corpus of Zeshin's art has been critically examined and compared with the art of his principal students. The spurious examples discussed above would seem to suggest, however, that 'workshop' productions and counterfeiting did occur, but to what extent is uncertain. It is the best of Zeshin for which we must be concerned, and it is to Mr and Mrs O'Brien's credit that so large a number of true masterpieces by Zeshin were brought together during a time when subsidiary research on Zeshin's art was non-existent. I am deeply grateful to them both for generously sharing their unique collection with Hawaii and deepening our awareness of the aesthetic qualities of the art of Shibata Zeshin.

HOWARD A. LINK

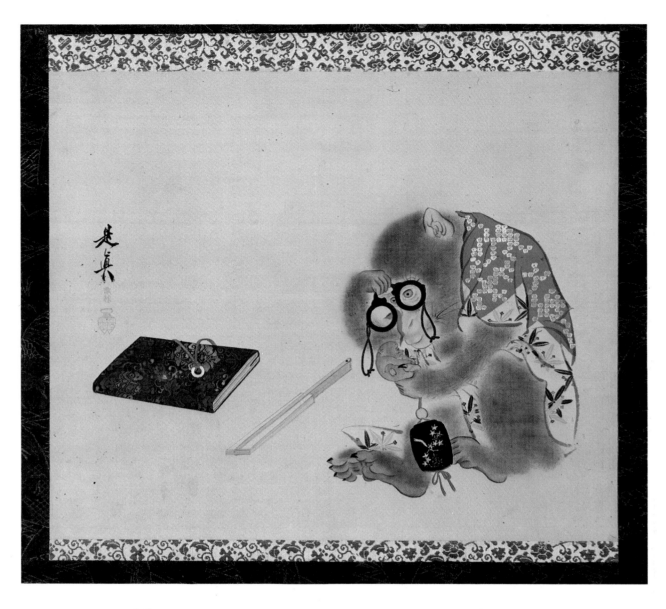

1 Monkey Posing as Collector

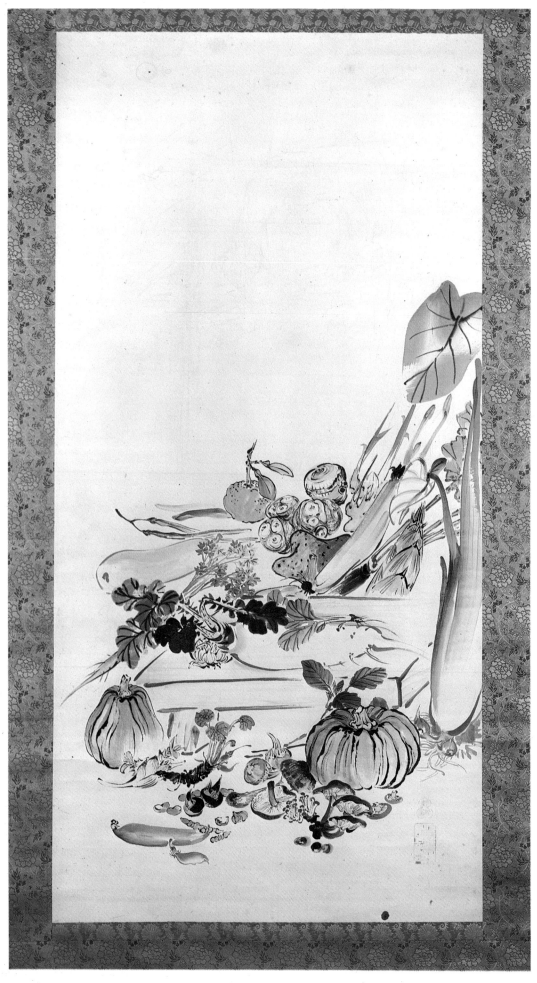

5 The Death of Buddha

Catalogue

2 Bamboo Container with Chrysanthemums

Paintings

1 Monkey Posing as Collector

Technical:	Ink and color on silk; $13\frac{5}{8}$ in. \times $17\frac{1}{8}$ in. (34.6 \times 43.5 cm.); mounted as a hanging scroll
Signature:	Zeshin
Seal:	Reisai, Zeshin
Date:	Middle period
Accession No.:	4582.1

The touch of a great master is in full evidence in this satirical painting, from the exquisitely detailed fabric cover of the book to the marvelously contrived facial expression of the astonished simian collector examining a *netsuke* carved in his own image. In dating this work the occurrence of the *Reisai* seal (not generally seen on paintings after 1832) in combination with a small jar-shaped seal reading *Zeshin* in lateral block characters suggests this is a transitional work, and it has been dated to about 1835. This dating also corresponds to the character of the signature, which is essentially done in the refined *sōsho* style of the period. Neither seal matches precisely those reproduced in Appendix II (see Nos. 5, 30 and 33), but it is not unreasonable to suppose that a number of versions of the same seal were used over the course of a given period. The small jar-shaped seal is supposed to have been used throughout Zeshin's life on works that particularly pleased him.

2 Bamboo Container with Chrysanthemums

Technical:	Ink, color and gold on colored paper; $14\frac{1}{8}$ in. \times $2\frac{3}{8}$ in. (36.2 \times 6 cm.)
Signature:	Zeshin
Seal:	Reisai
Date:	Middle period
Accession No.:	17,106a

An open chrysanthemum and a bud are depicted in a bamboo container (*noshi*). The composition in the elongated *tanzaku* format is enhanced with a sprinkling of gold in imitation of *urushi* (lacquer). Judging from the use of the *Reisai* seal and the light brush stroke of the signature, done in the refined *sōsho* style, both appearing on the bamboo *noshi*, this painting would seem to date around the mid-1830s.

3 Butterfly and Flowering Plant

Technical:	Color on paper; each: 42½ in. × 6¹¹⁄₁₆ in. (108 × 17 cm.); mounted as a pair of hanging scrolls
Signature:	Zeshin
Seal:	Zeshin
Date:	Middle period
Accession No.:	4599.1 & .2

These two scrolls were intended to be viewed together. The left scroll shows a single butterfly in flight, descending to light upon the flowering plant depicted in the right scroll. Zeshin deliberately left broad expanses of paper to create a sense of space and atmosphere surrounding the subject elements, which, though quite delicate, stand out clearly. The signature *Zeshin* appearing on both scrolls is characterized by the light brush stroke of the refined *sōsho* style. Zeshin utilized this type of signature from about 1832 to 1840. About 1842 Zeshin began to use the heavier *gyōsho* style of writing, particularly in the *ze* character. The tiny jar-shaped seal appearing on both scrolls, which includes the characters of *Zeshin* in lateral block style (No. 5 in Appendix II) was apparently employed throughout Zeshin's long career, particularly on works he considered to be of exceptional quality.

4 Cock and Hen

Technical:	Ink and color on paper; 11½ in. × 16⅜ in. (29.2 × 41.6 cm.); mounted as a hanging scroll
Signature:	Zeshin
Seal:	Zeshin
Date:	Middle period
Accession No.:	4581.1

Although the subject was a favorite of Zeshin, this painting does not display the sureness of brushstroke that characterizes his best work. The use of the Zeshin name first occurred soon after the master returned from Kyōto in 1832. At first the name was written in a rather light, refined *sōsho* style. Then about 1840 a heavier *gyōsho* form began to be used for the writing of the character *ze*. Since this signature change is not fully in evidence here, a date around 1840 is suggested. The seal *Zeshin* recorded in Appendix II, No. 1 differs in detail from the crisp impression on this painting. This, in combination with the mediocre quality of the painting itself, suggests that we should hold in reserve any opinion about the authenticity of this painting.

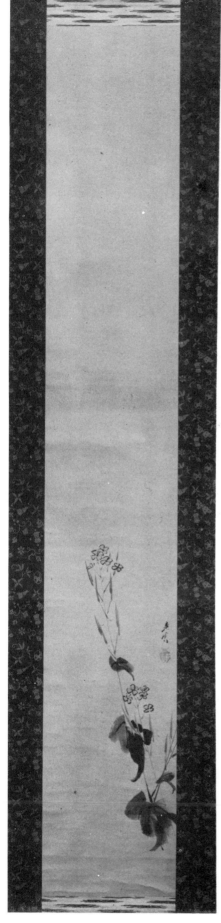

3 Butterfly and Flowering Plant

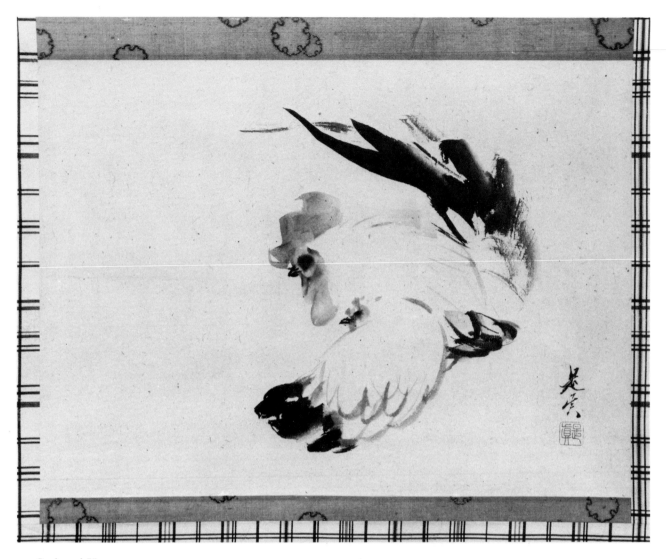

4 Cock and Hen

5 The Death of Buddha

Technical:	Ink and color on paper; 54⅛ in. × 27¼ in. (137.5 × 69.2 cm); mounted as a hanging scroll
Signature:	None
Seal:	Tairyūkyo, Zeshin no In
Date:	Middle period
Accession No.:	4598.1

The novelty of Zeshin's subjects was in part derived from his training in *haiku*, with its qualities of surprise and suggestion. This painting, masterfully conceived and executed, combines elements of humor and a kind of indirect approach (*rusu-moyō*). The latter refers to the use of an object or subject to stand in place of something that it is intended to represent by some aspect of association. In this work, vegetables are placed in positions which recall the *nirvana* scene (*nehan-zu*), or death of Buddha, common in Japanese art. The large white radish laid flat on a cutting board represents Shakyamuni, who has just died in a grove of sacred sala trees (here replaced by a tall leafy root), lying on his death bed surrounded by his many mourners (pumpkins, mushrooms, eggplant, etc.). The effect is one of surprise and delight, and it is the artist's intention to stir our interest in exploring the smallest details for additional visual puns. The brushwork of this painting is superb and stands as strong testimony of Zeshin's thorough assimilation of Shijō pictorial techniques. The work has been tentatively dated to Zeshin's middle period on the basis of the *Zeshin no In* seal, used until around 1845. Both this seal and the *Tairyūkyo* seal noted above are identical with other impressions reproduced in Appendix II, Nos. 43 and 28. Accompanying this fine painting is an official document from the chairman of Zeshin's memorial exhibition of 1907, Count Tanaka, noting that this work was accepted as genuine Zeshin. The posthumous exhibition was held at the Show Hall of the Nihon Bijutsu Kyokai of Sakuragaoka Ueno Park from December 6 to 15, 1907.

6 Cranes and Waves

Technical:	Ink and color on gold paper, mounted as a pair of six-fold screens; each screen 5 ft. 3¾ in. × 11 ft. 10½ in. (162 × 362 cm.)
Signature:	Zeshin (on each screen)
Seals:	Reisai Kan Jin; Shiba Zeshin In
Date:	Middle period
Accession No.:	4406.1

The color and brushwork of this attractive painting are characteristic of Zeshin's art in the mid-1850s, a dating first suggested by an earlier owner of the painting, the Osaka connoisseur, Hatsusaburo Yamamoto. The treatment of landscape detail is similar to other Zeshin works in the collection; the master's realistic rendering of cranes shows a decidedly Western influence in the manner of the Maruyama school. The occurrence of the *Reisai Kan Jin* and *Shiba Zeshin In* seals, both hitherto unrecorded but associated in other forms with an earlier period in Zeshin's career, need to be considered in a final determination of the probable date of this work.

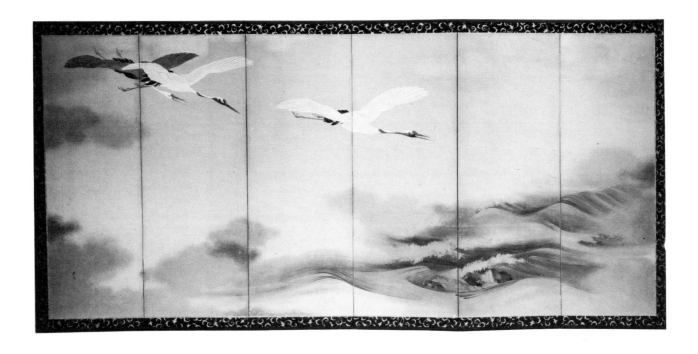

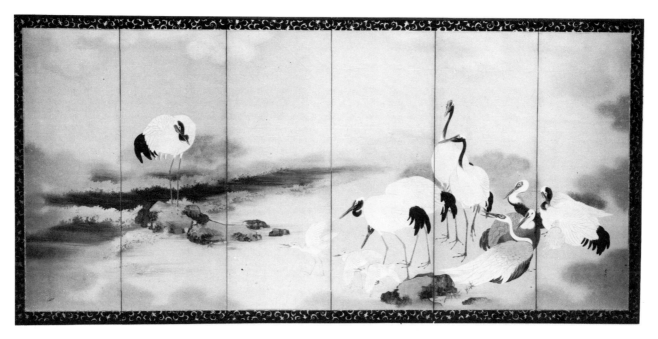

6 Cranes and Waves

7 Episodes from Life in Edo

Technical:	Ink and color on paper; $7\frac{3}{4}$ in. \times $165\frac{5}{8}$ in. (20 \times 420.7 cm.) mounted as a long handscroll
Signature:	Kei-ō Teiu chu to Nichi, o ju Zeshin
Seal:	Tairyūkyo
Date:	ca. Keiō 3 (1867), noted in signature
Accession No.:	4603.1

The cynical sophistication of this long handscroll with its symbolic indirect approach to specific episodes in the contemporary life of Edo requires minute knowledge of Edo customs in order to unravel Zeshin's urbane allusions. A picture of a fat-bellied man with a bag full of 'tricks' appears in the first segment of the long scroll; this is perhaps Hotei, one of the seven gods of good fortune associated with the New Year. Among the symbols included in the scroll are a broom wrapped in a head-cloth and a single *geta* (clog) at a door, both intended to imply that guests are not welcome. The signature has the heavy *gyōsho* form in the writing of *ze* while *shin* reveals a greater strength, especially in the two final 'legs' of the character. The seal *Tairyūkyo* corresponds with No. 45 in Appendix II and was used throughout Zeshin's mature period.

8 Wild Grass and Lotus

Technical:	Lacquer on paper in fan format; $5\frac{1}{4}$ in. \times 17 in. (13.3 \times 43.2 cm.)
Signature:	Zeshin
Seal:	Reisai
Date:	Middle period (?)
Accession No.:	4648.2

This delicately rendered painting bears a *Zeshin* signature characterized by a light brush-stroke and the seal *Reisai*, thought to have been used by the master in the 1820s and early 1830s. This seal is identical with one reproduced in Appendix II, No. 33, and is undisputedly genuine. The question as to when Zeshin began to utilize *urushi* (lacquer on paper has never been adequately answered. Professor Gōke notes that Zeshin first experimented with the application of lacquer on flat *fusuma* (sliding door screens) and *byōbu* (folding screens) and that it was not until 1872 that he began to work with lacquer applied to paintings in the hanging scroll format. This work, if we are to believe the early date of all genuine Reisai seals, would extend Zeshin's earliest experiments in lacquer back to the mid-1830s. In support of such a date, Gōke records that in a notebook on *urushi-e* there is mention of a colophon dated the first year of Kaei, which corresponds to 1848. For the present, however, Zeshin's early use of the *Reisai* seal must be brought into question with the discovery of this important work in the O'Brien Collection. The fan was probably once used, judging from its present state, and remounted as an album leaf to be paired with Catalogue No. 9.

9 Melons and Flowering Vines

Technical:	Lacquer on paper in fan format; $5\frac{1}{4}$ in. × 17 in. (13.3 × 43.2 cm.)
Signature:	Zeshin
Seal:	Shin
Date:	Middle period (?)
Accession No.:	4648.1

The delicate brushstroke of Zeshin's refined signature in *sōsho* style would seem to suggest that this painting dates to a time after the master received the name Zeshin in 1832 but before the 1860s. Zeshin's exaggerated concern for detail is well reflected in the fineness of this painting, which is stylistically related to Catalogue Nos. 8 and 10. The seal, *shin*, while not previously recorded, seems perfectly correct; at least ten seals reading *shin* have been recorded to date, spanning most of Zeshin's long career. This painting appears to have once been used as a fan and later removed from its structural form and mounted as an album leaf.

10 Bat Against a Crescent Moon

Technical:	Silver, lacquer and color on paper in fan format; $6\frac{3}{8}$ in × $18\frac{3}{8}$ in. (16.2 × 46.7 cm.)
Signature:	Zeshin (in brown lacquer)
Seal:	Koma
Date:	Middle period (?)
Accession No.:	4642.1

The hallmarks of Zeshin's art can still be discerned in this small fan-shaped painting, despite its poor condition. The use of the *koma* seal seems always to occur on lacquer paintings or lacquer objects. The name has its origin in Zeshin's formative years (ca. 1817) when he studied lacquering under Koma Kansai II. The seal form was apparently used throughout Zeshin's career, probably in homage to his teacher. The crescent moon in this work was originally silver but it has turned black with the passing of time. The work relates to two other fans mounted in recent times as a pair (Cat. Nos. 8 and 9), one of which carries a seal that is thought to date to Zeshin's formative years in the early 1830s. The signature comes close in style to Cat. No. 14.

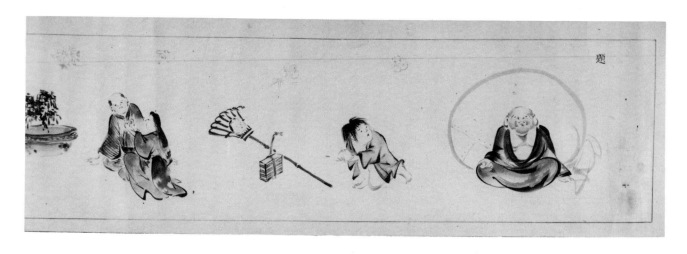

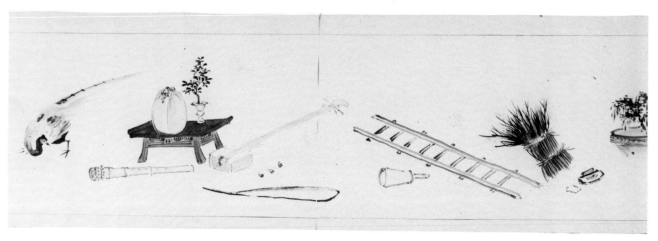

49

11 Badger Studying a Sutra

Technical:	Lacquer on paper; 6¾ in. × 8⅜ in. (17.1 × 21.3 cm.); album leaf mounted as a hanging scroll
Signature:	Zeshin
Seal:	Koma
Date:	Middle period
Accession No.:	4650.1

Zeshin delighted in placing animals in human settings, often wearing garments and involved in human activities (see Cat. Nos. 1 and 33). In this painting Zeshin placed a rather ponderous and awkward-looking badger leaning on a low table and supposedly examining an album or sutra. The badger, however, does not seem too interested in scholarly pursuits and gazes out at the viewer with a facetious grin. The effect is humorous, almost mocking. The *ze* character of the *Zeshin* signature is rendered in the somewhat heavy *gyōsho* form, while the *shin* remains in the thinner *sōsho* style, a signature tendency not observed until around 1842. For remarks about usage of the *koma* seal refer to Cat. No. 10.

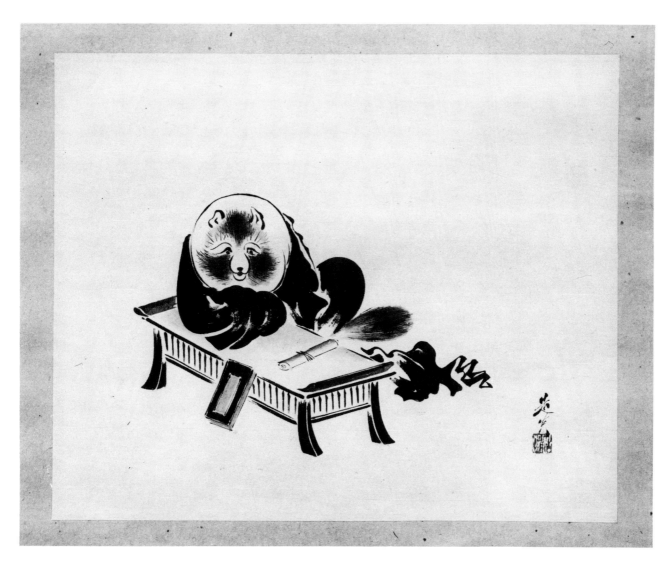

11　Badger Studying a Sutra

12 Symbols of the Weavers' Festival

Technical:	Red, brown and grey lacquer on silk; 8 in. × 7 in. (20.3 × 17.8 cm.); mounted as a hanging scroll
Signature:	Zeshin
Seal:	Zeshin
Date:	Middle period
Accession No.:	4660.1

Zeshin has depicted symbols associated with the weavers' festival, such as cloth, spools of thread, silkworm cocoons, and a hatched silkworm moth, placing them in a simple still life arrangement. The seal *Zeshin* was generally reserved for works of high quality and is reproduced in Appendix II, No. 5. The signature *Zeshin* has the *ze* character in the heavy *gyōsho* style, while the *shin* character remains in the so-called *sōsho* style. This signature is thought to have been used around the mid-1840s onwards. The same signature style occurs on Cat. No. 14.

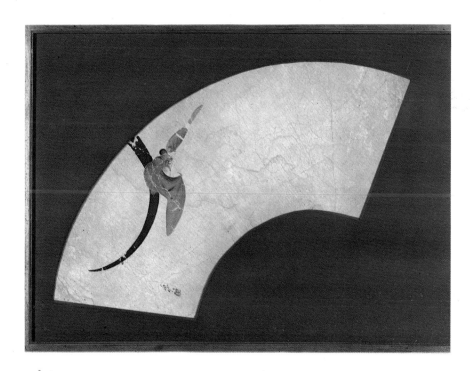

53

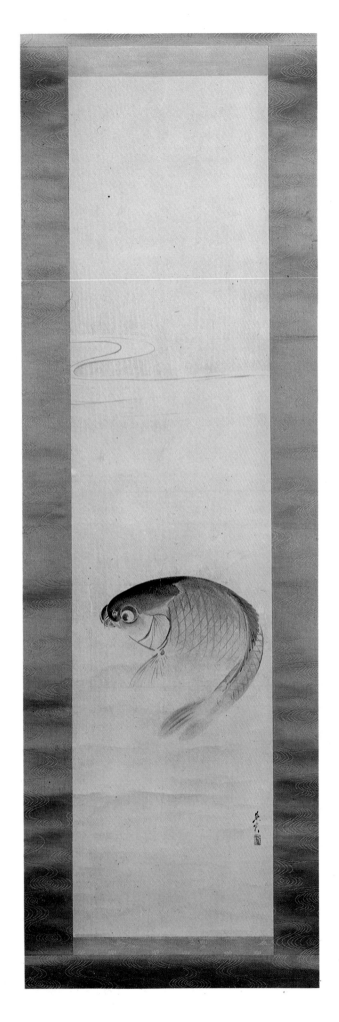

15 Carp

13 Album of Twelve Paintings

Technical:	Ink and light color on paper; each $3\frac{7}{8}$ in. × $5\frac{1}{2}$ in. (9.8 × 14 cm.); mounted as a double-page folding album
Signature:	Zeshin (on leaves a and c only)
Seal:	All twelve paintings are sealed with an undeciphered mark
Date:	Middle period
Accession No.:	4668.1

These loose, small sketches, utilizing ink and light color, seem roughly conceived and perfunctorily executed. However, the variety of subject matter, focusing on a range of details, is typical of Zeshin's art. To date, attempts to read the seal (which have included equating it with the character *hana*) have proved futile. The seal was used on a Zeshin illustration (page 9 of Vol. 1 in the unnumbered sequence) from the woodblock book *Shōga Kaisui* (see Mitchell, pp.481–2) published in Edo in 1832. The signature of the painting is also from the middle period, and the album has been dated accordingly.

List of album subjects:
a) Small Plants
b) Yellow Flowers
c) Two Fish (this design seems to be related to one of Zeshin's late prints)
d) Decorative Arrangement in Bowl
e) Fan and Insect
f) Peach
g) New Year Decoration
h) Radish
i) Leaves
j) Mushrooms and Twig
k) Goose and Reeds
l) House and Plum Branch

 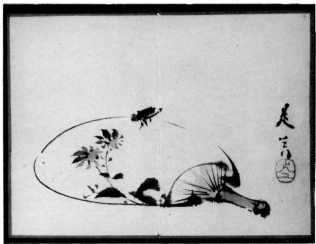

 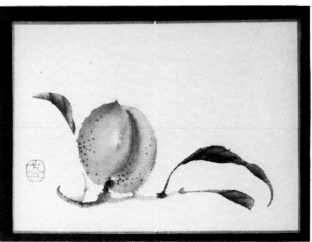

13 Album of Twelve Paintings

13 a) Small Plants

13 b) Yellow Flowers

13 c) Two Fish

13 d) Decorative Arrangement in Bowl

13 e) Fan and Insect

13 f) Peach

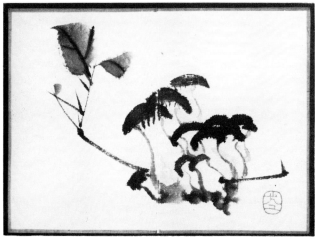

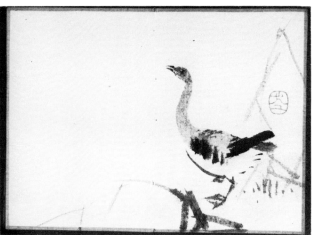

13 g) New Year Decoration

13 h) Radish

13 i) Leaves

13 j) Mushrooms and Twig

13 k) Goose and Reeds

13 l) House and Plum Branch

14 Album of Six Paintings

Technical:	Lacquer on paper; 6⅝ in. × 8⅜ in. (16.8 × 21.3 cm.)
Signature:	See commentary below
Seal:	See commentary below
Date:	Middle period
Accession No.:	4666.1

Here Zeshin demonstrates his superb ability to create a finished work utilizing the simplest subjects and compositions. Bound as a folding album in gold brocade (*nishijin*), the subjects included are:

a) *Gagaku Mask and Flute*, signed *Zeshin* with a seal reading *shin*
b) *Beetle and Wasp*, signed *Zeshin* with a seal reading *shin*
c) *Grapevine*, signed *Zeshin* with a seal reading *koma*
d) *Galloping Horse*, signed *Zeshin* and sealed with an undeciphered mark
e) *Leaping Fish*, signed *Zeshin* with a seal reading *shin*
f) *Crab*, signed *Zeshin* and sealed with the same undeciphered mark as in d

The seals reading *shin* impressed on a and e correspond to *shin* seal No. 26 in Appendix II. The seal reading *koma* recorded on c corresponds with No. 40 in Appendix II. None of these seals, however, appear to be from the same sealcut, nor are they useful in determining a probable date for the album. The heavy, rather confident signature appearing on these paintings suggests a date around the 1850s.

14 a) Gagaku Mask and Flute

14 b) Beetle and Wasp

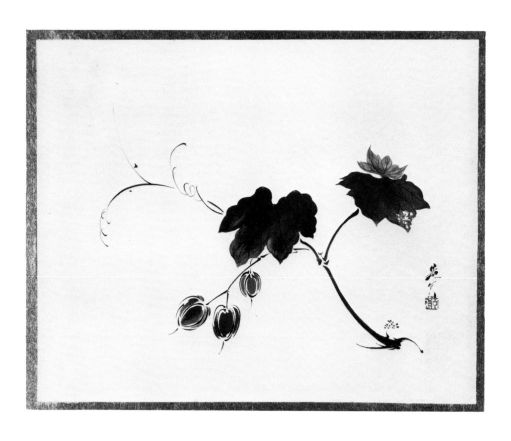

14 c) Grapevine

14 d) Galloping Horse

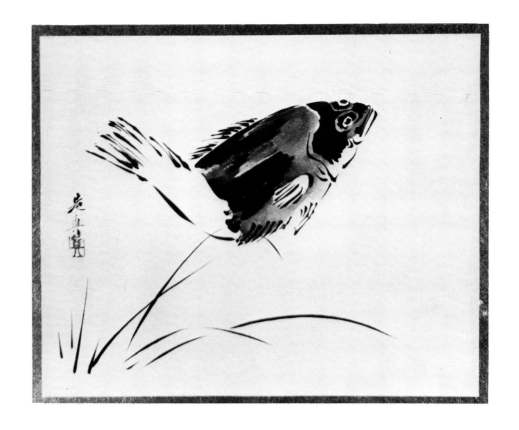

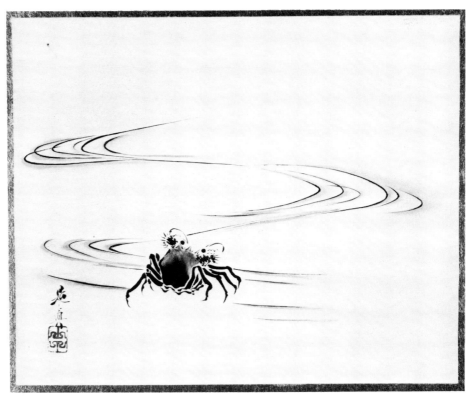

14 e) Leaping Fish

14 f) Crab

15 Carp

Technical:	Brown lacquer on paper; 37¾ in. × 9⅛ in. (95.9 × 23.2 cm.); mounted as a hanging scroll
Signature:	Zeshin
Seal:	Tairyūkyo (hitherto unrecorded in this form)
Date:	Late period
Accession No.:	4671.1

According to Soeda (no) Tatsumine (*Shibata Zeshin Ō No Kotodomo*), 'Shioda Shin explained to Zeshin "Your lacquer pictures show enormous talent but it is somewhat regrettable that you choose to display it only on flat, tough surfaces of *fusuma*, *byōbu*, and frames. Couldn't you try to do that same thing on a hanging scroll which may be unrolled and rolled up at will?" Zeshin demonstrated his ability with *iro urushi* by making a still-life depiction which he presented to Soeda. Soeda immediately mounted it on a yellowish scroll, rolled it up inside and when he spread it out again not even the slightest crack or split could be found'. It is traditionally thought that Zeshin began practising this kind of work in Meiji 5 (1872). Judging by the maturity and finesse of this painting and by the signature and seal, a date in the mid-1870s seems appropriate.

16 Plum Branch and Mandarin Ducks

Technical:	Brown and gold lacquer on paper; 44⅛ in. × 11¼ in. (112 × 28.6 cm.); mounted as a hanging scroll
Signature:	Zeshin
Seal:	Koma
Date:	Late period
Accession No.:	4649.1

Here Zeshin has masterfully controlled the use of his lacquer to create a painting as soft and sensitive as watercolor. The feeling of early spring is quietly conveyed in the delicacy of the elegantly conceived composition. The subdued signature *Zeshin* is in keeping with the overall restraint of the entire painting. This work has been dated to the 1870s, a time when it is traditionally thought that Zeshin first mastered *urushi-e* in the hanging scroll format. The seal, *koma*, which seems to occur only on lacquer paintings, is from a different stone than the one in Appendix II, No. 34. This painting is probably housed in its original box (*tomobako*) which bears the mistaken title, *Sakura to Tori* (Cherry and Bird), on its cover and the signature, *Tairyūkyo Zeshin Shi* with the seal *shin*. The *gyōsho* style of this additional signature is in keeping with the master's writing style in the 1870s.

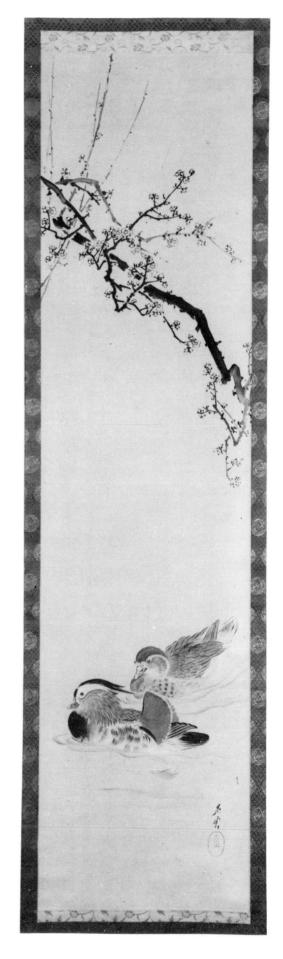

16 Plum Branch and Mandarin Ducks

17　Bird About to Alight on a Pier Post and Bird and Shells

Technical:	Black lacquer on mica-surfaced paper; each: 6¼ in. × 5¾ in. (15.9 × 14.6 cm.); mounted as a pair of hanging scrolls
Signature:	Zeshin (on both)
Seal:	Koma (on both)
Date:	Late period
Accession No.:	4652.1 & .2

Both of these scroll paintings have sea bird subjects, and they were probably meant to be viewed together. Though the paintings are directly related by the quality of surface, light and atmosphere produced by the silvery mica-surfaced paper used in both, each painting is quite different in the treatment of the subject. The right work shows a bird walking on the sand and eyeing some shells. Zeshin devoted great care to the delineation of the bird's feathers and legs and drew the shells with a few swift strokes. The overall feeling is one of extreme delicacy. In the left scroll he has created a scene showing a bird about to alight on a post. The posts are treated in heavy black strokes almost as silhouettes. In the background is a solid line of hills broken by the light-colored irregular shapes of boat sails. Only in the depiction of ripples in the water does Zeshin rely on the delicate lines he used in the companion scroll. The pair make an interesting and effective comparison of Zeshin's expressive talents. The signature style is similar in style to those on paintings dated to the mid-1870s.

18　The Fox, Messenger of Inari

Technical:	Ink and color on paper; 14¾ in. × 2½ in. (37.5 × 6.4 cm.)
Signature:	Zeshin
Seal:	None
Date:	Late period
Accession No.:	17,106b

This simple painting in the elongated format of a *tanzaku* or poem card shows an image of a white fox sitting on a striped base. Such images stood at the entrance of the shrines of Inari, the god of rice. The fox was considered to be the messenger of Inari and even to be the physical manifestation of the deity. The signature *Zeshin*, executed in heavy, bold strokes, suggests a date in the mid-1870s.

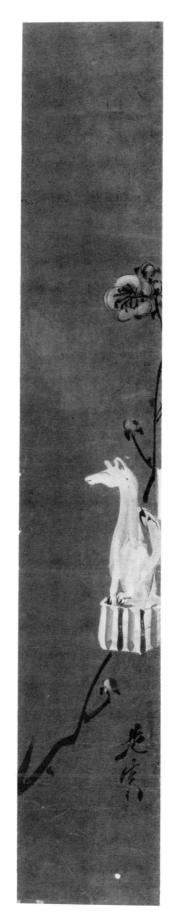

18 The Fox, Messenger of Inari

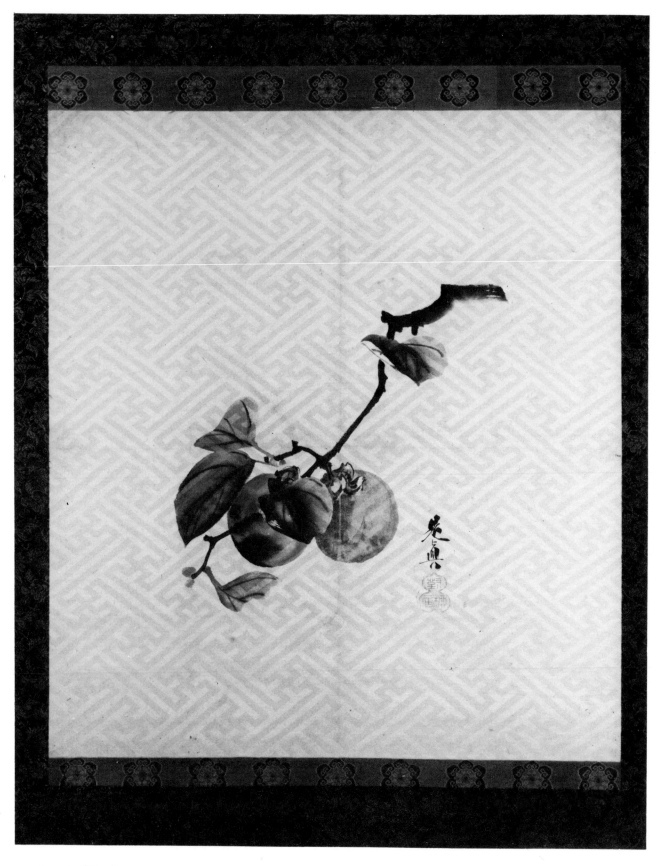

19 Branch of Persimmons

19 Branch of Persimmons

Technical:	Color on figured satin; 20⅝ in. × 18⅝ in. (52.4 × 47.3 cm.); mounted as a hanging scroll
Signature:	Zeshin
Seal:	Tairyūkyo
Date:	Late period
Accession No.:	4647.1

Zeshin's interest in nature and his attention to the smallest details of a subject is a reflection of his training in the realistic *Maruyama-Shijō* school. Zeshin faithfully recorded aspects of the world around him that others might easily overlook, such as this fragment from nature – a small branch of a persimmon tree laden with two fruits. This painting has been dated to about the mid-1870s because of the heavy style of the signature. Both the *ze* and *shin* characters have a strength of execution that classifies them in the *kaisho* style of script associated with works dated to the beginning years of Zeshin's late period. The *Tairyūkyo* seal is a reference to Zeshin's home by the Kanda River, a name used after he took up residence there in 1832. The authors of the exhibition catalogue *Shibata Zeshin* (published by Milne Henderson, 1976) suggest that this particular seal was used after Zeshin reached sixty-five. The seal impression is from the same cut as that reproduced as No. 43 in Appendix II.

20 Flowers and Insects

Technical:	Ink and light color on paper; 7½ in. × 119½ in. (19.1 × 303.5 cm.); mounted as a handscroll
Signature:	Zeshin
Seal:	Tairyūkyo
Date:	Late period
Accession No.:	4604.1

Zeshin's keen interest in and love for nature can be seen at its best in this scroll. Among the curling tendrils, shoots and stems, the lacy leaves and grasses, appear several kinds of insects (including butterfly, grasshopper and dragonfly) and even a frog and a snail. In the midst of this natural scene Zeshin placed a man-made decorative arrangement of rocks in a bowl. The painting is lively and beautifully executed and gives ample testimony to Zeshin's abilities in the medium and, likewise, to his considerable debt to the Shijō school. A comparison of the delicate naiveté of this work and the handscroll *Episodes from Life in Edo* (Cat. No. 7), with its urbane sophistication and allusions, shows the variety of moods which Zeshin could convey. Both handscrolls bear the seal *Tairyūkyo*, this example the same as that reproduced as No. 41 in Appendix II.

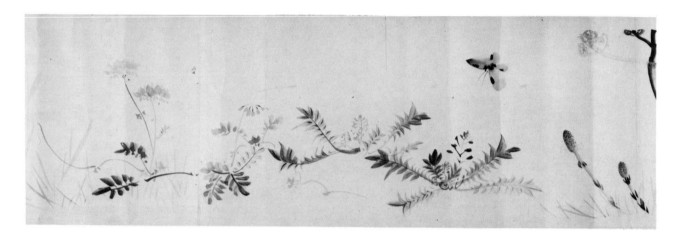

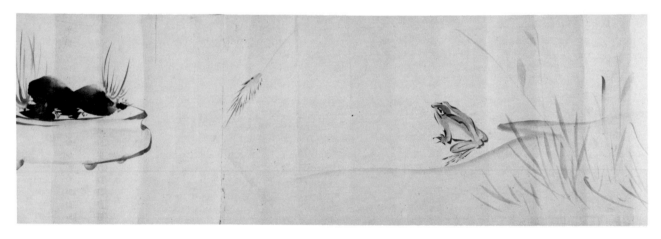

20 Flowers and Insects

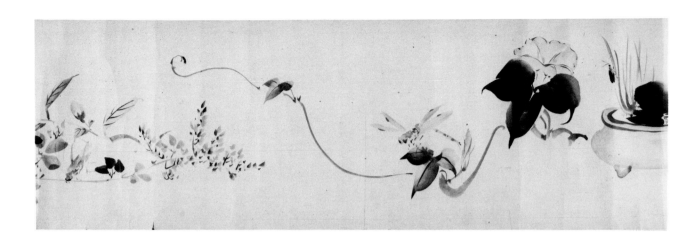

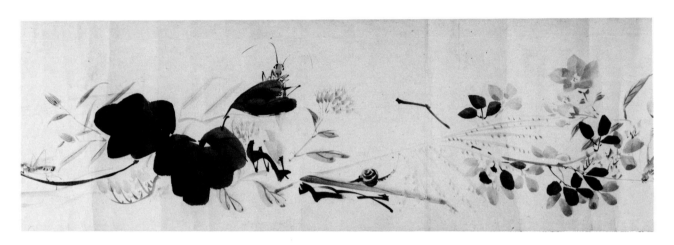

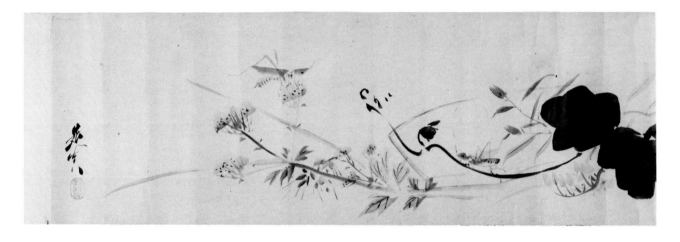

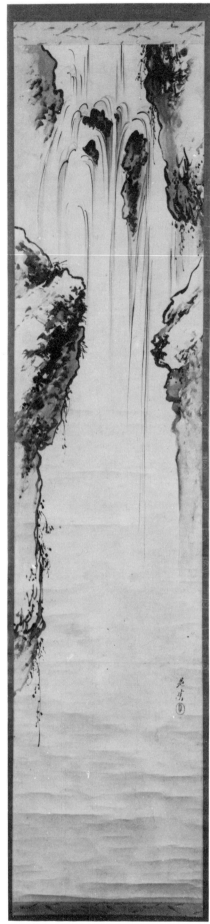

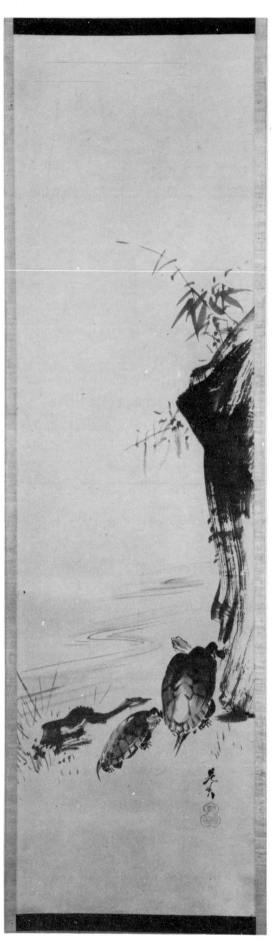

21 Waterfall

22 Tortoises on a River Bank

21 Waterfall

Technical:	Brown and black lacquer on paper; 45 in × 10⅛ in. (114.3 × 25.7 cm.); mounted as a hanging scroll
Signature:	Zeshin
Seal:	Shin
Date:	Late period
Accession No.:	4662.1

The composition of this painting, with water cascading down over rocks, plant-covered rock forms jutting in from both sides and a large open space at the bottom, is most impressive. The *shin* seal corresponds with No. 23 in Appendix II although from a different stone. The signature *Zeshin* suggests a date in the 1870s when it is traditionally thought that Zeshin first experimented with lacquer painting, particularly in the hanging scroll format. A similar painting of a waterfall, which is one of a pair of hanging scrolls, is reproduced in *Nihon no Bijutsu*, No. 93, Fig. 58.

22 Tortoises on a River Bank

Technical:	Ink on paper; 34¼ in. × 12¼ in. (87 × 31.1 cm.); mounted as a hanging scroll
Signature:	Zeshin
Seal:	Tairyūkyo
Date:	Late period
Accession No.:	4584.1

This painting reveals the strong, yet sensitive brushstroke of a master and points to Zeshin's early training in the Shijō school. The seal *Tairyūkyo* (from a different cut) is reproduced in Appendix II, No. 43. According to the authors of the exhibition catalogue *Shibata Zeshin* (published by Milne Henderson, 1976), this particular seal was utilized by Zeshin after the age of sixty-five. If so, this painting would have to date at the earliest to the mid-1870s, a dating which is in keeping with the heavy character of the signature and the general style of the painting.

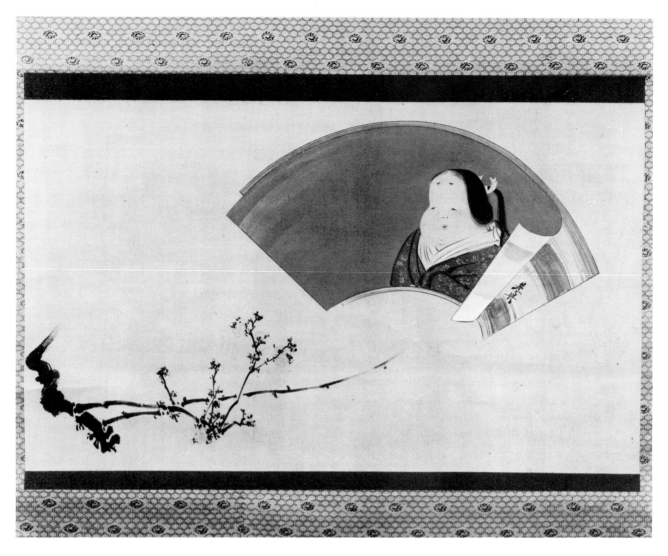

23 Okame with Plum Branch

23 Okame with Plum Branch

Technical:	Ink and strong color on silk; 18 in. × 31 in. (45.7 × 78.7 cm.); mounted as a hanging scroll
Signature:	Zeshin
Seal:	Koma
Date:	Late period
Accession No.:	4591.1

Okame, a reference to Ama no Uzume no Mikoto (Goddess of Mirth) who helped to get Amaterasu (Goddess of the Sun, who gave birth to the first Emperor of Japan) out of the cave into which she had retired, is an extremely common subject in Japanese art. She is usually depicted with puffed out cheeks, small mouth always in a smile and a narrow forehead with two ornamental black dots. Like the gods of good fortune, Okame has been given a great deal of humorous treatment by artists. She is frequently depicted stroking the elongated nose of a Tengu, or with very scanty clothing, her legs bowing under her heavy weight. Sometimes she is shown casting dried beans at devils as part of the Oni Yarae ceremony (see Cat. No. 24). In this work Zeshin painted her humorous portrait on a simulated fan-shaped piece of paper. In a *trompe l'oeil* effect, the paper seems to curl at the edge, and beneath is a lacquer tray in the shape of a fan on which can be observed the signature *Zeshin* and the seal *koma*, the latter corresponding to No. 31 in Appendix II and found only on lacquer objects and lacquer paintings.

24 Okame and an Oni

Technical:	Color on paper; 41⅜ in. × 16 in. (105.1 × 40.6 cm.); mounted as a hanging scroll
Signature:	Zeshin
Seal:	Zeshin
Date:	Late period
Accession No.:	4673.1

Zeshin has combined two legendary characters – Okame and an *oni* (devil) – both in reference to the Oni Yarae ceremony (Setsubun festival), in which Okame, dressed as a common girl, cast dried beans at the devils to scare them away for a year. The signature style suggests a work in the mid-1870s. Another Zeshin fan painting showing Okame with an Oni is reproduced in *Nihon no Bijutsu* No. 93, Fig. 53.

25 Portrait of Oto-Gozen (Otafuku)

Technical:	Color on silk; 35¾ in. × 15½ in. (90.8 × 39.4 cm.); mounted as a hanging scroll
Signature:	Zeshin
Seal:	Shin
Date:	Late period
Accession No.:	4670.1

Oto-gozen and Otafuku would appear to be alternate names for the stock figure Okame (see Cat. Nos. 23 and 24). Otafuku literally means 'big breasts' and is usually applied irreverently to large, overweight women. Pictures of Otafuku were most popular among the Edo townsmen and were usually carried on bamboo rakes (see Cat. No. 26) during the festival of the Tori-no-ichi. This festival, observed only in Edo, was celebrated at the Otori shrines on the Days of the Fowl in the eleventh month of the year. The subject must have delighted Zeshin, for a number of examples by him survive, all revealing the same droll, mocking humor. In this work the smiling Oto-gozen gathers her kimono and stoops or makes a bow toward the viewer. The folds of her garments and the dazzling brocaded and tie-dyed patterns of the fabric are drawn into interesting, almost abstract, shapes. The seal reading *shin* corresponds closely with No. 26 in Appendix II and may be from the same cut. The signature *Zeshin* follows a style observed in the 1870s. The work is accompanied by an authentication (dated Showa 16 or 1941) by Sasekawa Rimpu (1870–1947), a Zeshin enthusiast, who wrote essays on art criticism and art historical novels and edited the magazine *Teikoku Bungaku* (*Imperial Literature*). A similar portrait of Oto-gozen is reproduced in *Nihon no Bijutsu*, No. 93, Fig. 59.

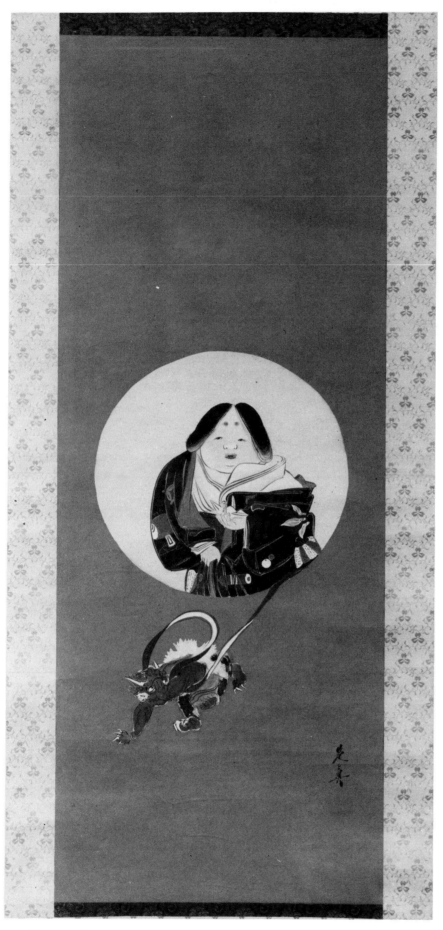

24 Okame and an Oni

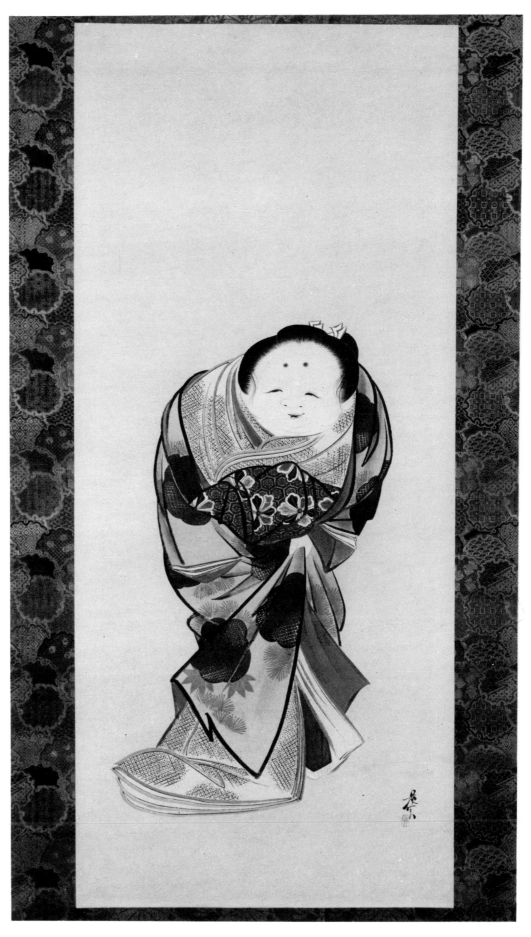

25 Portrait of Oto-Gozen (Otafuku)

75

26 Rake with Head of Otafuku

26 Rake with Head of Otafuku

Technical:	Ink and color on paper; $14\frac{5}{16}$ in. \times $2\frac{5}{16}$ in. (36.4 \times 5.9 cm.);
Signature:	Zeshin
Seal:	None
Date:	Late period
Accession No.:	17,106c

A representation of Otafuku (see Cat. No. 25) is shown attached to a bamboo rake (*kumade*). These rakes were sold in connection with the celebrations of the Tori-no-ichi festival and were usually colorfully ornamented with good luck symbols and charms. They were kept after the festival as a luck-bringer to 'rake in' good fortune. Also attached to the rake is a folded paper with the characters *oma mori* (honorable protection), a further reference to the beneficial aspects of the rake and festival. The signature reading *Zeshin*, done in the bold style associated with his name in his later years, suggests a work of the mid-1870s.

27 Seed Pods and Leaves

Technical:	Lacquer on paper; $14\frac{1}{4}$ in. \times $2\frac{9}{16}$ in. (36.2 \times 6.5 cm.); mounted as a hanging scroll
Signature:	Zeshin
Seal:	Han ma nin
Date:	Late period
Accession No.:	4651.1

In this work Zeshin created a painting of superb quality in a limited format. His composition reflects his complete mastery of the elongated narrow *tanzaku* (poem card form). The seal *Han ma nin* has been tentatively translated 'the dull-witted idiot' and is recorded in Appendix II, No. 59. The signature reading *Zeshin* is done in a heavy style of writing associated with his later years after the mid-1870s.

28 A Boy Picking Cherry Blossoms

Technical:	Ink and color on paper; $47\frac{1}{4}$ in. \times $16\frac{1}{4}$ in. (120 \times 41.3 cm.); mounted as a hanging scroll
Signature:	Shichiju o Zeshin
Seal:	Zeshin
Date:	1876 deduced from inscription
Accession No.:	4646.1

This painting, done in a quick sketch style, shows a boy held aloft by a man in Shinto garb while plucking a branch from a flowering cherry tree. This particular theme was a popular one during the Edo period and is often seen in works of the *ukiyo-e* school. The signature translates, 'The old man Zeshin at the age of seventy'. This corresponds with the date 1876. The round seal *Zeshin* corresponds with No. 4 in Appendix II although from a different cut.

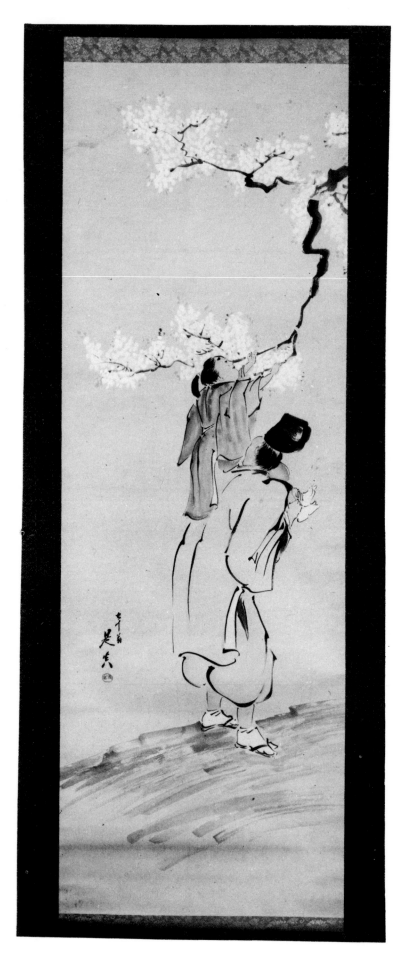

28　A Boy Picking Cherry Blossoms

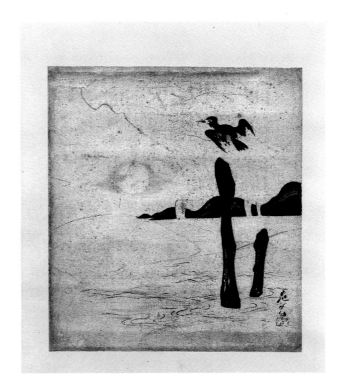

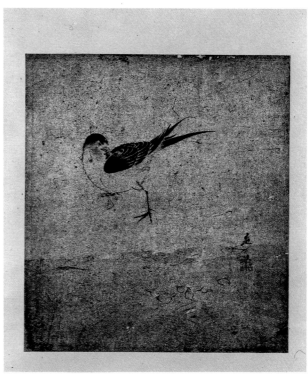

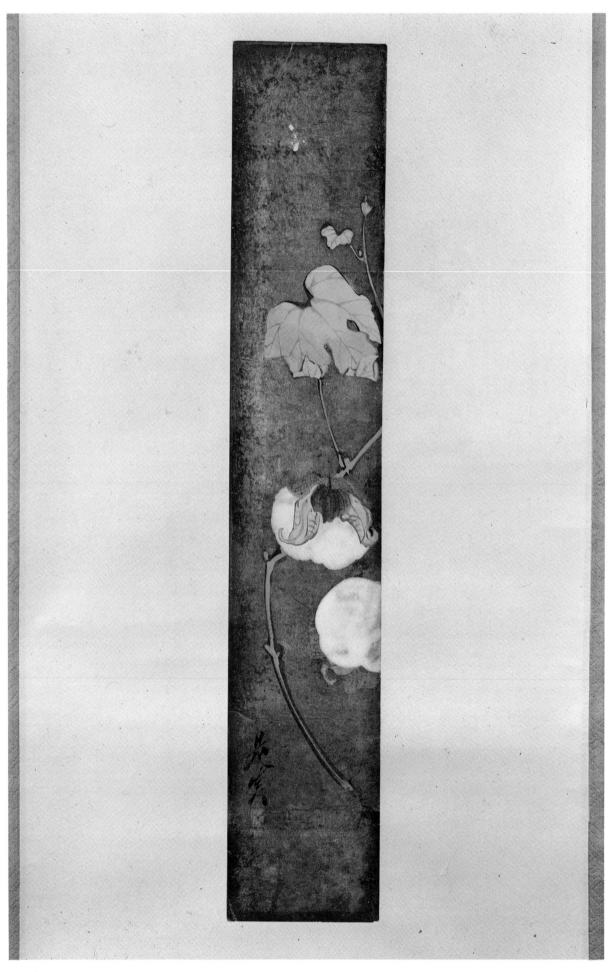

27 Seed Pods and Leaves

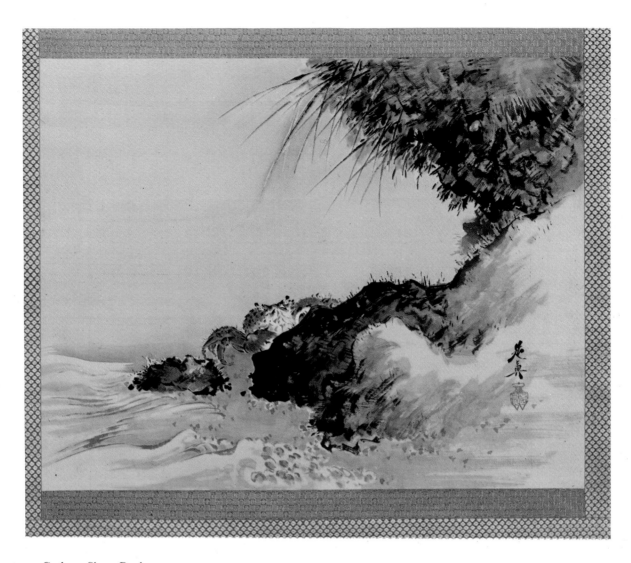

37 Crab on Shore Rocks

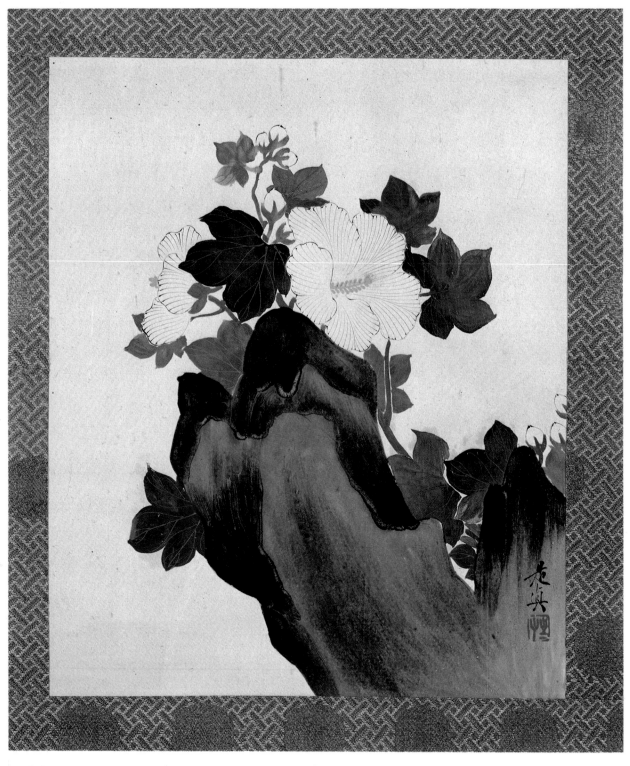

38 Hibiscus Flowers and Rock

29 Sōjobo Teaching Ushiwaka-Maru

Technical: Ink and color on silk; 36¼ in. × 12¼ in. (92 × 31 cm).; mounted as a hanging scroll

Signature: Zeshin

Seal: Shin

Date: Late period

Accession No.: 4586.1

Legend has it that Sōjobo, the king of the Tengu (mythical birdmen who dwelt on Mt Kurama near Kyoto), trained the most beloved hero of Japan, Minamoto no Yoshitsune, who as a youth was called Ushiwaka-maru (see Cat. No. 30), in acrobatic skill and fencing. The semi-*kaisho* style of the signature suggests a work of Zeshin's later years; the seal, *shin*, corresponds with one reproduced in Appendix II, No. 25 and may be from the same cut, although considerably more worn. The signature comes closest to that on Cat. No. 24.

30 Ushiwaka-Maru Asleep by Sōjobo

Technical: Lacquer on paper; 4¼ in. × 3 5/16 in. (10.8 × 8.4 cm.); album leaf mounted as a hanging scroll

Signature: Zeshin

Seal: None

Date: Late period

Accession No.: 4659.1

This small album leaf shows the king of the Tengu, Sōjobo, reading with his famous student Ushiwaka-maru (the early name of Minamoto no Yoshitsune) in attendance. Yoshitsune was the son of Yoshimoto and Tokiwa-gozen. His father was killed in the Heiji war of 1160, and Yoshitsune as well as his two brothers fled with their mother in order to avoid capture by Kiyomori. Yoshitsune was sent to a temple at Mt Kurama where it is said that he learned the art of fencing from the king of the mythical birdmen, old Sōjobo. The king is always depicted with a long crooked nose, white beard and huge piercing eyes; the small cap of the *yamabushi* (literally, mountain warriors), a type of traveling priest, perched on his huge head, is also a traditional feature. Zeshin's signature is forcefully rendered and suggests a date in the mid-1870s.

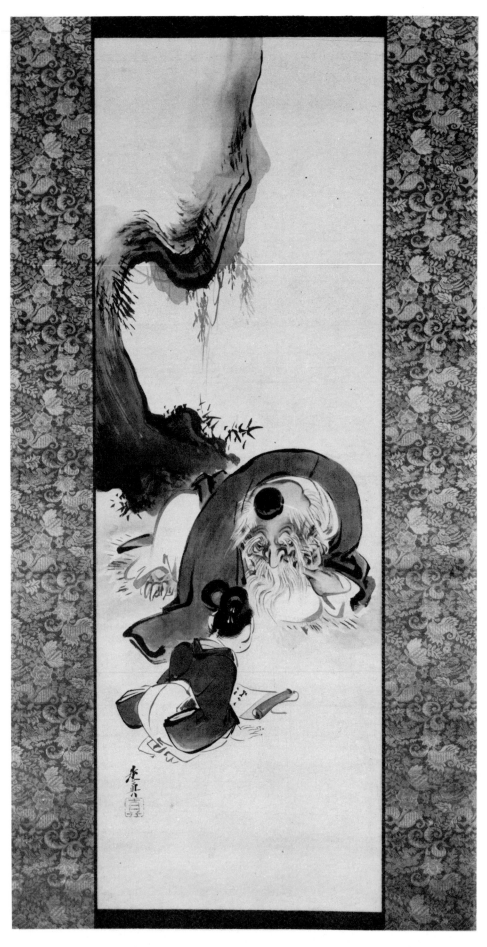

29 Sōjobo Teaching Ushiwaka-Maru

30 Ushiwaka-Maru Asleep by Sōjobo

31 Symbols of Old Age

Technical:	Ink and light color on paper; 48½ in. × 11⅜ in. (123.2 × 28.9 cm.); mounted as a hanging scroll
Signature:	Zeshin
Seal:	Shin
Date:	Late period
Accession No.:	4601.1

Zeshin selected two objects representative of old age – a pair of glasses and a *sake* bottle oil lamp. The poem above (which includes an undeciphered seal) explains the meaning of the cryptic symbols; it notes that a sumo wrestler's *sake* bottle is put down finally and converted to a reading lamp in old age. The seal *shin* is reproduced in Appendix II, No. 25. The signature *Zeshin* suggests a date for this work in the late 1870s.

32 Cat and Mouse

Technical:	Ink and color on paper; 10½ in. × 17½ in. (26.7 × 44.5 cm.); mounted as a hanging scroll
Signature:	Zeshin
Seal:	Tairyūkyo
Date:	Late period
Accession No.:	4667.1

This loosely rendered painting depicts a mouse or rat apparently draining a *sake* cup to the dregs while a cat watches expectantly. The scene has a humorous tone, but Zeshin left the faces of the two animals invisible so that the viewer is left with a variety of interpretations of the scene limited only by his own imagination. The seal corresponds with No. 45 in Appendix II although from a different cut. The style of the signature suggests a date for this work in the mid-1870s. The signature is close in style to that on Cat. No. 20 and No. 22.

33 Mouse Procession

Technical:	Ink and light color on silk; each: 33 in. × 10$\frac{5}{16}$ in. (83.8 × 29.2 cm.); mounted as pair of hanging scrolls
Signature:	Zeshin
Seal:	Tairyūkyo
Date:	Late period
Accession No.:	4590.1 & .2

As early as the Heian (794–1185) and Kamakura (1185–1333) periods, animals were substituted for humans in narrative themes in Japanese art. This pair of spontaneously conceived paintings shows a procession of mice on their way to some celebration or other formal occasion. Three of the mice wear *kameshimo*, jackets or vests with flaring shoulders with paper stiffening. These were worn over the kimono on special occasions by samurai, rich merchants or high-ranking officials. The three also wear swords which these classes of men would have been entitled to carry. The three mice are attended by other mice, representing servants, all of whom are carrying accessories or objects and one of whom is bent over by the burden of a large chest. On the left scroll is a branch with rice balls (*mochi*) and a poem *tanzaku* stuck on, which appeared at New Year celebrations, perhaps hinting at the nature of the occasion. The effect of this scene is refreshing, charming and humorous. The seals both from the same cut, correspond with No. 41 in Appendix II, although probably made from a different stone. Curiously, the inscription on the box accompanying this painting identifies the work as a fox procession, which may suggest either a mistake on the part of the writer or that the box was originally intended for a different painting. The signature suggests a date in the mid-1870s.

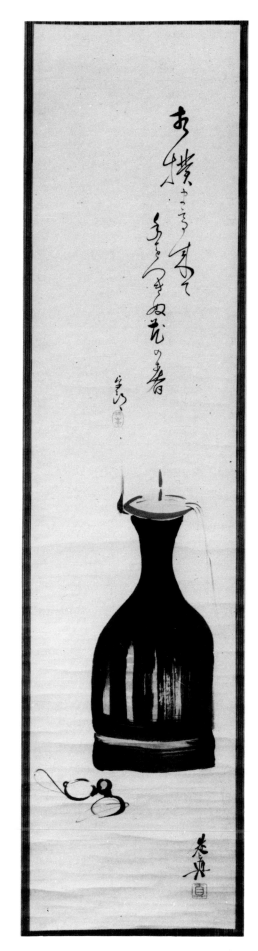

31 Symbols of Old Age

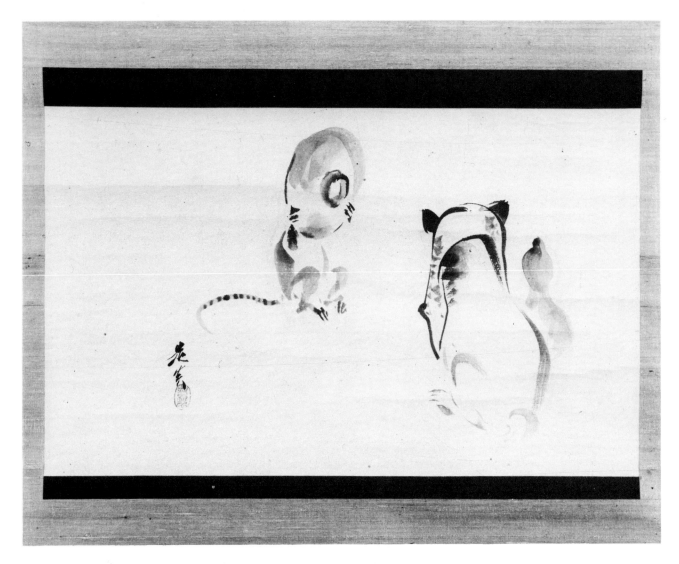

32 Cat and Mouse

33 Mouse Procession

34 Album of Ten Varied Subjects

Technical:	Lacquer on paper; each: 4¾ in. × 3 7⁄16 in. (12.1 × 8.7 cm.); mounted as a folding album
Signature:	Zeshin
Seal:	Koma (hitherto unrecorded in this form)
Date:	Late period
Accession No.:	4602.1 – .10

These small exquisite lacquer paintings of widely varied subjects were all done about the same time, judging from the signatures and seals. All of the paintings are of a singularly fine quality and would seem to have been done in the late 1870s. The ten subjects are:

a) Bird and Flowering Shrubs
b) Bag and Pine Branch
c) Parasol with Flowering Plum Branch
d) Priest or Monk
e) Cat at Rest and Plum Branch
f) Teapot and Plum Branch
g) Waterfall
h) Morning Glory
i) Boats at Anchor
j) Flowering Camellia Branch

34 a) Bird and Flowering Shrubs **34** b) Bag and Pine Branch

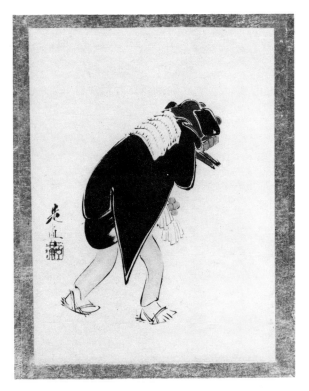

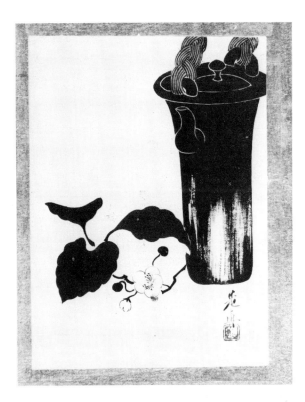

34 c) Parasol with Flowering Plum Branch

34 d) Priest or Monk

34 e) Cat at Rest and Plum Branch

34 f) Teapot and Plum Branch

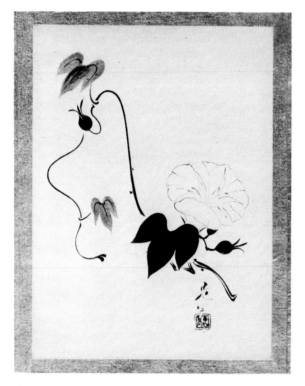

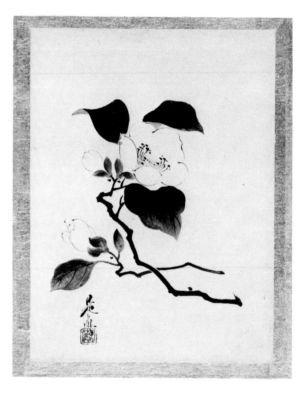

34 g) Waterfall

34 h) Morning Glory

34 i) Boats at Anchor

34 j) Flowering Camellia Branch

35 Landscape Paintings of the Twelve Months

Technical:	Ink and soft color on rough paper; each: 4½ in. × 3½ in. (11.5 × 8.9 cm.); mounted as an album of 12 leaves
Signature:	a–k: Zeshin
	l (the final leaf): Jinen Shichijūgo sō Tairyūkyo Zeshin
Seal:	a, f, j, k: Shin
	b, d, e, g, i: Zeshin
	c: Koma
	h: Ze
Date:	Late period, 1881 (deduced from inscription)
Accession No.:	4669.1

The twelve paintings in this exquisite, small album are ample evidence of Zeshin's complete mastery of Maruyama-Shijō landscape techniques. All of the paintings bear a genuine signature and seal. Documents attached to the album include a certificate from Zeshin's grandson who bought the album back from an early collector and a certificate mentioning that the album was mounted by Zeshin's son, Reisai. Leaf l includes a seal reading only *ze*. Seals bearing the single character *shin* of his last name are common, but according to Tadaomi Gōke, no genuine seal bearing only the *ze* character of the name had previously been discovered, making this album leaf of particular interest and value in the study of Zeshin seals.

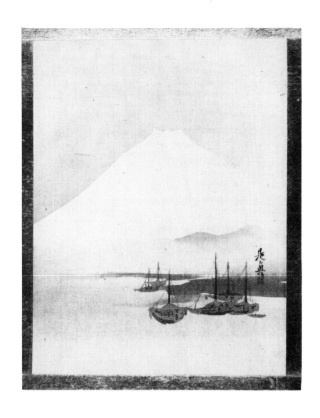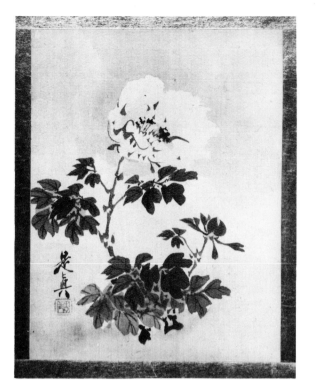

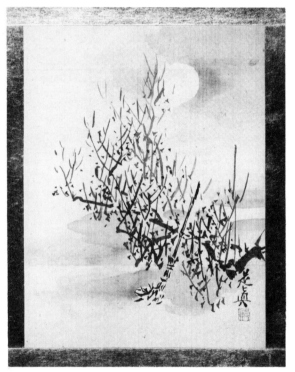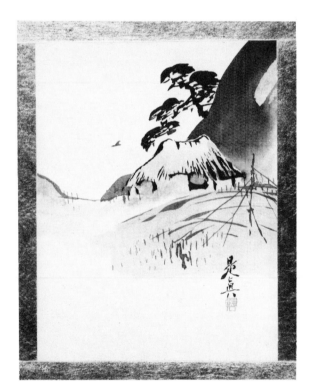

35 Landscape Paintings of the Twelve Months

35 a)

35 b)

35 c)

35 d)

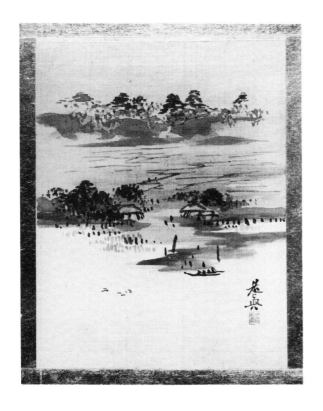

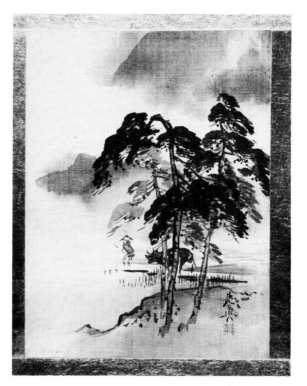

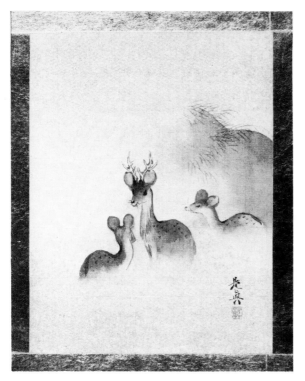

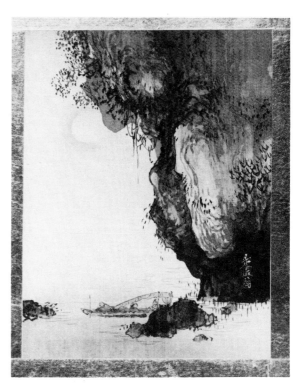

35 e)

35 f)

35 g)

35 h)

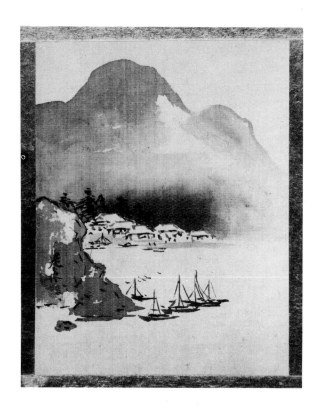

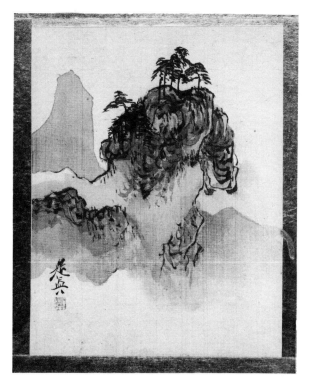

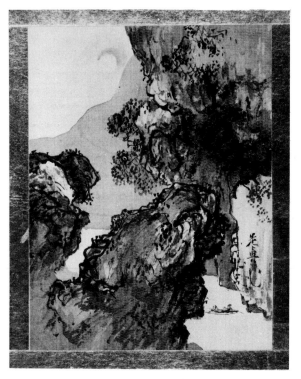

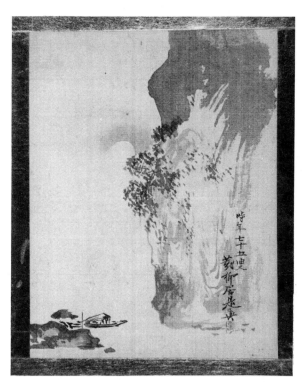

35 i)

35 j)

35 k)

35 l)

36 Mandarin Duck and Snowy Reeds

Technical: Ink on paper; 47½ in. × 11⅛ in. (120.6 × 28.3 cm.); mounted as a hanging scroll

Signature: Gyōnen Shichijū shichi sō Zeshin

Seal: Shin

Date: Late period, 1883 (in inscription)

Accession No.: 4645.1

According to the signature, Zeshin was seventy-seven years old when he did this simple painting showing a duck sheltering itself beneath dead reeds laden with snow. The seal reading *shin* corresponds with No. 25 in Appendix II and is probably from the same cut. The painting has an authentication inside the box lid by Zeshin's disciple Chikushin. Mr Foulds reports that Chikushin was 'one of the most elusive men among Zeshin's disciples with regard to biographical information and attributed works'. In the 1890s, Shōji Chikushin resided in Asakusa-ku, Makō Yanagibara-chō, Edo. He appears prominently in Shinsai's diary. The first entry including his name is dated February 9, 1869. Around this time he accompanied Zeshin and others on most major excursions out of Tokyo. He was also present at Zeshin's death on July 13, 1891. The last mention of his name in Shinsai's diary occurs on January 26, 1893.

37 Crab on Shore Rocks

Technical: Light colors on silk; 12½ in. × 16¼ in. (31.7 × 41.3 cm.); mounted as a hanging scroll

Signature: Zeshin

Seal: Zeshin

Date: Late period

Accession No.: 4587.1

This view of a crab climbing over shore rocks under an overhanging bank reveals Zeshin's skill at painting varied textures – water, rock, weeds. The strength and confidence of the signature helps date this work to the late years of Zeshin's life. The seal *Zeshin* corresponds with No. 5 in Appendix II, possibly from the same cut. Beginning after 1832, Zeshin employed this seal throughout his long life on paintings that he felt to be particularly accomplished. An album leaf dated by inscription to 1881 (when Zeshin was seventy-five years old) has a similar design of a crab in a seascape. The O'Brien Collection work may be dated similarly based upon this comparison (see *Nihon no Bijutsu*, No. 43, Fig. 48).

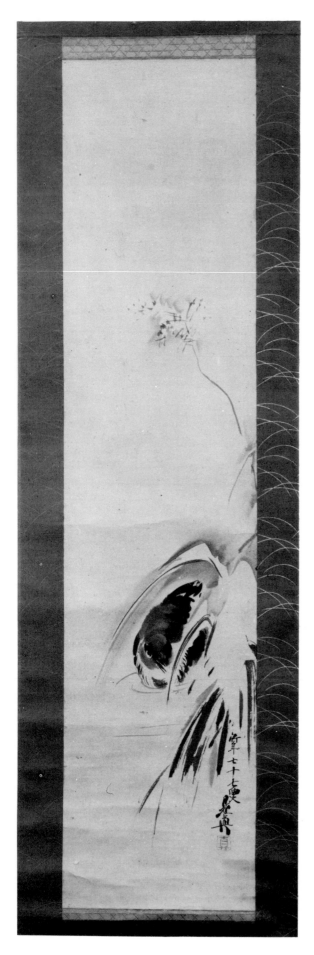

36 Mandarin Duck and Snowy Reeds

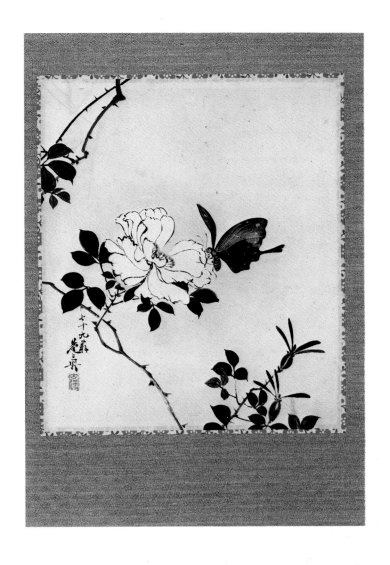

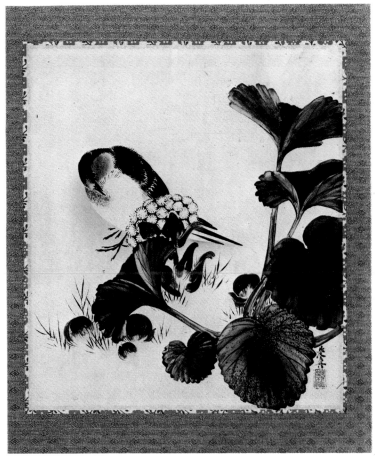

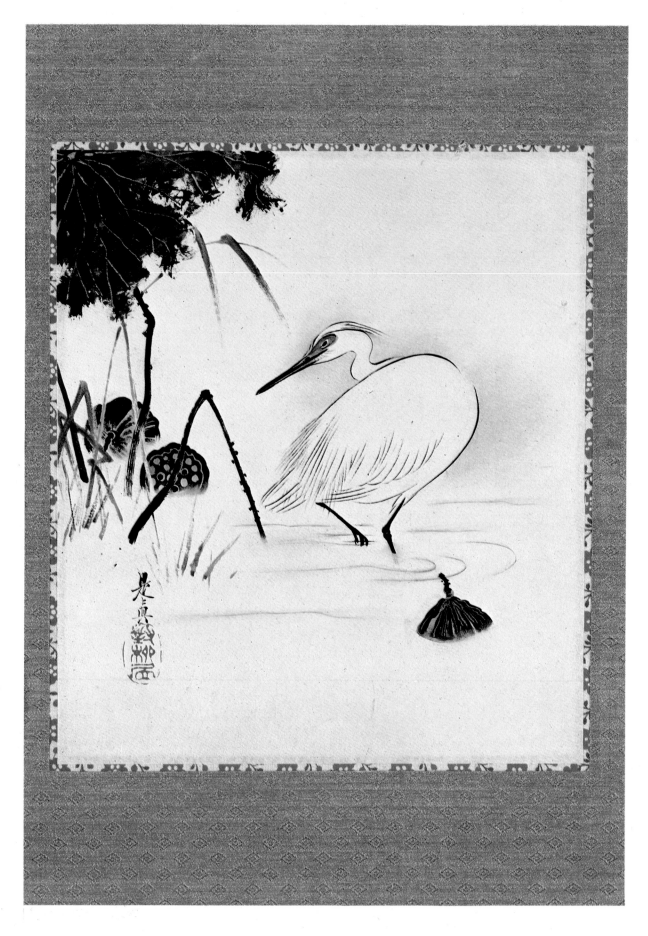

40 Heron and Lotus Pods

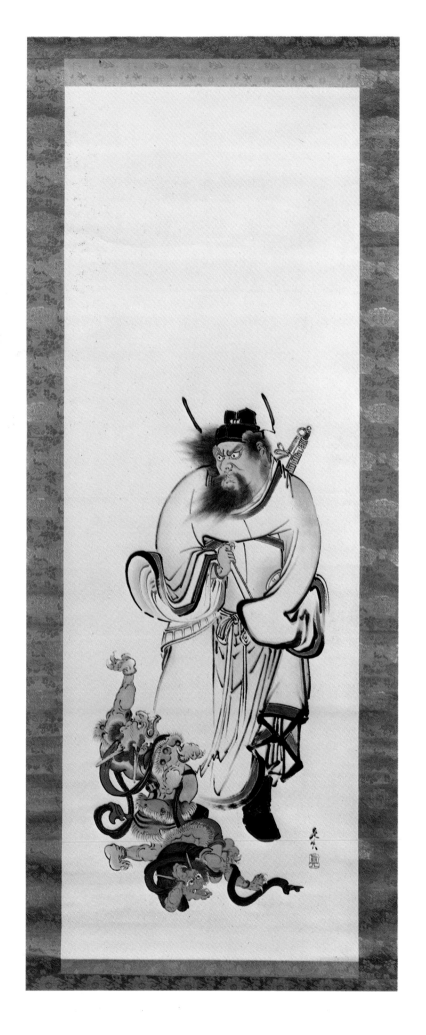

46 Shōki Quelling Two Oni

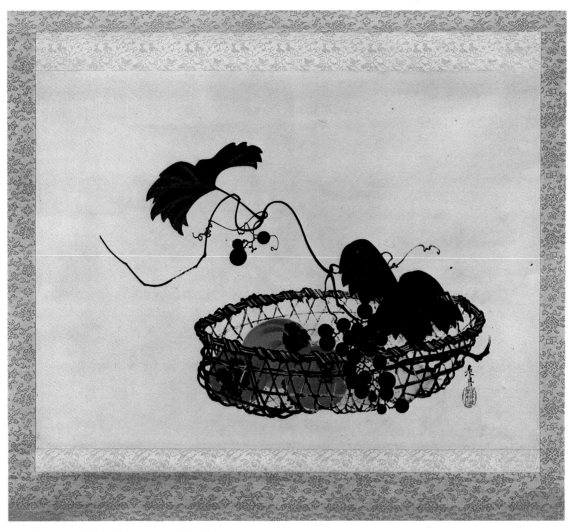

47 Autumn Basket of Grapes and Persimmons

38 Hibiscus Flowers and Rock

Technical: Colored lacquer on paper; 7¼ in. × 6½ in. (18.4 × 16.5 cm.); album leaf mounted as a hanging scroll
Signature: Zeshin
Seal: Undeciphered
Date: Late period
Accession No.: 4672.1

Typical of Zeshin's art in the late 1870s, this finely colored lacquer painting of hibiscus (*fuyō*) and rock was executed on specially-prepared paper which prevents cracking of the lacquer and is one of several 'check points' of connoisseurship in the authentication of Zeshin's lacquer paintings. Zeshin generally used a specially coated paper, which provided a flexible, soft support which was particularly suited for the adhering of lacquer and for prevention of cracking, even if the works were rolled up in scrolls.

39 Butterfly and Wild Rose

Technical: Lacquer on paper; 7⅜ in. × 6½ in. (18.7 × 16.5 cm.); album leaf mounted as a hanging scroll
Signature: Shichijū kyū ō Zeshin
Seal: Koma
Date: Late period, 1885 (in inscription)
Accession No.: 4658.1

This delicate painting of superb quality was done towards the end of Zeshin's life, yet there seems to be no faltering in inspiration or elegance of execution. The signature is rendered with such confidence and heaviness of stroke that it may be classified with the *kaisho* style of writing. Such a signature is commonly observed on works produced after the early 1870s. Although this painting is mounted to match three other album leaves in hanging scroll format (Cat. Nos. 40–42), it does not necessarily follow that all were accomplished during the same period. The signature translates, 'The old man of seventy-nine, Zeshin,' corresponding to the year 1885. The seal *koma*, from the same cut, is reproduced as No. 37, Appendix II.

40 Heron and Lotus Pods

Technical: Brown lacquer on paper; 7⅜ in. × 6⅝ in. (18.7 × 16.8 cm.); album leaf mounted as a hanging scroll
Signature: Zeshin
Seal: Tairyūkyo
Date: Late period
Accession No.: 4657.1

Of the four album leaves mounted as scrolls in matching fabric (also Cat. Nos. 39, 41 and 42), this painting stands out as particularly accomplished. The lines and angles of the well articulated broken lotus pods and dried reeds form a striking contrast with the sweeping curves of the heron's body as the bird turns in upon the composition. The forceful *kaisho* style of the signature suggests that it was painted at about the same time as Cat. No. 38, which bears the inscribed signature of the late 1870s. The seal *Tairyūkyo* is indisputably correct and is of the same cut as that reproduced as No. 41 in Appendix II.

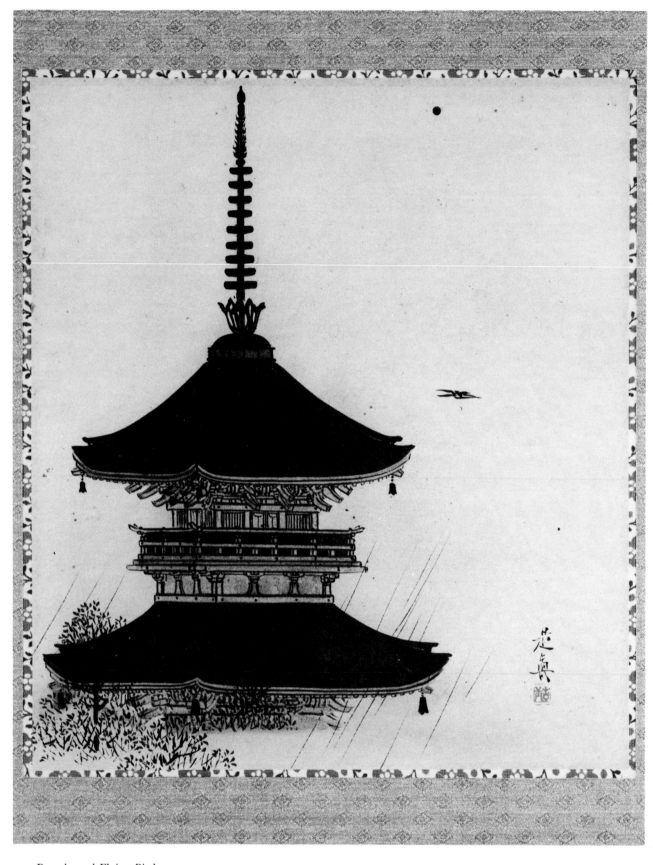

42 Pagoda and Flying Bird

104

41 Bird Standing by a Leafy Plant

Technical:	Colored lacquer on paper; 7⅛ in. × 7 in. (18.1 × 17.8 cm.); album leaf mounted as a hanging scroll
Signature:	Zeshin
Seal:	Tairyūkyo
Date:	Late period
Accession No.:	4656.1

Zeshin's love of nature and careful observation are nowhere more apparent in his work than in this finely composed view of a bird standing by a seed or flower cluster. The bird's head is tucked against its breast at an angle as if it is resting or preening its feathers. Zeshin carefully applied the lacquer to depict the veining and textures of the broad, heart-shaped leaves of the plant, which form an arrangement of attractive shapes. The signature of this fine painting matches in its forcefulness the signature style of other album leaves mounted for combined viewing (Cat. Nos. 39 and 40). The Tairyūkyo seal, while not recorded in this precise form, does occur in variant form in Appendix II, Nos. 45 and 41. A similar album leaf, also executed in lacquer, with the same plants as seen here, is reproduced on page 98 of the article 'Zeshin' by Alan Priest, appearing in the *Metropolitan Museum of Art Bulletin*, December 1953.

42 Pagoda and Flying Bird

Technical:	Lacquer on paper; 7½ in. × 6⅝ in. (19 × 16.8 cm.); album leaf mounted as a hanging scroll
Signature:	Zeshin
Seal:	Koma
Date:	(see comment)
Accession No.:	4655.1

A comparison of this painting with the other three paintings mounted as a group (Cat. Nos. 39–41) is instructive. The weakness and tightness of the brushstrokes in this work, particularly in the rendering of the rooftiles, and the unimaginative composition may suggest the hand of a follower of Zeshin rather than that of Zeshin himself. The signature is in keeping with the style of Zeshin's mature years appearing on other paintings (Cat. No. 39) and may suggest an atelier work, signed by the master. Significantly, the paper used for this painting differs from the paper Zeshin generally used in his *urushi-e* album and fan paintings (see Cat. No. 38) and which does occur in Cat. Nos. 39–41. Finally, it should be noted that these other works have spring, summer and autumn subjects. The subject of this painting does not fit with the seasonal *kachō-e* (flower and bird paintings) of the other album leaves, suggesting that they were brought together as a set at a later date.

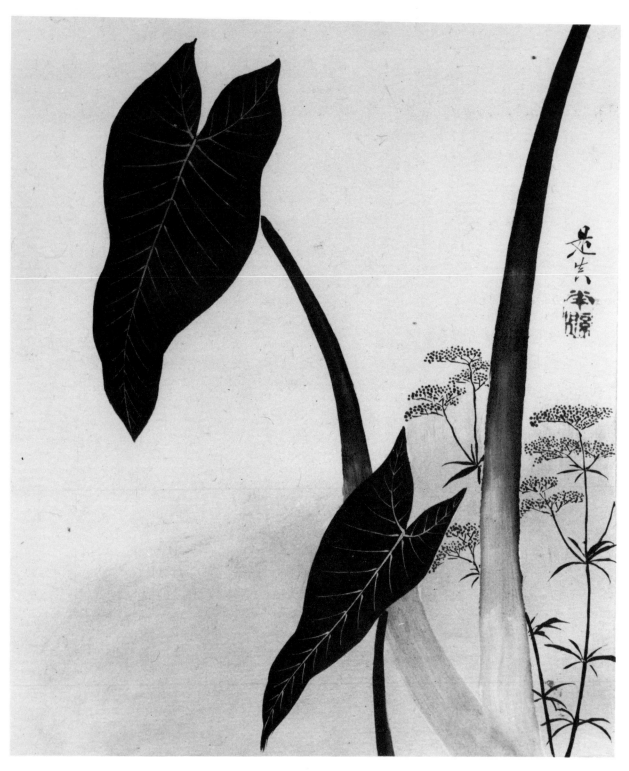

43 Leaves and Wild Grasses

43 Leaves and Wild Grasses

Technical:	Lacquer on paper; $7\frac{9}{16}$ in. \times $6\frac{5}{16}$ in. (19.2 \times 16 cm.); unmounted album leaf
Signature:	Zeshin
Seal:	Undeciphered (although lower character may read *ken*)
Date:	Late period
Accession No.:	4664.1

The long stalks and tapering, broad, veined leaves of taro plants provide a dramatic and bold foreground element in this painting, while in the background is the delicate *ominaeshi*, frequently depicted as one of the seven flowers of autumn (see also Cat. No. 75). The signature style suggests a date about 1880.

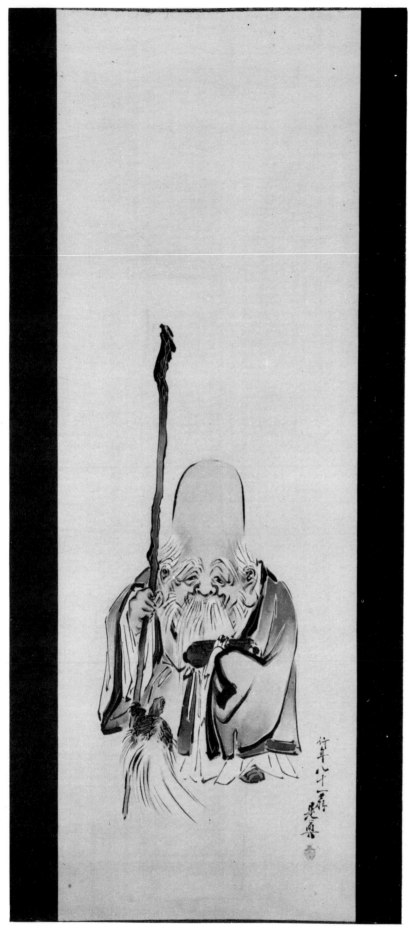

44 Jurōjin

44 Jurōjin

Technical:	Ink and color on paper; 39¾ in. × 13½ in. (101 × 34.3 cm.); mounted as a hanging scroll
Signature:	Gyōnen hachijū-ichi ō Zeshin
Seal:	Zeshin
Date:	1887 in inscription
Accession No.:	4588.1

The subject shows Jurōjin, god of longevity and one of the seven gods of luck. Jurōjin is usually depicted with a crane, a stag (see Cat. No. 48) or, as here, a tortoise, all symbols associated with old age. Dressed in the robes of a scholar, Jurōjin stands, smiling and slightly stooped from his many years, and holds his two attributes – the sacred staff (*shaku*) and a handscroll on which is recorded the wisdom of the world. The high, bald brow and head are usually characteristic of Fukurokuju, another of the gods of luck, and depictions of the two gods are often confusing (see again Cat. No. 48). The signature, which seems rather weakly written when compared with other signatures from this period in Zeshin's career, translates 'The age I have attained so far is eighty-one years, the old man Zeshin'. If this signature is genuine, the painting can be dated 1887. The jar-shaped seal *Zeshin* corresponds to No. 5 in Appendix II. The signature *Shibata Zeshin* and the seal *Zeshin* appear on a certificate accompanying this scroll. Both signature and seal are genuine; however, it is possible, of course, that this certificate once belonged to another painting. During the late 1880s Zeshin produced a number of portraits of Jurōjin (see Vol. 8 of *Kaiga Shōshi*, dated in colophon to November 30, 1887, with a signature age of eighty years, e.g. 1886; and Vol. VII of *Bijutsu Sekai*, with a signature age of eighty-one, e.g. 1887.)

45 Oni

Technical:	Ink and color on paper; 32½ in. × 11½ in. (82.5 × 29.2 cm.); mounted as a hanging scroll
Signature:	Oju Zeshin
Seal:	Shin (see Appendix II, No. 25, for an impression made from a different cut)
Date:	Late period
Accession No.:	4589.1

This rapidly and spontaneously executed painting is reminiscent of the folk style of the popular prints and paintings by the artisans of the village of Otsu. Zeshin shows an *oni*, a legendary demon or devil whom he invests, despite the traditionally quite ugly appearance, with a peculiar charm. The *oni* wears a Buddhist monk's robe and carries a folded parasol stuck through straps on his back. He supports himself on one hand and with the other strokes his chin while staring out with a perplexed, puzzled expression. The mythical *oni* could be of almost any size, small to giant and red, pink, grey or blue in color. They often have animal-like whiskers and horns, and are distinguished by having three fingers or toes on each limb. While sometimes mischievous, almost comic figures, they are more often depicted as cruel and evil and figure frequently as adversaries in the legends and stories of Japanese heroes (see Cat. No. 46). The signature *Oju Zeshin* suggests that Zeshin painted this by request. The style of this signature would seem to indicate a painting done towards the end of Zeshin's life, perhaps in the mid-1880s. It is suggested that this work may have been one of a pair with a picture of Shōki at left.

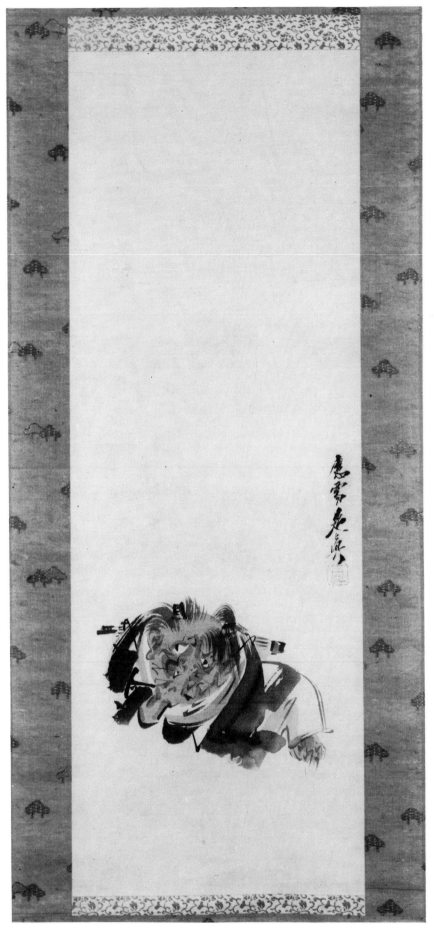

45 Oni

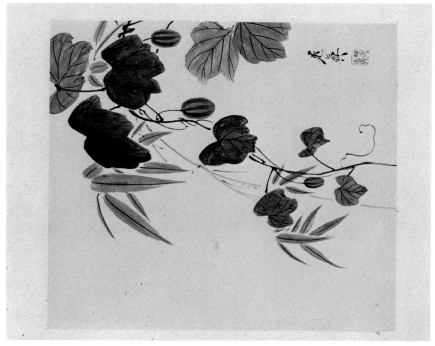

49 c) Vine and Bamboo

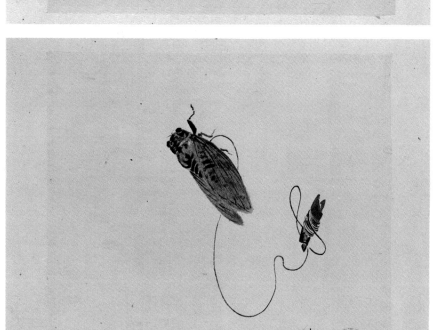

49 b) Semi (Cicada)

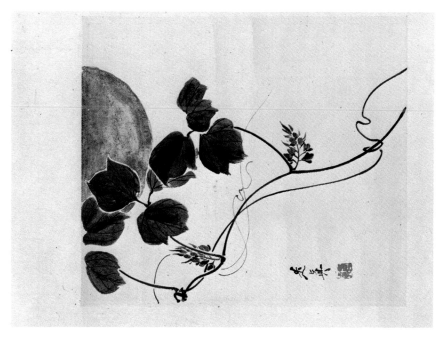

49 a) Flowering Vine

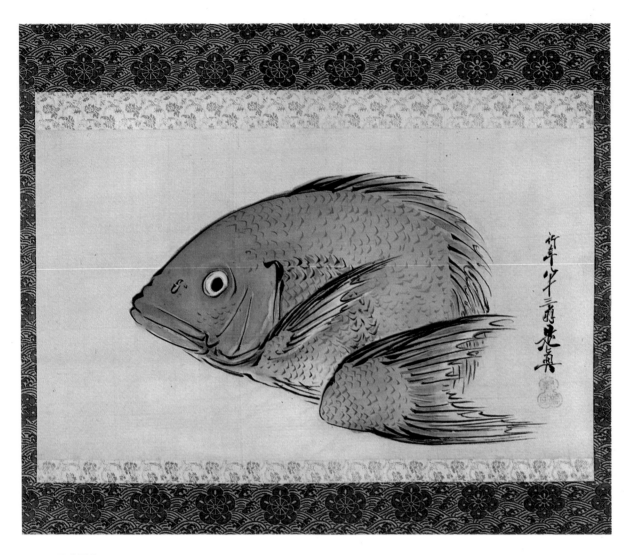

50 A Tai Fish

46 Shōki Quelling Two Oni

Technical: Strong colors and lacquer on paper; 43 in. × 15⅛ in. (109.2 × 38.7 cm.); mounted as a hanging scroll

Signature: Zeshin

Seal: Shin

Date: Late period

Accession No.: 4600.1

Zeshin chose a mythological subject for this superb lacquer painting, the largest and one of the finest examples of its type in the collection. Shōki (the Chinese demon-queller Chung Kuei) was a legendary hero of the T'ang dynasty (618–906) and the protector of the Emperor Ming Huang. He was originally a disqualified student who had committed suicide after his failure to pass the state examination. He was honored with an official funeral and thereafter resolved to rid the empire of all types of demons. Here he is about to quell two demons or *oni* (see Cat. No. 45); another undated painting showing Shōki quelling an *oni* has a very similar composition (see *Nihon no Bijutsu*, No. 93, Fig. 51). The signature of this powerful work dates it to the late 1870s, when Zeshin sprawled the two characters of his name with greater confidence and a heavier stroke. The *shin* seal, possibly from the same cut as No. 24 in Appendix II, is of particular interest, since Zeshin's son, Reisai, states in his *Senkō Shibata Zeshin* (*My Father Shibata Zeshin*) that Zeshin carved this one himself out of wood and that it was meticulously executed.

47 Autumn Basket of Grapes and Persimmons

Technical: Black and colored lacquer on paper; 13½ in. × 18½ in. (34.3 × 47 cm.); mounted as a hanging scroll

Signature: Zeshin

Seal: Tairyūkyo

Date: Late period

Accession No.: 4654.1

The technical virtuosity of Zeshin's late lacquer painting is beautifully illustrated in this highly decorative *urushi-e* still life showing grapes, leaves and persimmons in a basket. The forceful signature *Zeshin* is common on works of the late 1870s, and the seal *Tairyūkyo* reproduced in Appendix II, No. 45, but probably from a different cut, is common though not exclusive to works of Zeshin's mature years.

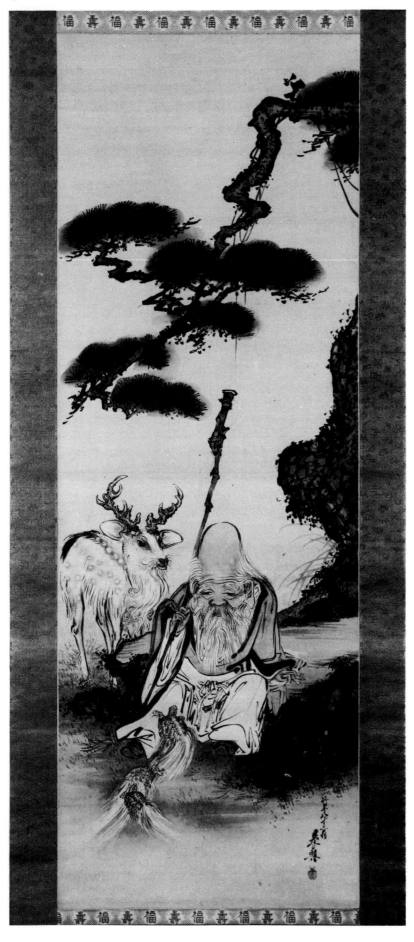

48 Jurōjin, Deer and Tortoises in a Lansdcape

48 Jurōjin, Deer and Tortoises in a Landscape

Technical: Color on silk; 48 in. × 17 in. (121.9 × 43.2 cm.); mounted as a hanging scroll
Signature: Gyōnen hachijū-san ō Zeshin
Seal: Zeshin
Date: 1889 in inscription
Accession No.: 4644.1

With deft brushwork Zeshin created a rather detailed scene showing Jurōjin, one of the seven gods of luck, seated in a landscape with several symbols of contented old age – tortoise, stag and pine. Jurōjin, god of longevity, wears his traditional garb of a scholar, and his face bears a solemn, contemplative expression. He holds one of his traditional attributes, a sacred staff or *shaku*. The elongated, bald head is a characteristic more often associated with another of the gods of luck, Fukurokuju, a god also combining qualities of longevity and wisdom. Some scholars suggest that Jurōjin is a variant of Fukurokuju; the problem of distinguishing the two remains unresolved. The signature loosely translates 'The age I have attained so far is eighty-three years. The old man, Zeshin'. The date of the painting can therefore be determined at 1889. This is in keeping with the style of the signature written with a heavy and confident brushstroke. The tiny jar-shaped seal bearing the lateral block characters reading *Zeshin* corresponds exactly with No. 5 in Appendix II. (See also Cat. No. 44 for another depicition of Jurōjin.)

49 Three Early Autumn Subjects

a. Flowering Vine
b. Semi (Cicada)
c. Vine and Bamboo

Technical: Lacquer on paper; each: 5¼ in. × 4⅝ in. (13.3 × 11.7 cm.); mounted as hanging scrolls
Signature: Zeshin (on each painting)
Seal: Zeshin (on each painting)
Date: 1889 (deducible from box inscription?)
Accession No.: 4653.1 – .3

These three paintings of autumn subjects were meant to be displayed together. The two side scrolls show autumn plants often grouped with the *aki no nanakusa* or seven flowers of autumn, which are associated with the moon-viewing festival (see Cat. No. 75). The left painting shows a vine *hagi* (lespedeza) in front of a silver moon. The right scroll shows another vine, *karasu-uri* (crow's pear), with bamboo. The diagonal compositions of these paintings act as framing devices and lead the eye to the central work, which shows a *semi* or cicada tied with a long string attached to a piece of wood (many young boys in Japan captured these insects and kept them leashed like pets). This delicate and simple painting represents Zeshin's *urushi-e* at its very best, the lacquer having been applied so that the cicada shines and stands out from the surface of the paper with an almost three-dimensional quality. These three works are very similar in execution and bear the same late form of Zeshin's signature and the same seal (though not from the same cuts; none of these is recorded except in a variant form reproduced in Appendix II, No. 8). Curiously, Gōke reproduces the middle picture 'Semi' as Plate 90 in his study in *Nihon no Bijutsu*, No. 93, but fails to record the seal; he attributes the work incorrectly to the collection of the Asian Art Museum, San Francisco. The paintings have never been remounted and remain with their original box, the lid of which bears the inscription of Zeshin reading *Gyōnen hachijū-san ō Zeshin* (The age I have attained so far is eighty-three years. The old man, Zeshin), followed by an undeciphered seal. The signature on the painting appears to be in a somewhat earlier style (ca. early 1880).

50 A Tai Fish

Technical:	Ink and color on silk; 12½ in. × 21⅞ in. (31.8 × 55.5 cm.); mounted as a hanging scroll
Signature:	Gyōnen hachijū-san ō Zeshin
Seal:	Tairyūkyo
Date:	1889 in inscription
Accession No.:	4597.1

Swiftly executed, powerful brushstrokes in red and black distinguish this painting of the front half and tail of a dead Tai fish, with wide staring eyes. The work was executed when Zeshin was eighty-three years old, two years before his death. Both the signature and seal provide convincing evidence of the authenticity of this work. The *kaisho* style signature and date may be observed in the heavy pressure of the final strokes of each character, while the seal *Tairyūkyo* (see Appendix II, No. 43 for an impression from the same seal cut) often occurs in works dated to Zeshin's late years of life. The signature inscription loosely translates, 'The age I have attained so far is eighty-three years. The old man, Zeshin'.

Ceramics and Lacquer Objects

51 Two Single-spout Teabowls

Technical:	Pottery; each 2½ in. (6.4 cm.) high, 5⅜ in. (13.7 cm.) diameter
Signature:	Zeshin (on the base of both bowls)
Seal:	None
Date:	Late period
Accession No.:	4605.1 & .2

According to the inscription on the box accompanying these single-spouted teabowls, they were designed, painted and glazed by Zeshin and potted of Kyoto clay in Tokyo by Ryōsai Inoue in the late 1860s. Inoue, whose actual name was Yoshitaka (alternate *gō*, Tōgyokuen) was born in Seto in 1828 and first began making pottery at Inuyama near Nagoya. He moved to Edo in 1866, opening a kiln at Asakusa.

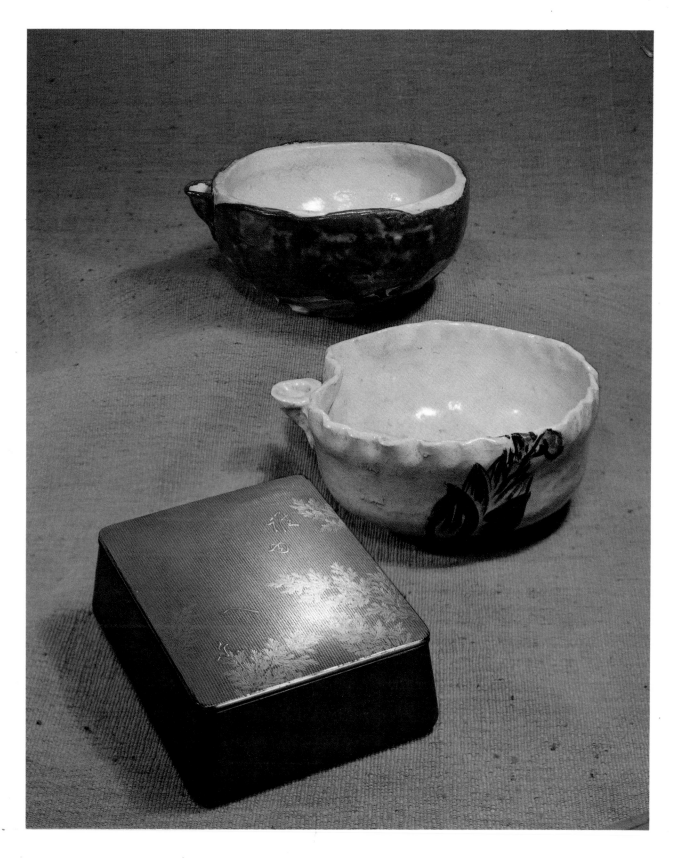

51 Two Single-spout Teabowls
81 Box

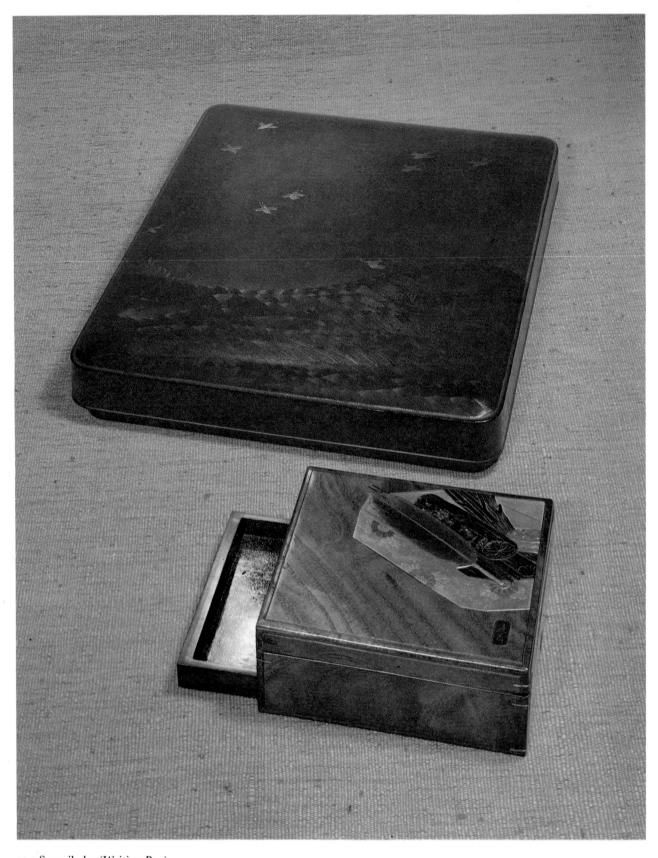

52 Suzuribako (Writing Box)
71 Small Box with Drawer

52 Suzuribako (Writing Box)

Technical:	Matte teadust green lacquer with design in gold and black lacquer; l. 9⅞ in. (25.1 cm) h. 1⅛ in. (2.9 cm.) w. 8¼ in. (2 cm.)
Signature:	Zeshin (incised on the exterior of lid, lower left corner)
Date:	Late period
Accession No.:	4547.1 & .2

The *suzuribako* or writing box has long been one of the most honored objects in Japanese culture and art and was produced from the end of the Heian period (897–1184). Usually the box was sectioned to hold an ink stone (*suzuri*) for grinding the ink, an ink stick (*sumi*), a small metal water container (*mizuire*) and writing brushes (*fude*). This example is perhaps the finest lacquer work in the O'Brien Collection and certainly a masterpiece in Zeshin's lacquer *oeuvre*. The low rectangular box has slightly in-curved sides, rounded corners and a somewhat bowed or domed lid, giving it a pleasing contoured shape. The interior holds a silver water container in the shape of a clam (*hamaguri*) with black striped pattern, an ink stone and a rack for holding two brushes. The surface of the box is done in matte-finish teadust green lacquer (a technique called *seidō-nuri*; see Cat. No. 58). The superlative design on the lid shows an expanse of swelling and falling water in lustrous black lacquer or *udo*. Above are several small plover (*chidori*) in gold lacquer (*maki-e*), diving, turning and rising in their search for fish. The water is depicted in undulating wave patterns through which can be seen pieces of seaweed in gold lacquer. Zeshin revived and perfected the technique for producing this wave pattern (known as *seigai-ha*), and this was one of his greatest achievements in the lacquer medium. The *seigai-ha* motif (literally, blue sea wave) involved the creation of a highly refined ripple effect, similar to that found on the reverse side of the small coins known as *bunkyūsen* and *kaseitsuho*. *Seigai-ha* lacquering came into fashion chiefly owing to the imaginative genius of Seigai Kanshichi, a lacquer artist who resided in Edo and gained prominence during the Genroku era (1688–1703). The technique was the result of his own personal experiments; however, after he died, it was inexplicably discontinued. Zeshin made a comprehensive study of Kanshichi's work and revived the technique with his disciple, Ikeda Taishin, in 1845 when Zeshin was asked by Matsumoto Heijiro, a merchant under the shogun's patronage, to use the technique in lacquering the sheath of a sword. *Seigai-ha* lacquering is one kind of *kawarinuri* (a technique of lacquering used on sword sheaths) and is otherwise known as *sayanuri* which means 'sheath lacquering' in literal terms. It refers to the method of applying lacquer to the sheaths of swords. During the Genroku era, the samurai delighted in the search for hundreds of innovative varieties of beauty. According to Sawaguchi Goichi in *Japanese Lacquer*, *seigai-ha* lacquering is done by applying black *shibourushi* or lacquer containing a sticky material very lightly and thinly over a surface. A spatula or brush is used to draw the rapidly solidifying lacquer into the desired wavy pattern. The shape of this rippling would, of course, be determined by the type of the tool used, and numerous variations could be achieved. Different methods of applying the finishing surface would also produce variations in gloss.

53 Teoke (Tea Caddy)

Technical: Black and cinnabar lacquer with design in gold and mustard-brown lacquer; cryptomeria wood cover lacquered brown; h. $1\frac{7}{8}$ in. (4.7 cm.) d. $2\frac{7}{8}$ in. (7.3 cm.)

Signature: Zeshin (incised on the outside near the bottom of the plant design)

Date: Late period

Accession No.: 4565.1

The ground of this tea caddy is worked in the *shitan-nuri* technique to simulate rosewood (for an explanation of the lacquer methods used to achieve this effect see Cat. No. 69). The elegant plant design is millet with leaves of gold lacquer and a grain cluster in mustard-brown lacquer carefully stippled with dots of lacquer.

54 Inro and Hako Netsuke

Technical: Bamboo with red, black and gold lacquer; *inro:* l. $2\frac{7}{8}$ in. (7.3 cm.) w. $1\frac{1}{2}$ in. (3.8 cm.) d. $\frac{3}{8}$ in. (1 cm.) *netsuke:* h. $1\frac{3}{8}$ in. (3.5 cm.) w. $1\frac{1}{8}$ in. (2.9 cm.) d. $\frac{5}{16}$ in. (.8 cm.)

Signature: Zeshin (incised on the side of the *inro* and on the *netsuke*)

Date: Late period

Accession No.: 4578.1 – .3

Inro first appeared in Japan in the late 15th century and were imported from China. These boxes were used as household containers for seals, thus explaining their name (*in* meaning seal, *ro* meaning vessel). *Inro* also were used as containers for medicine and around the latter half of the 16th century began to be carried as personal accessories. A bead or *ojime* (string fastener) adjusted the length of the cord that held the sections of the *inro* together. The *inro* was suspended from this cord which fastened to the person's sash and ended in a toggle (*netsuke*). The decoration of this bamboo *inro* shows an *uki* (fishing bobber) with fish hook, line and sinker, rendered in red, black and gold lacquer. Instead of being constructed with the usual horizontal sections, the *inro's* side pulls open to reveal five miniature drawers. A multi-colored ceramic *ojime* and a bamboo *hako netsuke* (box netsuke) with a design of two waterskates in black lacquer are attached to the cord. This *inro* and *netsuke* are reproduced in *Nihon no Bijutsu*, No. 93, Plate 115 (incorrectly listed as in the collection of the Asian Art Museum of San Francisco).

55 Kōbako (Incense Box)

Technical:	Lacquered wood with design in raised gold, inlaid cut gold and cut mother-of-pearl; l. 2⅞ in. (7.3 cm.) h. 1⅛ in. (2.9 cm.) w. 1 11/16 in. (4.3 cm.)
Signature:	Zeshin Sei (incised on bottom, lower left corner)
Date:	Late period
Accession No.:	4563.1

This oblong incense box has a rough red-brown lacquer ground with designs in raised gold, inlaid cut gold and cut mother-of-pearl (*aogai*). The lacquer ground is technically known as *tetsusabi-nuri* and was achieved by using *tetsusabi*, a mixture composed of powdered charcoal and red ochre. The box is thought to date from around 1875. Incense boxes or *kōbako* were used for holding powdered or chipped incense and were associated with both religious and secular culture. Incense was first imported to Japan from India via China. The Shōsōin Imperial treasure-house inventory lists five small silk pouches for incense and nine bags of *ebikō*, a blend of incense, used for scenting clothes, which entered the Shōsōin in A.D. 768. Included also is a log of incense wood (*o-jukkō*) from which, it is said, the Emperor cut one piece to be given to Shogun Shikaga Yoshimasa in the mid-15th century. Yoshimasa developed incense appreciation, known as *kōdō*, into an aesthetic cult in Japan. As a result, incense boxes became an important part of various cultural rituals and great artistry was given to their design and decoration.

56 Kashibako (Sweetmeat Box)

Technical:	Dull-black lacquer on leather with pewter rim; lid of *kiri* wood with crude black lacquer, design in gold; l. 4⅛ in. (10.5 cm.) h. 1¾ in. (4.5 cm.) w. 2⅞ in. (7.3 cm.)
Signature:	Zeshin (incised in bottom of box, lower left corner)
Date:	1870 (according to authentication by Chikushin)
Accession No.:	4562.1

The design of loquats in raised gold is particularly effective against the *kiri* wood and crude lacquering of the lid. Zeshin has purposely created a flaw in this lid in order to suggest age. The piece is accompanied by a fine brocade bag. The outer box carries an authentication by Zeshin's disciple, Chikushin (see Cat. No. 36). The piece is thought to have been done around 1870.

57 Teoke (Tea Caddy)

Technical:	Paulownia wood with design in red-brown and black lacquer, and silver and gold *maki-e*; h. 3 in. (7.6 cm.) d. 3⅜ in. (8.6 cm).
Signature:	Zeshin (incised on side panel, lower left)
Date:	Later period
Accession no.:	4561.1

This *teoke* was used as a container for paper-wrapped tea (*cha-oke*). The narrow, parallel grain of the natural, light-coloured paulownia wood serves as an elegant, patterned background for Zeshin's design of leafy vines in red-brown and black lacquer. Some of the lacquer was carefully scraped away to create the veins in the leaves. Tiny clusters of flowers in red-brown and gold lacquer provide accents of color. A vertical side panel inset has a smaller design of the same flowering vines in raised silver and gold *maki-e* on a silver lacquer ground. The interior has a thin application of gold lacquer.

58 Tray

Technical:	Dark green lacquer with design in red, gold and silver lacquer; l. 14¾ in. (37.4 cm.), h. 1⅛ in. (2.9 cm.) w. 9⅞ in. (25.1 cm.)
Signature:	Gyōnen Shichijū-san ō Zeshin (the last character following this inscription cannot be deciphered). The inscription is incised on the back of the tray.
Date:	1879 (deduced from inscription)
Accession No.:	4557.1

Zeshin developed many ways of applying decoration in lacquer. Among these, *seidō-nuri* or bronze-lacquering is especially famous. A dark-green lacquer was painted over a wrinkled pattern and apeared to have the luster and tone of aged bronze ware. The technique was used for the ground of this tray. A large teapot used by farmers to carry tea to harvest fields is depicted in red lacquer. Gold and silver raised lacquer is used for the rice stalks. The grasshopper clinging to the handle is incised. This tray was perhaps used for presentation of gifts. The incised signature appearing on the back indicates that it was made in 1879 when Zeshin was seventy-three. The wooden box for this tray includes a signature and seal thought to be those of the original owners of the tray.

59 Hako Netsuke (Box Netsuke)

Technical:	Black and gold lacquer with mother-of-pearl inlay; h. 1⅛ in. (2.9 cm.) w. 1⅛ in. (2.9 cm.) d. ½ in. (1.3 cm.)
Signature:	Zeshin (incised on reverse, left upper corner)
Date:	Late period
Accession No.:	4579.1

This square black lacquer *hako netsuke* (box netsuke) has rounded corners and edges so that the surface has a pleasing continuous, smooth contoured shape. The design is a tiny landscape showing a pond or pool with an undulating wave design (see Cat. No. 52 for a description of this wave technique). Beside the water are tall grasses, flowering plants and criss-crossed panels representing bamboo fencing, all in gold lacquer. The inner spaces of the fencing are inlaid with tiny square bits of *aogai* shell (mother-of-pearl).

60 Inro and Hako Netsuke

Technical:	*Inro*: dull and shiny black lacquer; l. 3 in. (7.6 cm.) w. 1⅞ in. (4.7 cm.) d. 9⁄16 in. (1.5 cm.); *netsuke*: dull brown lacquer with design in glossy red, gold and silver lacquer; h. 1¼ in. (3.2 cm.) w. 1 in. (2.5 cm.)
Signature:	*Inro*: Zeshin sha (incised on side at lower corner); *netsuke*: Zeshin (incised on reverse)
Date:	Late period
Accession No.:	4576.1 – .3

This *inro* (see Cat. No. 54) in dull and shiny black lacquer is shaped like a cake of ink. The edges have been made to look chipped and worn, and the surface has an irregular, incised all-over pattern simulating the dried *craquelé* of an old ink cake. One side has a raised design of classic Chinese calligraphic characters in a central panel surrounded by a border showing ancient musical instruments. The other side has a raised design showing a ribbed sphere (possibly a lantern) being partially obscured by a wave or cloud; in the lower left corner is a simulated seal of the master, Ritsuo, reading *Kan*. Jahss says of Zeshin (p.449), 'Particularly outstanding are his works that imitate the styles of old masters while retaining their own individuality'. Here his inkstone *inro* and even his *netsuke* are meant to emulate the style of Ritsuo, the great master of the 17th century. The use of the *Kan* seal is therefore deliberate. The *inro* is suspended on a purple silk cord with a coral *ojime* and attached to a *hako netsuke* (box netsuke) of matte-finish brown lacquer. The netsuke is ornamented with three circular crest designs in glossy red, silver and gold lacquer. The work has the added distinction of an authentication by Chikushin, a disciple of Zeshin. A similar *inro* shaped like a Chinese ink cake is reproduced in *Nihon no Bijutsu*, No. 93, Fig. 110. Another *inro* in the collection of George Lazarnick, omits the *Kan* seal, but includes the same inscription 'Ho Ro Dai' in the center panel of the opposite face as on the O'Brien example.

61 Tonkotsu (Tobacco Pouch)

Technical:	Dark red lacquer on wood with design in black, gold and silver lacquer; l. 3¾ in. (9.5 cm.) h. 2¼ in. (5.7 cm.) w. 1 in. (2.5 cm.); *netsuke* h. 1⅛ in. (2.9 cm.)
Signature:	Zeshin (incised on bottom)
Date:	Late period
Accession No.:	4575.1 – .3

This *tonkotsu* done in fine dark red lacquer on wood includes a design of an island in glossy black lacquer, a starfish and other sea creatures in gold and silver lacquer. The former identification of Rabbit Island, a reference to Oki Island near Izumo Grand Shrine in the Sea of Japan where Emperor Gotoba was exiled in 1239, is unlikely. This identification was probably based upon the inclusion of a rabbit *netsuke* in silver lacquer with red eyes and ears. The *netsuke*, however, may have been added at a later date and was probably not by Zeshin himself: it includes an unidentified *kakihan*. Attached to the bottom of the *tonkotsu* by a rope is a gold metal *ojime* with a design of a quail in flat black lacquer and two *kiku* (chrysanthemums) in gold lacquer. This *ojime* carries a signature which reads *Harunaga*, recorded in Shinkichi Hara (p.18) as a 19th century Edo artist whose family name was Ōtake. (The *Shosankenshu* reads *Harunaga* as *Shunei*.)

62 Tonkotsu (Tobacco Pouch) and Hako Netsuke

Technical:	*Tonkotsu:* teadust green lacquer with design in gold, silver and black lacquer; h. 2½ in. (6.4 cm.) w. 3 in. (7.6 cm.) d. 1 in. (2.5 cm.); *hako netsuke:* reddish-brown and brown/black lacquer
Signature:	Zeshin (incised on *tonkotsu* and *netsuke*)
Date:	Late period
Accession No.:	4574.1 – .3

This oblong wood tobacco container has a *seidō-nuri* ground (see Cat. No. 58) of matte-finish teadust green lacquer. The design of leafy plants and tiny grasses is done in gold, silver and black lacquer. It is connected by a grey silk cord with a coral *ojime* to a *hako netsuke* (box netsuke) in brown/black lacquer with a raised design of a pod or eggplant on which sits a fly or beetle.

63 Tonkotsu (Tobacco Pouch)

Technical:	Teadust green lacquer on wood with gold, silver and brown lacquer design; h. 2¼ in. (5.7 cm.) w. 2⅞ in. (7.3 cm.) d. 1½ in. (3.8 cm.); *netsuke:* h. ⅜ in. (1 cm.) w. ½ in. (1.3 cm.)
Signature:	Zeshin (incised on exterior, bottom lower left corner)
Date:	Late period
Accession No.:	4573.1 – .3

Against the background of teadust green lacquer is a design in relief showing a moon window with bamboo bars; drying leaves hang from the eaves. A gold lacquer hoe and a plant tied in burlap ready to go into the ground complete the design. The lid is made of wood lightly lacquered and polished, and attached to the *tonkotsu* is a rope with a green ceramic *ojime* and a *hako netsuke* in reddish-brown and gold lacquer on wood with a design depicting a bamboo basket. The *hako netsuke* and the *ojime* are not necessarily by Zeshin since they do not bear a signature.

64 Tonkotsu (Tobacco Pouch)

Technical:	*Tonkotsu:* lacquered wood with raised gold and black lacquer and brown lacquer with mother-of-pearl inlay; h. 2⅞ in. (7.3 cm.) w. 3½ in. (8.9 cm.) d. 1 in. (2.5 cm.); *netsuke:* h. ⅜ in. (1 cm.) w. 1⅜ in. (3.5 cm.) d. 1½ in. (3.8 cm.)
Signature:	Zeshin (incised on outside on the narrow end of the *tonkotsu*)
Date:	Late period
Accession No.:	4572.1 – .2

This *tonkotsu* in greenish-black lacquer has a design showing a horse done in raised gold and black lacquer emerging from a stable done in raised dark-brown lacquer with a barred window of mother-of-pearl (*aogai*) inlay. The box-shaped *netsuke* with a design of a reclining cow or bull in raised brown on dark rusty-brown lacquer is not, however, by Zeshin but bears the signature of the artist, Issai. Issai is recorded in Jahss (p.406) as a '19th century artist of the Zeshin school who was outstanding for his lacquer work, particularly many netsuke'.

65 Yatate (Traveler's Writing Case)

Technical:	Bamboo with gold and brown-black lacquer; h. 1½ in. (3.8 cm.) w. 1⅝ in. (4.2 cm.) d. 1¼ in. (3.2 cm.); cherry branch: l. 5¾ in. (14.6 cm.)
Signature:	Zeshin (incised on the bottom of the bamboo)
Date:	Late period
Accession No.:	4571.1 & .2

This oval ink container made from a section of bamboo is decorated with a tiny mountainous island landscape in brown-black lacquer and stylized *chidori* (plover) hovering above done in gold lacquer. The dark wood lid is also ornamented with plovers in gold lacquer. The container is suspended on a purple silk cord to a piece of a cherry branch with its natural red-brown bark and includes a bamboo *ojime*. This branch is hollowed out from one end, possibly to hold a writing utensil, and could perhaps have been tucked into a traveler's costume with the ink container allowed to dangle.

66 Chestnuts

Technical:	Brown and black lacquer on gold paper; mounted in a small table screen; 7⅝ in. × 6½ in. (19.4 × 16.5 cm.)
Signature:	Zeshin yama (incised on lower right corner)
Seal:	None
Date:	Late period
Accession No.:	4665.1

This finely executed framed lacquer 'picture' showing a sprig of chestnut with chestnuts falling from an open pod is typical of Zeshin's work in the 1870s, when he first began to frame lacquer works in the manner of a Western oil-painting.

67 Ink Stone and Cover

Technical:	Stone: carved wood lacquered in red-brown; h. ½ in. (1.3 cm.) w. 2½ in. (6.4 cm.); cover: l. 4 in. (10.2 cm.)
Signature:	Zeshin (incised on bottom, lower left corner)
Date:	Late period
Accession No.:	4566.1

In this work Zeshin lacquered wood in glossy red-brown to simulate a stone for grinding ink and mixing it with water. A carved blossoming plum branch ornaments one end and spills over the side. The cover is lacquered in dark brown and black to look like *shitan* (rosewood) and has an incised grain pattern with occasional knotholes to complete the illusion. The piece is thought to date from around 1880.

68 Pipe Case

Technical: Teadust green lacquer with design in gold, light olive green and rough black lacquer; l. 9 in. (22.9 cm.) w. 1¼ in. (3.2 cm.) d. 1 in. (2.5 cm.)

Signature: Zeshin (incised on the outside)

Date: Late period

Accession No.: 4556.1

This two-piece tubular case is done in teadust green lacquer lightly textured to look like leather. The design shows a fox disguised as a priest with a bamboo pilgrim staff and standing among tiny gold and black flowers. The black textured lacquer surface of the priest's robe simulates cloth, a technique referred to as *usuginubari-nuri*. Very fine light silk (*usuginu*) starched with lacquer is pasted to the undercoating and then sprinkled with patina dust, scoured and allowed to dry. Once dry, the whole surface is lightly honed with a whetstone and then chafed slightly with a brush designed to dull the glare. Following an overlaying coat of lacquer and then later black lacquer, about two applications of colored lacquer are added to provide the finishing touches.

69 Jikirō (Covered Box)

Technical: Brownish black and cinnabar lacquer; h. 4 in. (10.2 cm.) d. 6¼ in. (15.9 cm.)

Signature: Zeshin (incised inside of cover, lower left corner)

Date: Late period

Accession No.: 4551.1

Zeshin was adept at using lacquer to simulate other materials, and there are several examples of this type of work in the O'Brien Collection. For this circular box, Zeshin used brownish-black and cinnabar lacquer worked to achieve the look of rosewood (also known as red sandalwood). The technique for simulating rosewood (*shitan*) is known as *shitan-nuri* and in the case of Zeshin, involved one of two methods according to Professor Gōke. In the first method, wax-colored lacquer is applied to the undercoating, and the areas where the wood pattern is desired are scooped out by means of a small spatula and then filled in with deep vermilion lacquer applied with a small brush. These areas are smoothed out with another brush and carefully gradated as they meet the wax-colored and red lacquer. After the luster has been eliminated and transparent lacquer applied, the whole is coated with wax lacquer again. The work is completed by scratching extremely fine lines into the surface with an awl, producing the texture of rosewood grain. In the second method, the surface of the second coating, orange-ochre lacquer, which is a mixture of wax, colored lacquer and red ochre is administered. As in the first method, the dark red and black lacquer which covers the areas to be decorated in the wood pattern is scraped out and deep vermilion lacquer containing a small quantity of wax-colored lacquer is worked in the appropriate manner to fashion the finished grain. Again, it is smoothed out and gradated with a brush until the obvious border is eliminated. Herberts (*Oriental Lacquer*) describes the technique of *shitan-nuri* differently, indicating that small broken lines are engraved in a ground of red lacquer before it is dry, then polished with charcoal; black ink is applied in strips with indistinct edges. This is followed by a light application of *seshime* (raw lacquer which dries slowly but is very hard) and then polished.

70 Jikirō (Covered Cake Box)

Technical:	Teadust green lacquer with designs in gold, silver, brown-gold and black lacquer with *aogai* shell inlay; h. 3¼ in. (8.3 cm.) l. and w. 7¾ in. (19.7 cm.)
Signature:	Zeshin (incised inside of cover, lower left corner)
Date:	Late period
Accession No.:	4552.1

In this exquisite square box with tapered sides and overhanging lid, Zeshin utilized a combination of *maki-e* and other lacquer techniques, including tiny shell inlay to achieve a blending that is quietly subtle, balanced and rich. The box is done in teadust green lacquer worked to look like leather. The top edge of the box and the bottom edge of the cover have lightly incised geometric meandering patterns. The decoration features on the side of the box the legendary *hō-ō* bird (phoenix), holding a leafy vine in its beak, and on the lid, elaborate, stylized butterflies. The wings and trailing tail feathers of the butterflies are executed in gold and silver *takamaki-e* and glossy black, brown and rough black lacquer techniques (the lower tips of the large butterfly are in rough black lacquer achieved by a process described in Cat. No. 68, and the wavy pattern on the upper wings of the small butterfly is discussed in Cat. No. 52). *Maki-e* designs are achieved by spreading and scattering gold or silver dust, flakes, nuggets or leaf on a drawing done in sticky lacquer applied over a hardened lacquer foundation. *Takamaki-e* refers to decoration in low relief and is distinguished from *hiramaki-e*, or decoration which is generally flush with the surface. Tiny bits of iridescent *aogai* shell ornament the large butterfly's wings and the tail of the phoenix.

71 Small Box with Drawer

Technical:	*Keyaki* wood with design in red, gold, black and dark-brown lacquer; l. 4¼ in. (10.8 cm.) h. 1¾ in. (4.5 cm.) w. 3⅛ in. (8 cm.)
Signature:	Zeshin (incised in cartouche on lower right corner of lid)
Date:	Late period
Accession No.:	4554.1

This small box of highly polished *keyaki* wood has a false bottom and a single drawer below which opens from one side. The design on the lid shows a portion of a tray or box in gold lacquer which holds items such as charcoal logs, twigs, metal chopsticks, a feather and a round lacquer box, all ingredients or utensils used for making a fire to heat water for the tea ceremony. These are done in red, black and dark-brown lacquer carefully worked to suggest the textures of each object and to give them an almost three-dimensional appearance. The interior of the box and the drawer have tiny particles or filings of gold sprinkled into black lacquer and covered with a thick layer of lacquer to give a glossy, smooth surface. This technique is called *nashiji* or pear ground lacquer for its resemblance to the granular skin of a Japanese pear.

72 Boat-shaped Bowl

Technical: Brown lacquer ground with design in black and gold *takamaki-e*; l. 1⅞ in. (4.7 cm.) h. 1⅞ in. (4.7 cm.) w. 4½ in. (11.5 cm.)

Signature: Zeshin (incised on the outside wall at the larger end of the bowl)

Date: Late period

Accession No.: 4555.1

A background color often preferred by Zeshin was a dark glossy brown which here provides an elegant, subdued foil for his designs of seaweed, rope, and boat oar done in black and gold *takamaki-e* (see Cat. No. 70 for explanation of this technique).

73 Five Sweetmeat Plates

Technical: Red-brown lacquered wood with red, gold, black, mustard yellow, teadust green and silver lacquer designs; each: d. 4½ in. (11.5 cm).

Signature: (See commentary)

Date: Late period

Accession No.: 4564.1 – .5

These superbly executed sweetmeat plates of very thin wood with a red-brown lacquer finish were intended for use in the tea ceremony. They have designs of fruit or seed pods done in various combinations of red, gold, black, mustard-yellow, teadust green and silver lacquer. Three of the plates are signed on the top with the signature *Zeshin* and the seal *shin* in lacquer; the other two plates are signed on the bottom with the signature *Zeshin* in lacquer.

74 Covered Box

Technical: Red-brown lacquer with black lacquer design; l. 5 in. (12.7 cm.) h. 2¼ in. (5.7 cm.) w. 3¼ in. (8.3 cm.)

Signature: Zeshin

Seal: Koma (both signature and seal are in lacquer on the exterior of one of the long sides)
Yonehara (pressed into bottom of work)

Date: Late period

Accession No.: 4569.1 & .2

This simple oblong box is done in highly polished reddish-brown lacquer made to look like lacquered leather. Simple yet bold brushstrokes in black lacquer on the cover and sides constitute the only ornamentation on the box. The overall effect is one of subdued elegance. A blue kidskin pouch case with tiny red, green and white printed designs accompanies this box, and it has been suggested that the designs were done by Zeshin himself. However, this case seems more likely to have been made in Persia or the Middle East.

75 Suzuribako (Writing Box)

Technical:	Matte black lacquer with designs in teadust green, silver, gold, red, brown and black lacquer with inlay; l. 13½ in. (34.3 cm.) h. 6⅛ in. (15.5 cm.) w. 3⅞ in. (9.9 cm.)
Signature:	Zeshin (in ink or black lacquer in corner inside cover)
Date:	Late period
Accession No.:	4549.1 & .2

This narrow, elongated *suzuribako* for the writing and storage of *tanzaku* (vertical poem cards) is one of the finest examples of Zeshin's superb lacquer artistry in the O'Brien Collection. The box has two sections: the upper one holds a black inkstone, a silver water container (*mizuire*) in the shape of a lotus leaf (*hasu-no-ha*), and a silver box with hinged lid containing a well, perhaps for mixing ink or cleaning brushes; the lower compartment held the long poem cards. The surface of the box is done in *udo* or matte-finish black lacquer. Zeshin used a masterful blending of subdued, dark shades of red, gold, silver, teadust green and brown lacquers for his design of plants. A few inlaid tiny white beads are randomly scattered throughout and provide occasional enlivening highlights. The total effect is balanced and subtle, yet sumptuous and rich. The plants depicted are the *aki no nanakusa* (seven flowers of autumn), collected and displayed during the moon-viewing festival (*Tsukimi*) and often used in Japanese art. The *aki no nanakusa* group includes several kinds of flowering plants or grasses which seem to be interchangeable to get the number seven and are depicted in different combinations. The seven varieties on this box include *hagi* (lespedeza), *obana* or *susuki* (a kind of pampas grass), *nadeshiko* (wild carnation), *ominaeshi* (patrinia) and *kikyō* (bellflower) and two more. The box has a carefully fitted silk brocade wrapping case of the same period.

76 Bowl

Technical:	Matte rough red and green lacquer with design in red and yellow lacquer; h. 1¾ in. (4.5 cm.) d. 6⅜ in. (16.2 cm.)
Signature:	Zeshin (in gold lacquer on interior)
Date:	Late period
Accession No.:	4560.1

For the interior of this bowl Zeshin used olive-green, perhaps his most celebrated lacquer, lightly stippled and roughened, to provide a subdued ground for his design of persimmon and grape done in carved red and yellow lacquer (*tsuikin*). The exterior of the bowl is done in red lacquer, which has also been given a stippled and roughened texture. (See Cat. No. 86, *shūmon-nuri* technique.)

[Reproduced in color, see frontispiece]

77 Small Square Tray

Technical: *Keyaki* wood with design in black, dark green, silver, gold and coral lacquer; 6 in. (15.3 cm.) on all sides, d. $\frac{5}{8}$ in. (1.6 cm.)
Signature: Zeshin (in gold lacquer in lower left corner)
Date: Late period
Accession No.: 4559.1

Against the varied and wavy grain pattern of *keyaki* wood Zeshin created a simple design of curling fern fronds in black, dark green, silver, gold and coral lacquer and a small bird in green and gold lacquer soaring skyward. The sides of the tray have pierced designs. The utilization of the wood grain is superb.

78 Tray

Technical: *Tsuge* wood with design in black and gold lacquer; l. 15$\frac{3}{8}$ in. (39.4 cm.) w. 8$\frac{1}{4}$ in. (21 cm.) d. $\frac{3}{4}$ in. (1.9 cm.)
Signature: Zeshin (in dark red lacquer in lower right corner)
Seal: Shin (in dark red lacquer in lower right corner)
Date: Late period
Accession No.: 4558.1

Zeshin used the fine natural grain of *tsuge* wood to create the illusion of transparent, calm water for his delicate rendering of a carp. A single brushstroke in lacquer marks the curved ripple created as the carp breaks the surface. Gold lacquer highlights the eye and gill of the fish. Documentation accompanying this tray indicates that it was made for a special memorial tea ceremony.

79 Hako Netsuke (Box Netsuke)

Technical: Wood and bamboo with black and gold lacquer design; h. 1$\frac{3}{8}$ in. (3.5 cm.) w. $\frac{7}{8}$ in. (2.2 cm.) d. $\frac{1}{2}$ in. (1.3 cm.)
Signature: Zeshin (in lacquer on the reverse, lower left corner)
Date: Late period
Accession No.: 4580.1

This *hako netsuke* of wood is distinctive for its oval shape and bamboo cover. The simple design shows a bottle-like oil lamp done in black and gold lacquer. A tiny flame is emitted from the spout of the lamp. A similar lamp is shown in a painting (see Cat. No. 31).

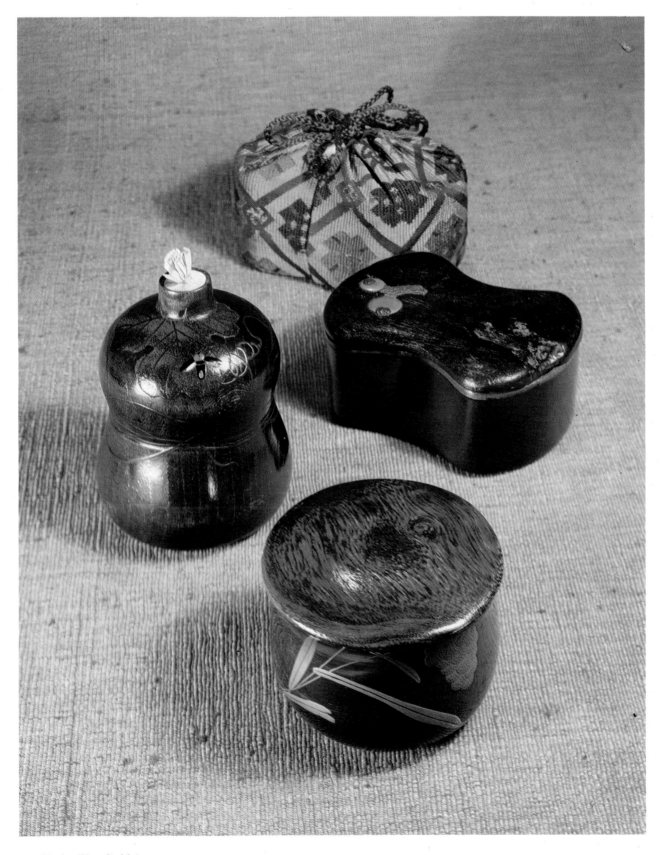

53 Teoke (Tea Caddy)
56 Kashibako (Sweetmeat Box)
83 Jar

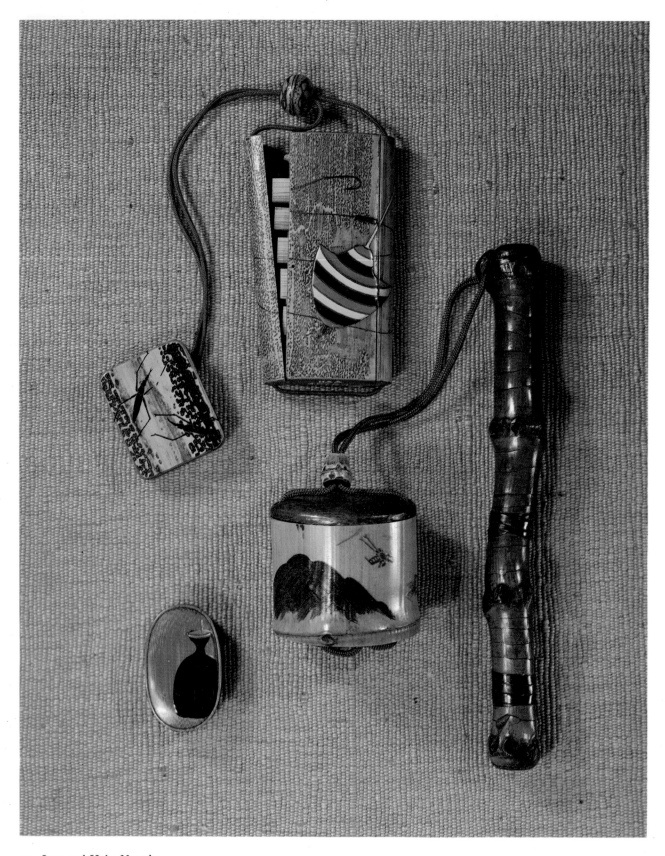

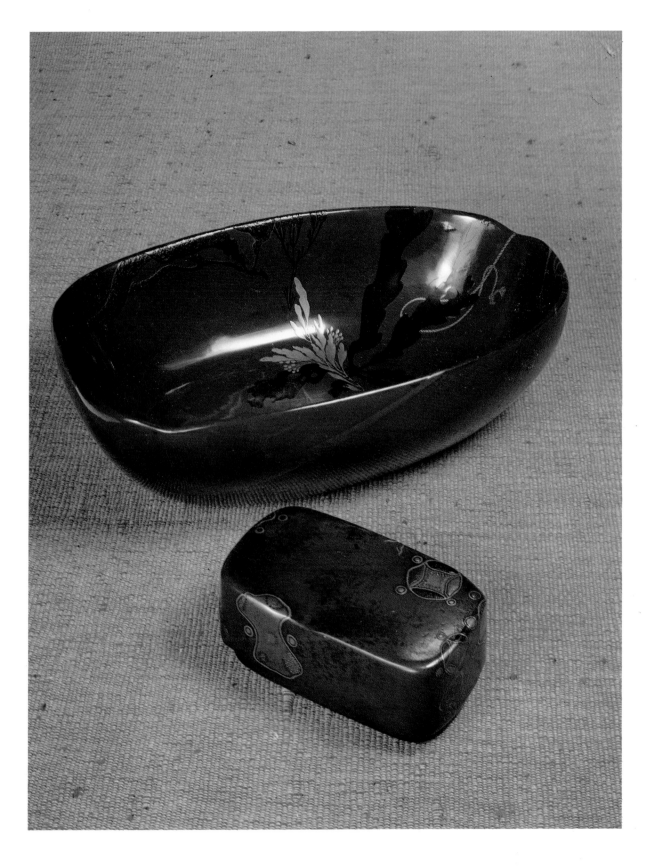

55 Kōbako (Incense Box)
72 Boat-shaped Bowl

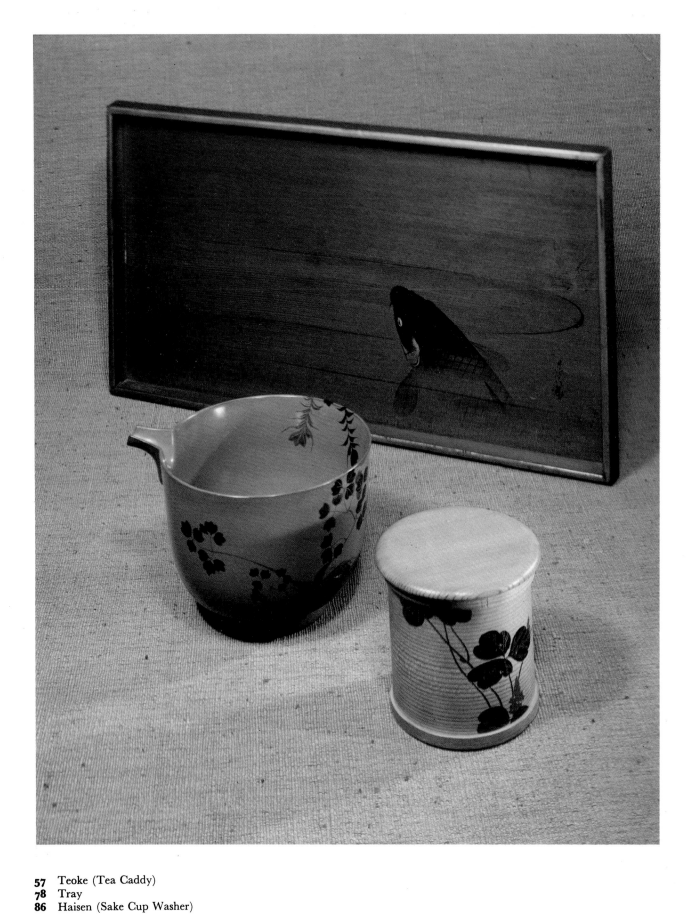

57 Teoke (Tea Caddy)
78 Tray
86 Haisen (Sake Cup Washer)

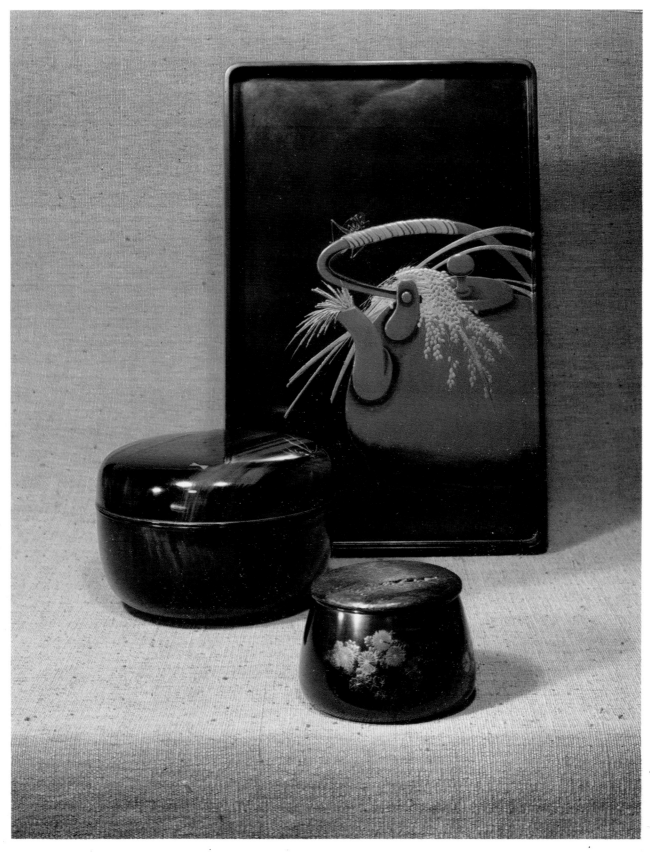

58 Tray
69 Jikirō (Covered Box)
82 Teoke (Tea Caddy)

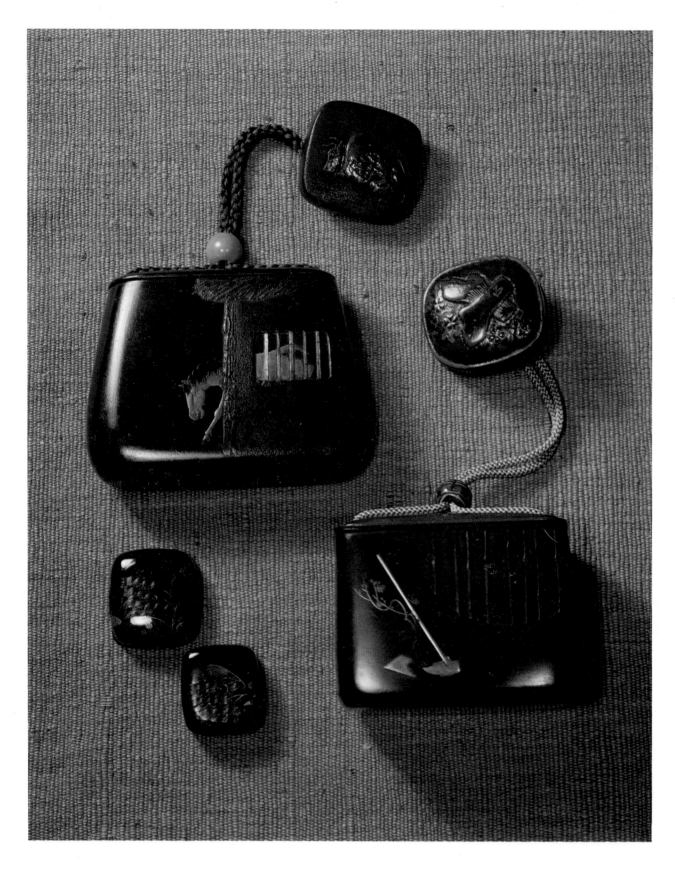

59 Hako Netsuke (Box Netsuke)
63 Tonkotsu (Tobacco Pouch)
64 Tonkotsu (Tobacco Pouch)

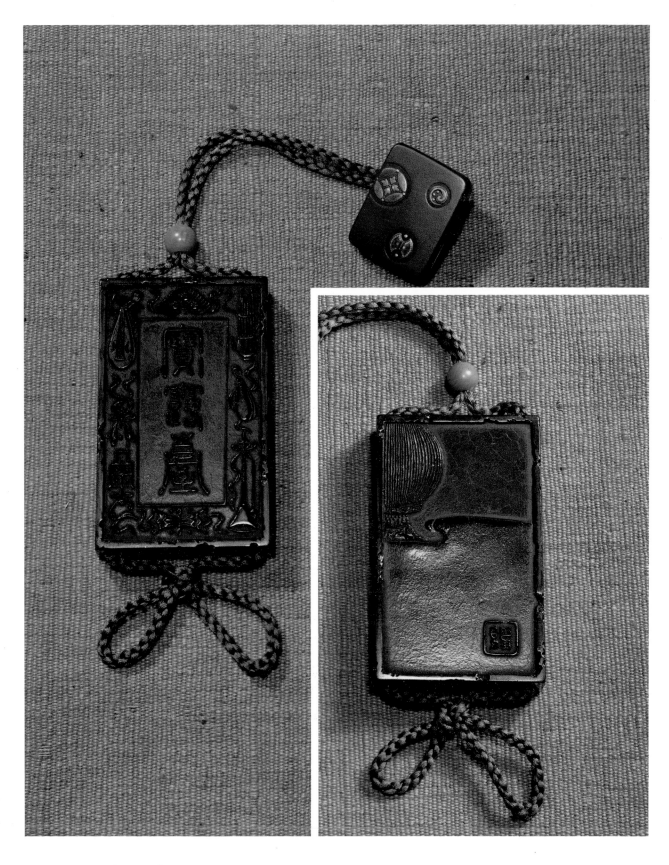

60 Inro and Hako Netsuke

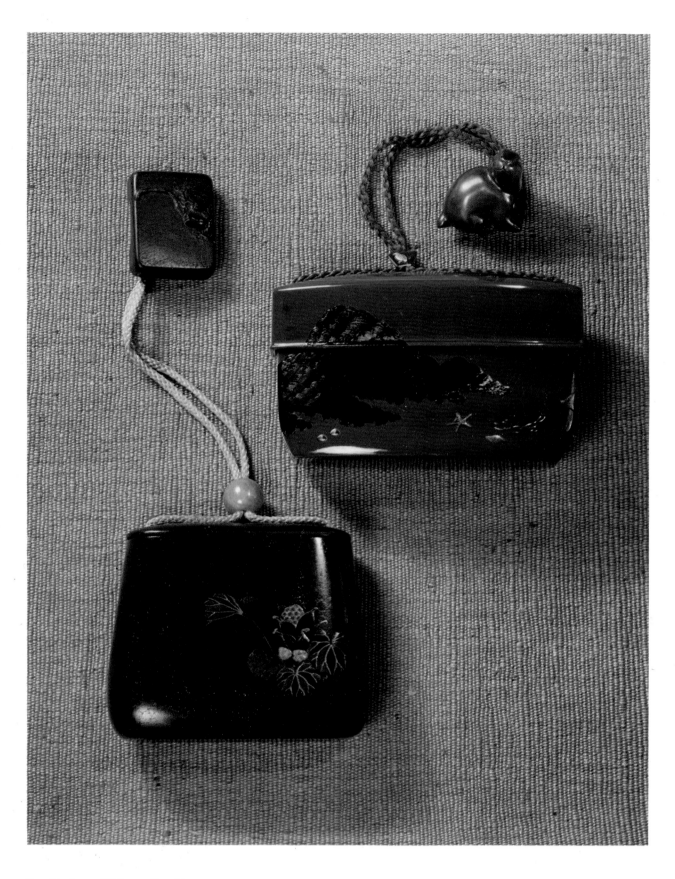

61 Tonkotsu (Tobacco Pouch)
62 Tonkotsu (Tobacco Pouch) and Hako Netsuke

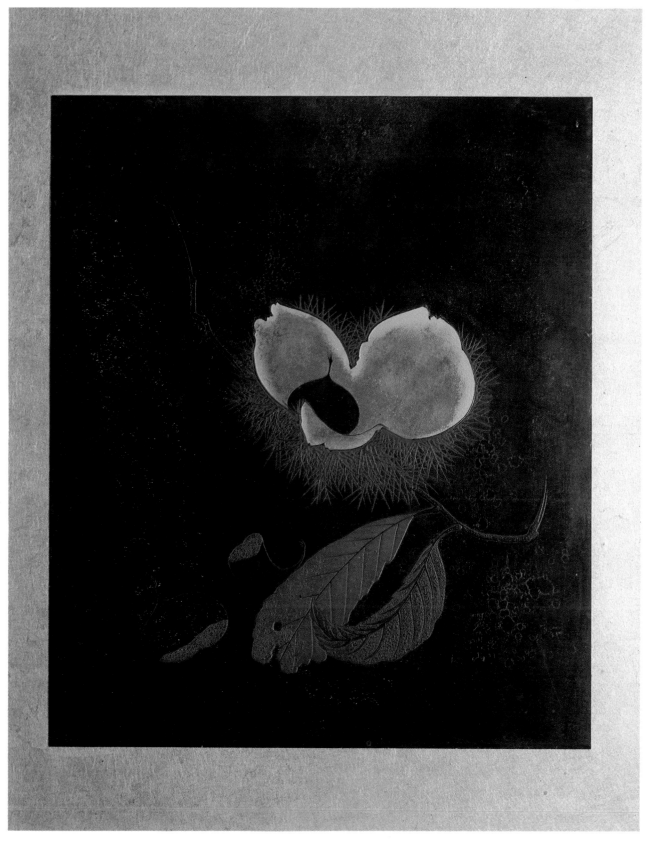

66 Chestnuts

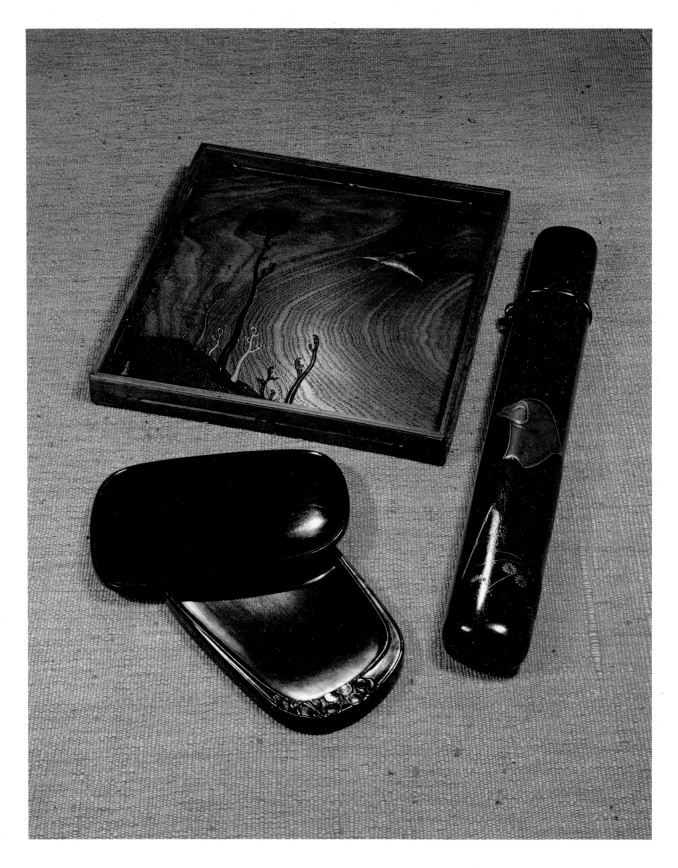

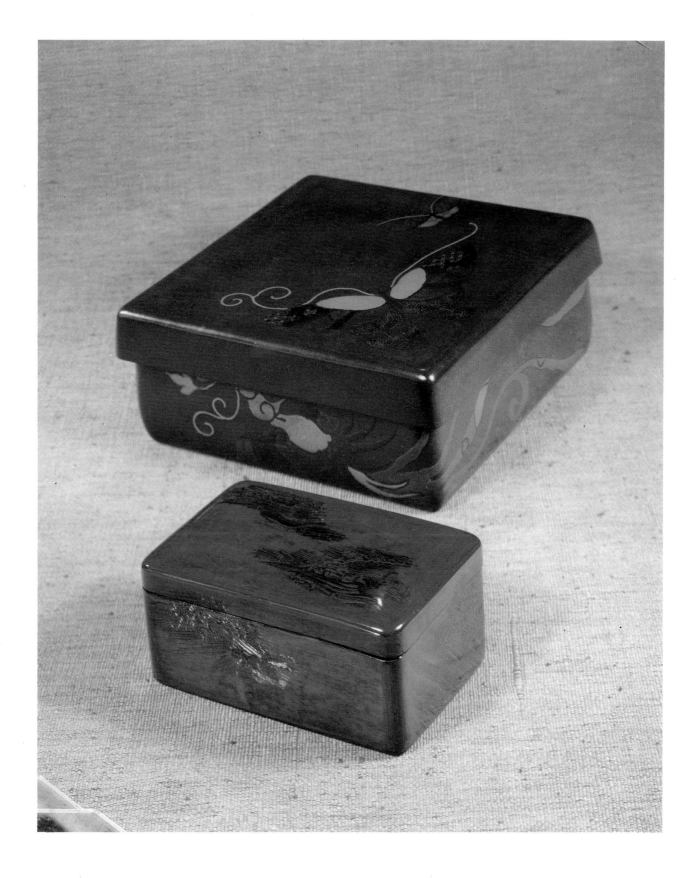

70 Jikirō (Covered Cake Box)
74 Covered Box

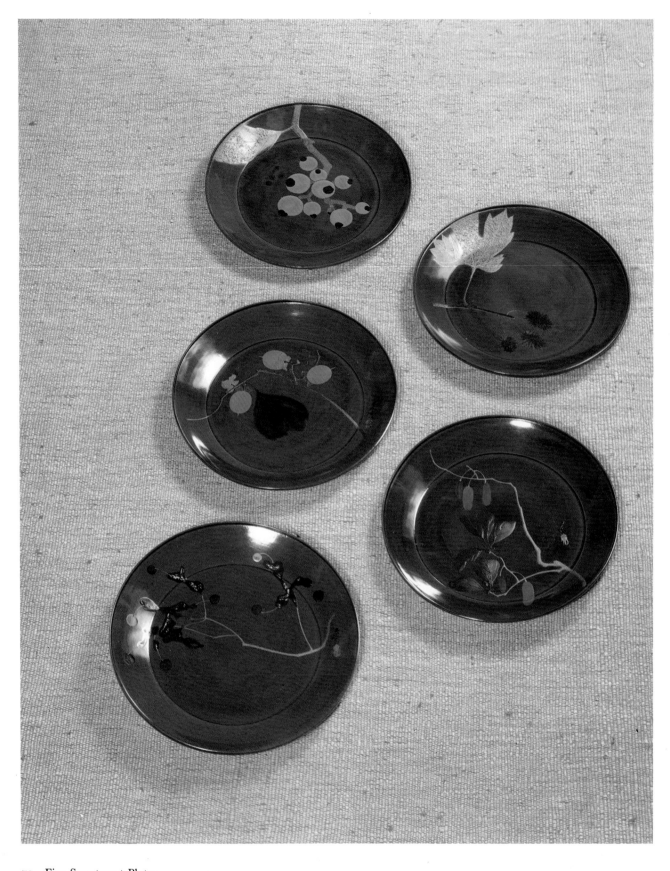

73 Five Sweetmeat Plates

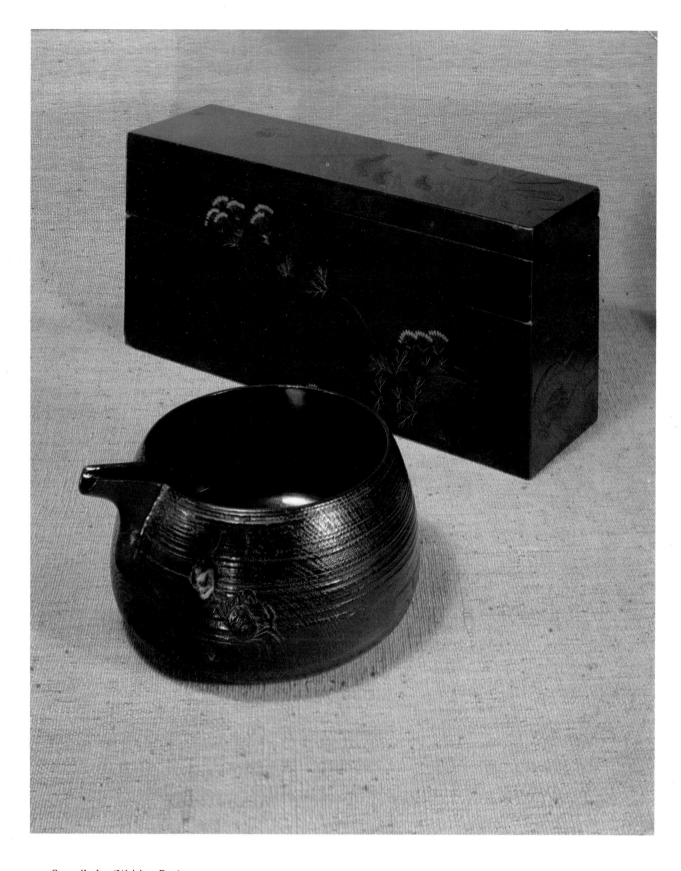

75 Suzuribako (Writing Box)
85 Haisen (Sake Cup Washer)

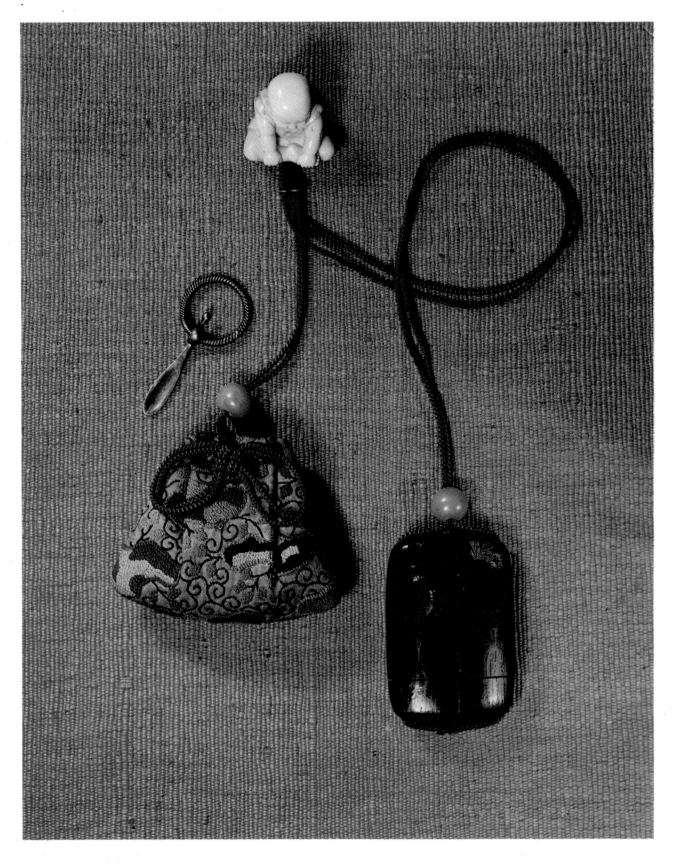

80 Miniature Inro

80 Miniature Inro

Technical:	Cryptomeria wood with raised metal, and gold and red lacquer; h. 2⅛ in. (5.4 cm.) w. 1⅝ in. (4.1 cm.) d. ½ in. (1.3 cm.): netsuke h. 1½ in. (3.9 cm.)
Signature:	Zeshin (in gold lacquer on tree trunk of *inro*, lower left)
Date:	Late period
Accession No.:	4577.1 – .6

This fine miniature three-case *inro* is made of natural cryptomeria wood. Zeshin chose a design of a carved tree-trunk with a small fly or cicada in raised metal. Gold lacquer delineates the branch of a tree, which almost completely conceals a *tori* (bird) in red lacquer. The *inro* is attached to a cord with two coral *ojime* and one thin metal *ojime* in *sashi* form. An ivory *netsuke* of a seated boy is signed *Ryōmin* on the lower edge of the boy's garment. Ryōmin is recorded in the *Netsuke Handbook* by Ueda Reikichi and adapted by Raymond Bushell, as No. 839 in the index of netsuke carvers. Little is known of Ryōmin except that he preferred to work in ivory and that his period of activity occurred sometime between 1801 and the beginning of the Meiji period (1868). Also attached to the cord and tied with a french knot is an embroidered bag perhaps imitating an *Asakusa kinchaku* or type of gold brocade bag used in the Asakusa district of Edo. A gold metal ring with small flat blade is stuck into the bag. A similar work with a cicada in high relief against bamboo is reproduced in *Nihon no Bijutsu*, No. 93, Fig. 24.

81 Box

Technical:	Crude black lacquer, teadust green lacquer, and fine lacquer mesh work in gold; l. 4¾ in. (12.1 cm.) h. 1½ in. (3.9 cm.) w. 3⅝ in. (9.2 cm.)
Signature:	Zeshin (in teadust green lacquer under cover, lower left)
Date:	Late period
Accession No.:	4570.1

Several lacquer techniques were used in this box. The exterior of the box was done in crude black lacquer while a fine teadust green lacquer was utilized for the interior. However, it is the lid of the box on which Zeshin lavished great care, creating a sumptuous fine lacquer mesh in gold over green, on which are arranged gold calligraphy and leafy ferns or branches done in green-gold and rose-gold. Zeshin rarely used gold lacquer for backgrounds, and in this respect this fine work is of particular interest and importance to the collection.

82 Teoke (Tea Caddy)

Technical: Dark brown and black lacquered wood with designs in gold, black and silver lacquer; cryptomeria wood lid lacquered dark brown; h. 2⅜ in. (6 cm.) d. 4 in. (10.2 cm.)

Signature: Zeshin (in lacquer on the outside near the chrysanthemum design)

Date: Late period

Accession No.: 4568.1

The ground of this tea caddy is streaked in places with a mixture of black and dark brown lacquers to look like wood. The decoration consists of clusters of tiny chrysanthemum blossoms in silver lacquer (now oxidized) and leaves in black lacquer with gold veining. Zeshin included a false age crack in gold lacquer with a silver lacquer simulated staple repair. Zeshin frequently simulated such effects of age and use, sometimes perhaps intending to try to fool the viewer's eye. However, in this example the crack is so obviously false that it probably appealed to Zeshin's sensibility as decoration alone. The cover of cryptomeria wood has been purposefully aged and includes an area made to look like rotted wood. Near this area are little ants made of black lacquer.

83 Jar

Technical: Mulberry wood with design in red, orange, green, brown and black lacquer with mother-of-pearl inlay; h. 3¾ in. (9.5 cm.) d. 2¾ in. (7 cm.)

Signature: Zeshin (in lacquer on outside lower section)

Date: Late period

Accession No.: 4567.1

Mulberry wood was carefully worked in the shape of a double-bodied gourd for this jar. The wide, slightly raised grain of the wood provides an elegant surface for the lacquer design of vines and curling tendrils which wrap around the waist of the container and swirl up over the rounded shoulder. Below the neck is a large leaf in speckled red, orange and green lacquer on which sits a firefly in raised black and red lacquer. Spots on the back and the underwings of the firefly are inlaid with *aogai* (mother-of-pearl), providing iridescent highlights. This work was done when Zeshin was eighty according to an accompanying identification by his son, Ryūshin (alias Reisai) together with a certificate of authenticity.

84 Shikishi Bako (Box for Square-shaped Paper)

Technical: Orange, green, greenish brown, black and gold lacquer on cryptomeria wood; h. 1½ in. (3.8 cm.) l. 8⅜ in. (21.3 cm.) w. 7½ in. (19.1 cm.)

Signature: Zeshin (in gold lacquer on the inside cover, lower left)

Date: Late period

Accession No.: 4548.1

Zeshin frequently chose beautifully patterned natural woods rather than lacquer as backgrounds for his lacquer designs. Perhaps no object in the O'Brien Collection illustrates this better than this exquisite *shikishi bako* or box for square-shaped paper. The rough, dense grain of cryptomeria wood is a dramatic support for the simple still life arrangement of a persimmon, eggplant, bean, pea pod, chestnut and loquats in colored lacquers in low and high relief. The edges and corners of the lid and box have thumbnail molding and beading in black lacquer. The interior is also done in shiny black lacquer.

[Reproduced in color, see frontispiece]

85 Haisen (Sake Cup Washer)

Technical:	*Keyaki* wood with black, brown and silver lacquer; h. $3\frac{1}{2}$ in. (8.9 cm.) d. $6\frac{1}{4}$ in. (15.9 cm.)
Signature:	Zeshin (in gold lacquer on the left side of the spout)
Date:	Late period
Accession No.:	4550.1

The exterior of this bowl has a beautiful, textured surface produced by the rough swirling natural grain of the *keyaki* wood and the horizontal grooves from the carving and turning of the piece. The presence of a knothole, simulated cracks and dovetail mends further emphasize the aged, rustic quality of the work. The interior and spout, by contrast, are finished in smooth, shiny black and brown lacquer, respectively. The only decoration consists of two crabs in raised silver lacquer (now tarnished and black) on the side of the bowl.

86 Haisen (Sake Cup Washer)

Technical:	Mustard-colored lacquer with design in black, gold and brown lacquer; h. $3\frac{1}{2}$ in. (8.9 cm.) d. $4\frac{7}{8}$ in. (12.4 cm.)
Signature:	Zeshin (in black lacquer under the spout)
Date:	Late period
Accession No.:	4553.1

Unlike most lacquer artists, Zeshin preferred not to use gold lacquer backgrounds. He experimented instead with various ground colors such as dark brown, light tan, olive and mustard yellow, as on this spouted bowl. The decoration, in brown and both glossy and rough black lacquer, shows a *seri* (water parsley) growing on a mound of earth executed in several swift strokes and given a finely combed texture. A thistle-like plant wraps over the rim and continues on the interior of the bowl. The mustard-colored ground is smooth and glossy in imitation of Edo period porcelain. Often, however, Zeshin stippled and toughened the ground to produce an effect like earthenware. To achieve this, Zeshin utilized a technique known as *shūmon-nuri*. Wax-colored lacquer or simply colored lacquer was administered as evenly as possible to the second coating. Before this application had time to dry, egg white, sometimes mixed with a small quantity of water, was spread on the whole surface with a soft brush. The egg white caused the evaporation of moisture and as it dried, tiny cracks developed in the still-wet lacquer underneath. When the egg white was removed, the finished surface had an effect very similar to the pores or indentations of earthenware.

87 Daikoku Beckoning To a Group of Mice

Woodblock Prints

87 Daikoku Beckoning to a Group of Mice

Technical:	Color woodblock print; 9 in. × 11½ in. (22.9 × 29.2 cm.)
Signature:	Zeshin
Seal:	Tairyūkyo
Date:	Late period
Accession No.:	17,116

This sheet, and all others in the group (Cat. Nos. 87–105), come from Vol. 1 and Vol. 2 of the three-volume set, *Shibata Zeshin Gafu* (Shohen) (original cover title) published in Tokyo (no date); a complete copy of which is in the New York Public Library. Although the covers of the first series measure 22.6 × 15.1 cm. and the unnumbered double sheets 22.5 × 29.8·cm. (see Mitchell, p.470–471) and therefore do not precisely conform with the loose page size of the O'Brien examples, according to Mr Rankin of the New York Public Library, all the prints seem to be almost identical with ones found in the first two folding albums of the C. H. Mitchell copy, down to the occurrence of signatures, seals and form of seal. Vol. 1 of the set contains 11 sheets, including a title page (printed on pink paper) giving the title, *Shibata Zeshin Sensei Gafu* and sub-title, *Ehon Yamato Nishiki no uchi*; publisher, Kinkadō of Toto (Eastern Capitol). The O'Brien Collection contains all ten unnumbered illustrations from this volume (Cat. Nos. 87–96). Volume 2 consists of ten unnumbered sheets; the O'Brien Collection includes all but one (Cat. Nos. 97–105). Although we have followed the above ordering, there is no physical evidence to suggest that the O'Brien prints were stripped from albums. There is the possibility, in fact, that they were first issued as single-sheets and later collected and published in album form. There have been other such instances (e.g. the *Hana Kurabe* prints, first issued singly). Published as reproductions of Zeshin's drawings, these prints evoke a special quality of warmth and sly humor that marks the master's style at its very best. For example, the god Daikoku, shown dressed in Chinese guise as a prosperous individual with a peculiarly shaped hat or cap, is seen with all of his emblems in plain view. His mallet-like hammer, bearing the sign of the jewel lies next to his left foot. He playfully extends his hand to a group of mice, which are supposed to have symbolic and moral meaning in connection with the wealth hidden in Daikoku's bag of precious things, against which he reclines. In the background a pair of boots stand next to bales of rice.

88 Daikon (Radish)

Technical:	Color woodblock print; 9 in. × 11½ in. (22.9 × 29.2 cm.)
Signature:	None
Seal:	None
Date:	Late period
Accession No.:	17,123

In this design Zeshin took a large *daikon* or radish and by the clever placement of the root and the leaves creates an interesting composition.

88 Daikon (Radish)

89　Rabbits Silhouetted Against the Moon

Technical:	Color woodblock print; 9 in. × 11½ in. (22.9 × 29.2 cm.)
Signature:	Zeshin
Seal:	Reisai
Date:	Middle period
Accession No.:	17,111

The imitation of fine brushwork in a print medium is here given excellent expression. Zeshin's subject alludes to Japanese folklore and the tale of the rabbit who inhabits the moon and pounds the elixir of immortality. A group of rabbits (*usagi*) are seen carrying a rice or *mochi* pounder, while in the background is a large, full moon. This is also a humorous pun on the word *mochi*, which can either mean rice cake or full moon.

89　Rabbits Silhouetted Against the Moon

90 Blue and White Tea Pot

Technical: Color woodblock print; 9 in. × 11½ in. (22.9 × 29.2 cm.)
Signature: Zeshin
Seal: Shin
Date: Late period
Accession No.: 17,109

Zeshin delighted in focusing his attention on everyday objects, often viewing them with a precision that other artists could not bring to their work. In this simple still life arrangement a blue and white teapot is shown in a red woven tea cozy; alongside are three teacups bearing butterfly designs.

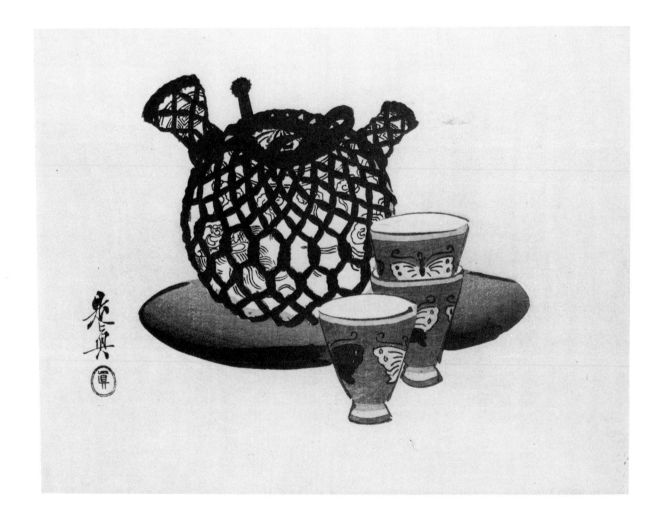

90 Blue and White Tea Pot

152

91 Tea Pickers

Technical:	Color woodblock print; 9 in. × 11½ in. (22.9 × 29.2 cm.)
Signature:	Zeshin
Seal:	Reisai
Date:	Middle period
Accession No.:	17,114

Zeshin often expressed the contentedness he felt in human nature and activity. He frequently selected aspects of daily life for his subjects which a viewer could easily respond to or associate with in some way. This scene of rural folk is a fine example. A naked boy, who has just been given a bath, is running to evade putting on his clothes again, while around him adults are engaged in daily work tasks. Perhaps Zeshin had a certain moral purpose in mind, but such a subject has a warmth and humor familiar to all. Zeshin's style in this print is more illustrative than many other works.

91 Tea Pickers

92 Carp Splashing Upstream

Technical: Color woodblock print; 9 in. × 11½ in. (22.9 × 29.2 cm.)
Signature: Zeshin
Seal: Tairyūkyo
Date: Late period
Accession No.: 17,107

Zeshin's daring sense of design in some of these prints shows a relationship to the concept of lacquer design for *inro* or boxes, on which the compositions spill over from top to sides or wrap around corners. The cropped appearance of this print, for example, recalls a view of one surface of a box which the viewer must turn to follow the design. Zeshin's motif of a carp leaping a waterfall was not new in Japanese art and is, in fact, an allusion to a Chinese story about a sturgeon of the Huang Ho River which, having swum up-river, crossed the rapids of the Lung Men, the Dragon Gate, on the third day of the third month of the year and itself became a dragon. The carp was traditionally regarded as a symbol of courage and strength.

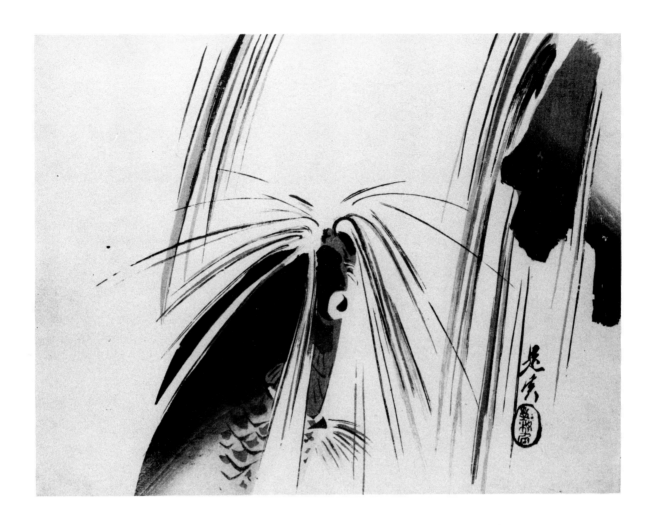

92 Carp Splashing Upstream

93 Bird Resting on a Bamboo Carrying Device

Technical :	Color woodblock print; 9 in. × 11½ in. (22.9 × 29.2 cm.)
Signature :	Zeshin
Seal :	Zeshin
Date :	Late period
Accession No. :	17,119

A shoulder-carrier of bamboo with wood platforms provides the framework for this rural still-life. A solitary bird sits on the cross-bar which a peasant would support on his shoulder to carry tools and materials to and from the fields. On one platform are a bamboo stalk and young shoots, perhaps just dug up for cooking. The other platform has a partial screen of woven grass and holds a bucket or other container with an unidentifiable utensil inside.

93　Bird Resting On a Bamboo Carrying Device

94 Sleeping Workman

Technical:	Color woodblock print; 9 in. × 11½ in. (22.9 × 29.2 cm.)
Signature:	Zeshin
Seal:	Tairyūkyo
Date:	Late period
Accession No.:	17,118

Zeshin sometimes used subtle details to contribute to the overall mood or atmosphere of a scene. In this rural scene showing a peasant sleeping next to a wooden rack on which rests his enormous burden, the sense of lazy relaxation is reinforced by the draping of a piece of cloth, in the way a pair of straw sandals hangs unused and by the fluttering of two butterflies nearby in quiet attendance.

94 Sleeping Workman

95 A Crowd

Technical:	Color woodblock print; 9 in. × 11½ in. (22.9 × 29.2 cm.)
Signature:	None
Seal:	None
Date:	Late period
Accession No.:	17,122

Zeshin visually creates the feeling of a crowd through several devices. The densely packed heads of the people going in many directions, the cropping of the scene and the oblique view looking down reinforce the sense of busy activity in a tight space. Zeshin does not complete certain figures or the checkered canopy, showing only what is necessary for the viewer to complete the scene in his mind's eye.

95 A Crowd

96 Parasols

Technical:	Color woodblock print; 9 in. × 11½ in. (22.9 × 29.2 cm.)
Signature:	Zeshin
Seal:	Tairyūkyo
Date:	Late period
Accession No.:	17,113

Zeshin's remarkable and daring composition of parasols and women's heads leaves half the sheet completely bare, and yet the work has a fine sense of balance. Zeshin did not show all of the parasols and even leaves out a woman's nose, but through the careful selection of details, however, no expression is lost.

96 Parasols

97 Shichifukujin (The Seven Gods of Luck)

Technical: Colour woodblock print; 9 in. × 11½ in. (22.9 × 29.2 cm.)
Signature: Zeshin
Seal: Tairyūkyo
Date: Late period
Accession No.: 17,115

A procession representing the seven gods of good luck and happiness is seen marching across the sheet from the top left to the lower right. This group of household deities has been variously described and to each of its members given a number of more or less fanciful attributes. Endowed with human failings and endless proclivities for enjoyment, the gods of good luck and happiness have received at the hands of various artists pleasantly humorous, if irreverent, treatment. The luck-bringing god of wealth, Daikoku, of Indian origin, leads the procession while his supposed son, Ebisu, of Shinto descent, carrying a fishpole symbolic of his patronage of fishermen, and the female divinity, Benten, follow. Fukurokuju, the ever-smiling god, is followed by the rollicking Hōtei and behind him barely visible, Jurōjin, the god of longevity, and Bishamon. Zeshin's composition again reflects a debt to lacquer design in the cropping of the composition at the top. A similar scene showing at least two of the seven gods of good luck is painted on a fan and includes a similar signature and the seal *Tairyūkyo* (see *Nihon no Bijutsu*, No. 93, Fig. 55).

97 Shichifukujin (The Seven Gods of Luck)

98 Sail of a Treasure Ship

Technical:	Color woodblock print; 9 in. × 11½ in. (22.9 × 29.2 cm.)
Signature:	None
Seal:	None
Date:	Late period
Accession No.:	17,125

In this design Zeshin concentrated on one specific detail of a much larger subject. It shows a curved section of a sail, the edge of which has a flame or wave-like border with a frieze of scroll work below. In the lower left corner is a rough and very hastily executed calligraphy reading '*Takara*'.

99 Sharing a Meal

Technical:	Color woodblock print; 9 in. × 11½ in. (22.9 × 29.2 cm.)
Signature:	Zeshin
Seal:	Reisai
Date:	Late period
Accession No.:	17,121

In this print, Zeshin has created contrasting types of people about to engage in dinner. The male figure holding a fan relaxes heavily against the leg of a table while others sit more formally as if in attendance. The work is marked by a straightforwardness and a touch of sly humour.

98 Sail of a Treasure Ship

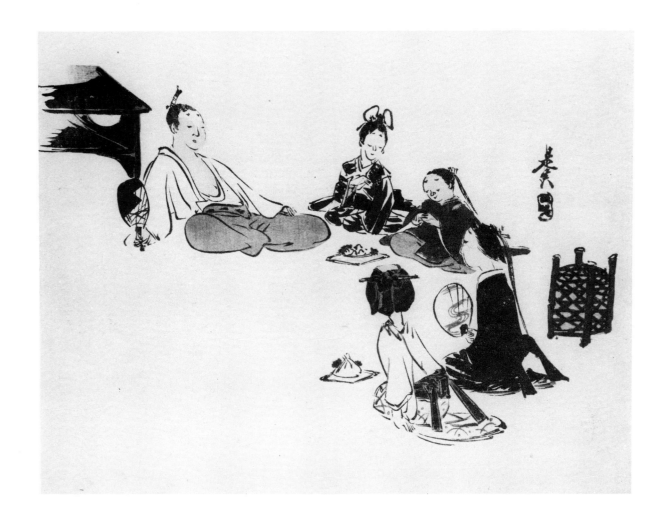

99 Sharing a Meal

100 Fish and Lily Pads

Technical:	Color woodblock print; 9 in. × 11½ in. (22.9 × 29.2 cm.)
Signature:	None
Seal:	None
Date:	Late period
Accession No.:	17,124

One senses in this view of tiny fish clustered around lily pads and breaking the surface or foraging for food a feeling of stopped action. Visible at the bottom is the tail of a large fish, probably a carp, which has just leaped out of the water and is about to disappear again beneath the surface. Zeshin created an illusion; it is as if the surface of the paper and that of the water are the same.

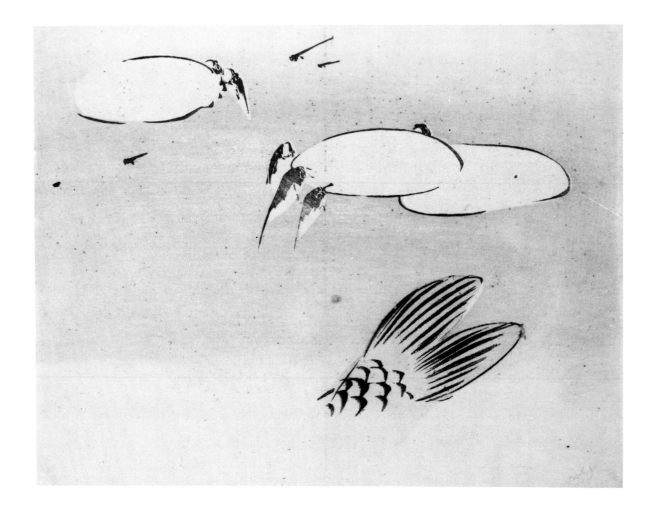

100 Fish and Lily Pads

101 Two Stacks of Bamboo Baskets and a Spray of Blue Iris

Technical: Color woodblock print; 9 in. × 11½ in. (22.9 × 29.2 cm.)
Signature: Zeshin
Seal: Reisai
Date: Middle period
Accession No.: 17,112

Zeshin delighted in depicting little details that he knew would be attractive. Zeshin's method was always subtle; he conveyed his ideas often with the simplest of means. Background is not usually required since the expressive strength in the subject he has selected is sufficient to convey the desired effect.

101 Two Stacks of Bamboo Baskets and a Spray of Blue Iris

102 Western Ships at Anchor

Technical:	Color woodblock print; 9 in. × 11½ in. (22.9 × 29.2 cm.)
Signature:	Ō Jū Zeshin
Seal:	Tairyūkyo
Date:	Late period
Accession No.:	17,108

As in most of Zeshin's prints, here there is a marvelous realization of brushwork in a print medium, and this is perhaps the genius inherent in these works. The suggestion that the ships at anchor in the harbor may be a reference to the Black Ships of Commodore Perry, who in the 1850s opened Japan to Western commerce, is doubtful. For one thing, Perry did not arrive with such a great fleet.

102 Western Ships at Anchor

103 Young Birds in a Nest

Technical:	Color woodblock print; 9 in. x 11½ in. (22.9 × 29.2 cm.)
Signature:	Zeshin
Seal:	Tairyūkyo
Date:	Late period
Accession No.:	17,110

Zeshin's ability to invite and draw in the viewer to share in his response to a vignette from the everyday world which might easily be missed otherwise is well illustrated in this print. Zeshin focussed closely on a brood of young sparrows taking shelter under an eave. The grasses of their nest poke out from under the roof tiles, and one of the young sparrows clings rather awkwardly to the bamboo gutter, probably ready to test his wings. As in many of his works, Zeshin has cropped the image, allowing the scene to run off the edge of the print to be completed in the viewer's mind's eye. However, somewhat unusually, rather than allowing the roof tiles to bleed gradually out, Zeshin curved the design at these edges; it is almost as if the design was conceived to fit into a circular format.

103 Young Birds in a Nest

104 Bent Against the Wind

Technical:	Color woodblock print; 9 in. × 11½ in. (22.9 × 29.2 cm.)
Signature:	Zeshin
Seal:	Tairyūkyo
Date:	Late period
Accession No.:	17,117

Zeshin has here created an illustration reminiscent of numerous studies of figures by Katsushika Hokusai (1760–1849) published in the *Manga* and elsewhere. Three travelers bend against a strong wind, while ahead, over the crest of the hill, one can see the peak of a farmhouse roof. In the portrayal of the human figure Zeshin paid as much attention to the back presentation of a figure as he did to the front. He accomplished this, moreover, without the loss of expressive force.

104 Bent Against the Wind

105 Attendants Greeting an Important Visitor

Technical:	Color woodblock print; 9 in. × 11½ in. (22.9 × 29.2 cm)
Signature:	Zeshin
Seal:	Shin
Date:	Late period
Accession No.:	17,120

In this marvelous sketch, two female attendants kneel to greet an important guest who emerges from a palanquin (*norimono*), a portable conveyance carried on the shoulders of two or more men. Here the versatile Zeshin paid as close attention to details of urban fashion, such as a fan, a parasol, the tying of the *obi* and the long pins stuck into the coiffures, as he did to nature subjects in other works.

105 Attendants Greeting an Important Visitor

106 Kabuki Actor and Wigs

Technical:	Color woodblock print; 17 in. × 22 in. (43.2 × 55.9 cm.)
Signature:	Zeshin
Seal:	Ima hachi jū
Date:	Meiji 14 (1881)
Accession No.:	17,127

A kabuki actor in a brightly-colored, elaborately patterned kimono is shown kneeling next to a group of theatrical wigs in a variety of hairstyles. The columns of calligraphy are short poems by popular 19th-century actors, arranged in pairs. The actors include Ichikawa Danjūrō, Onoe Kikugorō, Nakamura Sōjuro, Morita Kanya, Sawamura Suketakaya and Tanosuke Takasuke. The particular *surimono* (special print for the New Year) may have been commissioned by Tanosuke, the actor whose name appears last in a place of honor. The Meiji 14 date (1881) appearing to the left suggests that the age seal 'Ima hachi-jū', which would normally be read now at eighty years (e.g. 1886), should be interpreted as 'now a really old man'.

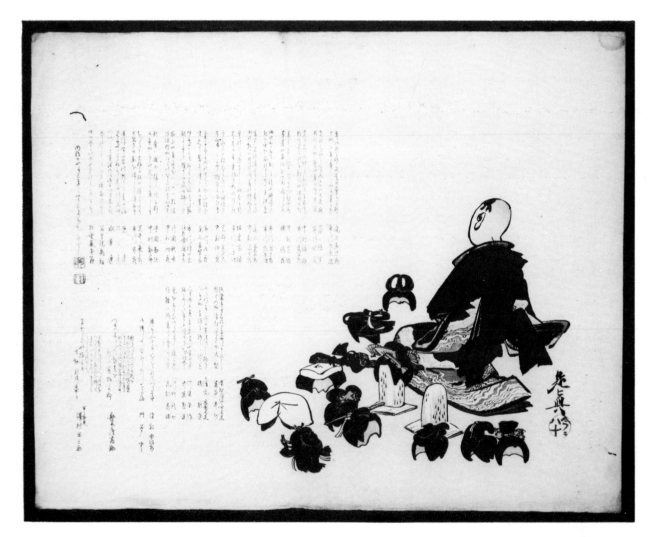

106 Kabuki Actor and Wigs

107 New Year's Special Greeting

Technical:	Color woodblock print; 17 in. × 22 in. (43.2 × 55.9 cm.)
Signature:	Zeshin
Seal:	Tairyūkyo
Additional seal:	Kikakudō (possibly a collector's seal)
Date:	Late period
Accession No.:	17,128

The *surimono*, or special print for a New Year's gift or greeting, includes the auspicious symbols, pine and a sake cup, along with a group of *haiku* poems composed by writers listed under each verse, for example, Tojaku and Sansho. These writers were famous kabuki actors signing themselves with their poetry names. A *trompe l'oeil* effect plays a significant part in the design of this print. In one corner Zeshin creates the illusion that the edge of the sheet has been turned back revealing a purple backing paper and a red and green lacquer tray beneath. The tray carries the signature and seal noted above. The work relates to Cat. No. 106.

107 New Year's Special Greeting

Technical: 1 Vol. complete. 9 15/16 in. × 5 15/16 in. (22.5 × 14.9 cm.). Original covers, orange. Original cover title, printed in black on light grey slip. 45 sheets (unnumbered) 1–2 introduction by Kawakami (?) ichirō; 3–44 color illustrations; 45 book store information

Signature: Zeshin (p.24)

Date: Late period

Accession No.: 17,129

The introduction to this volume indicates that this edition combines an earlier two volume edition into one. Only page 24 bears a signature although the style of all the illustrations is clearly that of Zeshin. The plates cover a wide range of typical Zeshin subjects. Shown here is the closing plate to the volume – a portrait of Jurōjin, one of the seven gods of good luck. [For similar portraits, see Cat. No. 44; plate 4, Vol. 8 of *Kaiga Shōshi* dated in colophon to Nov. 30, 1887 (with a signature age of eighty years, e.g. 1886); and Vol. VII of *Bijutsu Sekai*, with a signature age of eighty-one, e.g. 1887.] These comparisons suggest a similar date for the present work. The final page also provides the following information in a vertical cartouche: 'Wakan Shoseki sembai Kohan Kai ire dokoro' (*Waken Shoseki*, secondhand book store for Chinese and Japanese books). 'Hatsubai Shorin' refers to the store's purpose as a 'seller of books'; this is followed by the store's address. Takeda Danemon and Ōgawa Natakichi were the publishers.

108 Zeshin Gafu

109 Zeshin Iboku Tairyūkyo Gafu

Technical : 1 Vol. (folding album), complete. 10⅛ in. × 7⅛ in. (25.7 × 18.2 cm.).
Original covers, buff, with crosshatched embossing. Original cover title,
printed in black on light grey slip. 15 sheets (unnumbered)

Signature : Zeshin (13th double leaf; illustration k)

Seal : Shin (13th double leaf; illustration k)

Date : Meiji 40 (1907)

Accession No. : 17,130

The variety of typical subject matter includes nature studies, people from everyday life and
many animals. The seal *shin*, corresponds with No. 24 in Appendix II. A seal on the interior
cover indicates that this book was once in the collection of Tsukahara. Sheets 1 and 2
include calligraphy, dated Meiji 40 (1907), signed Seizan-koji, sealed Kobunkan and (?).
Sheets 3–14 show double-page color illustrations of (a) flowering plum branch, (b) monkey
and trainer, (c) young fisherman with net, (d) cucumber vine, (e) tuna, (f) boatman on a
river, (g) duck and reeds, (h) cat at rest, (i) court lady and young man, (j) priest selling tea
whisks, (k) tortoise with long tail and (l) persimmon. Sheet 15 is the colophon dated
Meiji 40, noting designs copied by Shoji Chikushin; the editor, Shibata Ichitarō (of
Tokyo); the printer, Matsumura Yataro (of Tokyo); and the publisher, Yoshida Kyubei
(of Tokyo).

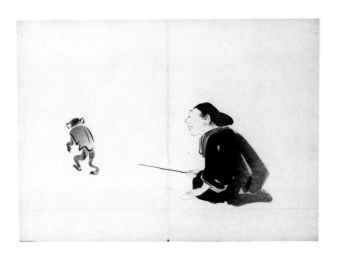
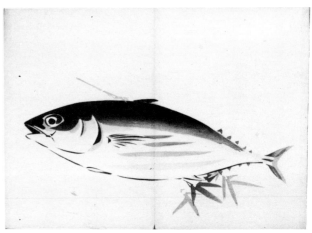
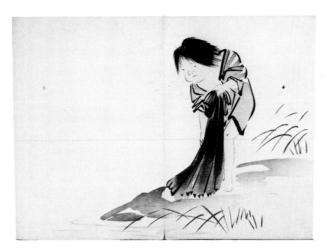
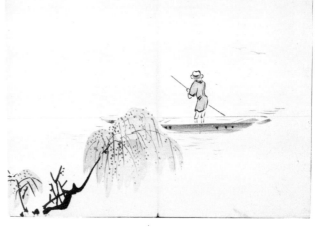

109 a) Flowering Plum Branch

109 b) Monkey and Trainer

109 c) Young Fisherman with Net

109 d) Cucumber Vine

109 e) Tuna

109 f) Boatman on a River

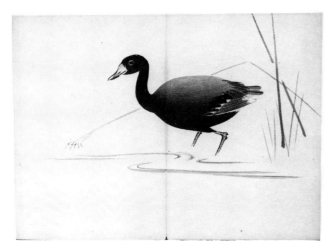

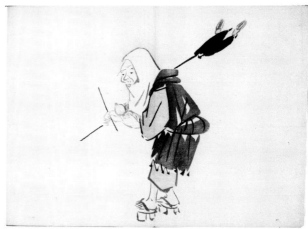

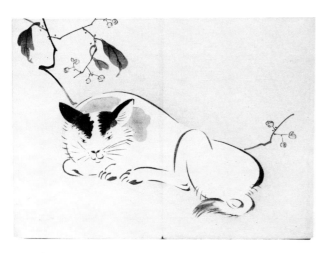

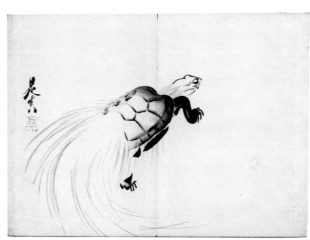

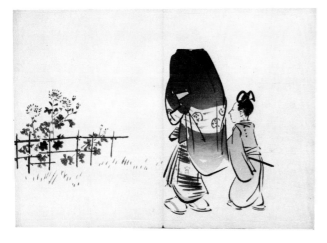

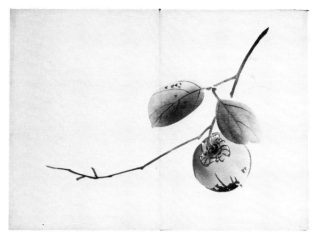

Signatures and Seals on Paintings in this Catalogue

The following signatures and seals are reproduced from paintings in the O'Brien Collection where the size of illustration rendered the signature and seal unclear for study purposes. Selected signatures on lacquer objects are reproduced in the *Signature Book of Netsuke, Inro and Ojime Artists in Photographs*, OB No. 132, and *Netsuke and Inro Signatures and How to Read Them*, Nos. 4580, 4575, 4573 and 4562, both compiled by George Lazarnick.

1 Monkey Posing as Collector **3** Butterfly and Flowering Plant **4** Cock and Hen

5 The Death of Buddha **6** Cranes and Waves **7** Episodes From Life in Edo

 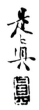

8 Wild Grass and Lotus **9** Melons and Flowering Vines **10** Bat Against a Crescent Moon

11 Badger Studying a Sutra **12** Symbols of the Weavers' Festival

13 Album of Twelve Paintings

14 a) Gagaku Mask and Flute **14** b) Beetle and Wasp **14** c) Grapevine

14 d) Galloping Horse 14 e) Leaping Fish 14 f) Crab

15 Carp 16 Plum Branch and Mandarin Ducks 17 Bird About to Alight on a Pier Post

17 Bird and Shells

19 Branch of Persimmons 20 Flowers and Insects 21 Waterfall

179

22 Tortoises on a River Bank **23** Okame with Plum Branch **24** Okame and an Oni

25 Portrait of Oto-Gozen **27** Seed Pods and Leaves **28** A Boy Picking Cherry Blossoms
(Otafuku)

29 Sōjobo Teaching Ushiwaka-Maru **31** Symbols of Old Age **32** Cat and Mouse

33 Mouse Procession **36** Mandarin Duck
and Snowy Reeds **37** Crab on Shore Rocks

38 Hibiscus Flowers and Rock **39** Butterfly and Wild Rose **40** Heron and Lotus Pods

41 Bird Standing by
a Leafy Plant **42** Pagoda and Flying Bird **43** Leaves and Wild Grasses

181

44 Jurōjin

45 Oni

46 Shōki Quelling Two Oni

47 Autumn Basket of
Grapes and Persimmons

48 Jurōjin, Deer and
Tortoises in a Lansdcape

49 a) Flowering Vine

49 b) Semi (Cicada)

49 c) Vine and Bamboo

50 A Tai Fish

Appendices

NOTE: Research into Zeshin's background and works has begun on an organized scale only in recent years. These appendices, compiled by Mr. Martin Foulds, are not intended as an irrefutable lexicon but as a general and subsidiary aid to dating and authenticating works by and attributed to Zeshin. They are based on accepted signatures and seals found on objects in other collections and do not include alternate impressions, or new seals discovered on works in the O'Brien Collection. Sources for these seals and signatures are: *Bijutsu Sekai* (The Art World), No. 16, Tokyo, February, Meiji 25 (1892); *Shibata Zeshin Gafu*, Tokyo, n.d.; and Shioda Shin, *Zeshin-Ō Gakan*, Tokyo, 1873.

Appendix I

Signatures of Shibata Zeshin

In his monograph entitled *Senko Shibata Zeshin* (*My Father Shibata Zeshin*), Reisai states clearly that Zeshin had at his disposal signatures that may be classified into five basic categories. This is confirmed by Gōke's study in his recent publication and can be supported by research to the present time.

Four of the signature types were used both for lacquer products and paintings, while the remaining one (see signature No. 5) was reserved exclusively for *maki-e, urushi-e,* and all other lacquer-related items.

1. *Reisai* 〔令哉〕

This signature was applied chiefly to paintings accomplished between 1822 and 1832 (i.e., between when Zeshin began regular tuition in painting under Nanrei and when he returned from his first training period in Kyoto). The signature is written in the calligraphic *gyōsho* style, and bears the distinctly sophisticated touch which typifies many of Zeshin's early artistic productions.

2. *Zeshin* 〔是眞〕

Zeshin began to use this name in his signature soon after his return from Kyoto in 1832. He continued to sign the two characters alone until about 1873, after which he grew into the habit of adding either his age or the year of his work (occasionally more precisely with the month and day) or both (see signatures No. 3 and 4).

The change in his style of writing is almost imperceptible when traced over a short period of ten years or so, but the difference between the signature in his early days and that in his later years is sufficiently marked to warrant an explanation. For the sake of clarity, therefore, we have attempted to classify this *Zeshin* signature into three distinct types:

(i) From 1832 to about 1840, both the characters *ze* [是] and *shin* [眞] are executed in the very light brushstroke of the refined *sōsho* style. The effect is one of fastidiousness that borders on the effeminate, and no doubt reflects Zeshin's exaggerated concern for perfection.

(ii) From around 1842 or so, there is a tendency for the *ze* character to adopt the somewhat heavier *gyōsho* form although the *shin* remains in the *sōsho* style.

(iii) The older and the more confident Zeshin became, the more heavily he would apply his signature. By 1873 or thereabouts, the *shin* – especially in the two final strokes (the 'legs' of the character) – reveals a strength that for all intents and purposes may be classified as belonging to the *kaisho* style of writing.

We should note at this juncture that Zeshin did not totally discard the *Reisai* signature in favor of the *Zeshin* signature; he continued to use it but with increasing rarity. The *Zeshin* signature was of course never used until he received the name from Nanrei (i.e. never before 1832).

3. *Tairyūkyo* [對柳居]

4. *Hachijū-ni Zeshin* [八十二是眞]

Upon his return from Kyoto in 1832, Zeshin moved his address to 11 Banchi, Kami-heiemon, Asakusa – an idyllic site on the northern bank of the Kanda River, a little more than a hundred yards from its confluence with the Sumida River at Yanagi Bridge. (This area has since been renamed 1 chome, Asakusa-bashi, Daitō-ku, Tokyo) Zeshin called his new home Tairyūkyo (The House Opposite the Willows) and from 1832 sometimes incorporated the name into his signature.

It is most unusual to find the three characters of *Tairyūkyo* standing alone; they are generally accompanied by the *Zeshin* signature or age note.

In his later years, beginning when he was about sixty-six years old (1873), Zeshin would frequently include his age with his signature. This was often prefixed by the two characters reading *gyonen* [行年] which loosely translated means 'The age I have attained (so far) is . . .'

Works bearing the year (in some cases with the month and day) instead of or with his age are not uncommon after 1873.

Examples of this type of signature dating from the 1870s appear in the *gyōsho* style, but progress rapidly into the forceful *kaisho* style that is characterized by heavy pressure on the final strokes of each character. It is this style of handwriting, as we have indicated above, that is particularly evident in works produced during the last five years of his very long life.

5. *Koma Zeshin* [古満是眞]

no documentary photograph available

Zeshin began working under Koma Kansai in 1817, but so little information is as yet available about these formative years that we cannot be certain of his standing in the workshop or of when he began to use this particular signature. What is certain, however, is that he reserved it exclusively for lacquer items and used it throughout his life as a reminder of his close relationship to the Koma Family.

This signature has not yet been discovered on any type of work that does not in some way relate to lacquer.

When the signature appears in lacquered products, it is either incised with a sharp point of some kind (some say a rat's tooth) or applied in raised gold, dark red or brown lacquer. It therefore lacks the same degree of control as the brush, and stylistic changes in the calligraphy are apt to be misjudged.

Appendix II

Seals of Shibata Zeshin

Zeshin is reputed to have used as many as eighty different seals at various stages of his career. Most of these have been categorized into eight major varieties according to character and approximate date:

(i) *Seal numbers 1–16*

Seals which display only the two characters of his name: Zeshin [是眞]. Particularly dear to Zeshin, although not carved by his own hand, was a tiny jar-shaped seal bearing his name in lateral block characters. He is said to have employed it throughout his life and applied it on occasions when he felt especially pleased with a finished work (see Seal No. 5).

As in the case of the signature, the seals in this category date from 1832.

(ii) *Seal numbers 17–27*

Seals bearing only the single character of the last part of his name: *shin* [眞]. No genuine seal bearing only the other character of his name, *ze* [是], has yet been discovered with the exception of one album leaf in the O'Brien Collection (see Cat. No. 35).

Reisai remarks that in this group there is one particular seal that Zeshin carved himself (see Seal No. 24). It was made of wood, of an overall height of about five centimeters and embellished with a meticulous carving of a wild goose seated on a stone with its neck inclined backwards. It was smothered in black lacquer.

Again, these seals date from 1832.

(iii) *Seal numbers 28 and 29*

Seals of this category bear the name of the artist and include supplementary characters to emphasize the finished work.

They date from 1832 and probably belong to Zeshin's maturing period; that is, to about 1845.

(iv) *Seal numbers 30–33*

This category consists of four seals· (there may be more) bearing the characters *Reisai* [令哉]. They were used during Zeshin's formative years, sometime from his acceptance into Kansai's workshop until his return from Kyoto in 1832.

(v) *Seal numbers 34–40*

Seven seals displaying the name *Koma* [古満]. Like the signature, it was used throughout his life exclusively for lacquer related objects.

(vi) *Seal numbers 41–46*

The seals in this section bear the characters *Tairyūkyo* [對柳居], referring to his home by the Kanda River. They were used after his move there in 1832.

Seal No. 46, a variation on the main characters, reads *Tairyū-ō* [對柳翁] and loosely translated means 'the master-gentleman from opposite the willows'. Zeshin appears to have used it only from the beginning of the Meiji period (1868).

(vii) *Seal numbers 47–54*

This category offers a selection of seals bearing Zeshin's age. They are probably the most useful of all in the study of authenticity since they pinpoint the exact year when a particular work was completed.

The seals often include additional characters, the most common of which are *so* [叟] and *o* [翁], both placed after the age and both meaning roughly 'old master-gentleman of . . . (age) . . .'.

(viii) *Seal numbers 55–61*

This category consists of a selection of perhaps the most interesting of all Zeshin's seals. They generally bear references about himself in terms of his emotion at the time or otherwise reflect an estimation of his own standing in the world.

No dates are yet available for these seals.

With reference to the size of the seals, Reisai comments in his article that Zeshin tended to use his collection of *mame-in* ('the flyspeck seal'; see especially Seals Nos. 6, 14, 19–22) for lacquered *maki-e* works. There were a few occasions when he would use them also on extremely small scroll paintings, album leaves and small *surimono* works. No flyspeck seal has yet been found on a normal size painting.

In connection with Zeshin's leaning towards novelty, it is interesting to note that he occasionally allowed part of his signature or seal to hide behind (see Cat. No. 30) or in some other way improve upon the three-dimensional aspect of a subject (see Cat. No. 25).

(i) ZESHIN [是眞] (*Seal Nos.* 1–16)

1.

2.

3.

4. 5. 6. 7.

8.

9.

10.

11.

12.

13.

14. 15. 16.

(ii) SHIN [眞] (*Seal Nos.* 17–27)

17. 18. 19. 20.

21. 22. 23. 24.

25. 26. 27.

(iii) ZESHIN NO . . . [是眞之] (*Seal Nos.* 28 and 29)

28. 29. ZESHIN NO IN 〔是眞之印〕
 [Object (made) by Zeshin]

(iv) REISAI 〔令哉〕 (*Seal Nos.* 30–33)

30. 31. 32.

33.

(v) KOMA [古満] *(Seal Nos.* 34–40)

34. 35. 36.

37. 38. 39. 40.

(vi) TAIRYŪKYO [對柳居] *(Seal Nos.* 41–46)

41. 42. 43.

44. 45. 46.

(TAIRYŪ-Ō)

47. NANAJŪ-GO
75 years [1881]

48. NANAJŪ-NANA-SO
77 years [1883]

49. NANAJŪ-NANA-SO
77 years [1883]

50. HACHIJŪ-SO
80 years [1886]

51. HACHIJŪ-NI-O
82 years [1888]

52. KON HACHIJŪ-NI
Now 82 years [1888]

53. KŌ HACHIJŪ-YON
84 years [1890]

54. GANEN HACHIJŪ-GO
85 years [1891]

55. REISAI KANJIN
Reisai, Man of Leisure

56. ZESHIN GAHEKI
Zeshin, The Joy of
Painting Pictures

57. SHI KYŪ JŌ
Received the pigeon
cane

[Reference to an old Chinese custom: a minister would receive a cane, the handle of which was carved in the form of a pigeon, from the Emperor as a token of appreciation for his loyalty and long service.]

58. KYŪ JŌ Ō
Master with the
pigeon cane
[see reference above]

59. HAN MA NIN
The dull-witted idiot

60. SHIBA ZESHIN IN
The Seal of Shibata
Zeshin

61. GANKŌ GAJIN
The Stubborn Painter

[This seal includes the characters 含光 which read 'ganko' and mean 'inclusive of light'; this is homophonic with 'gankō' 頑固 meaning 'obstinate'.]

Selected
Bibliography

ANONYMOUS. 'Ō no Ie Sude-ni Yonketsu-o Idasu,' *Yomiuri Shimbun*, July 21, 1892.

ANONYMOUS. 'Shibata Zeshin-Ō Den,' *Kyoto Bijutsu Kyōkai Hōkoku*. Kyoto, September and October, 1897.

ARAKAWA SAMPO. 'Shibata Zeshin Denki,' *Tōbi*, No. 8. Tokyo, 1942.

ASO ISOJI. 'Iki to Tsu,' *Nihon Bungaku Kōza*, Vol. VII. Tokyo, 1959.

GEMPUAN MONTO. 'Shibata Zeshin to Kawanabe Gyōsai,' *Bi no Kuni*. Tokyo, August 1927.

GŌKE TADAOMI. 'Shibata Zeshin,' *Nihon no Bijutsu*, No. 93, Shibundō Series. Tokyo, February 1974.

HAMADA GIICHIRŌ. 'Edo-Tokyo: Hito no Kishitsu to Ninjō,' *Kokubungaku Kaishaku to Kanshō*. Tokyo. January 1963.

HERBERTS, K. *Oriental Lacquer*. Abrams, New York, n.d.

HILLIER, J. *Japanese Drawing from the Seventeenth through the Nineteenth Century*. New York, 1965.

HILLIER, J. *Poésie de l'instant: peinture de l'école Shijō, XVIIIe – XIXe siècles*. Paris, 1964.

HILLIER, J. *The Uninhibited Brush: Japanese Art in the Shijō Style*. London, 1974.

HŌGA NOBORU. 'Tempō Kaikaku to Edo Chōnin Shakai,' *Edo Chōnin no Kenkyū*, Vol. I. Tokyo, 1972.

HOLLOWAY, OWEN E. *Graphic Art of Japan: The Classical School*. Tiranti, London, 1957 (reprinted, Tuttle, Tokyo, 1971).

HURTIG, BERNARD. 'Shibata Zeshin,' *The Journal of the International Netuske Collectors Society*, Vol. 5 (1977–78), Nos. 1, 3 and 4.

JAHSS, MELVIN AND BETTY. *Inro and Other Miniature Forms of Japanese Lacquer Art*, Charles E. Tuttle Company, Rutland, Vermont and Tokyo, 1971.

JŌNŌ SAIGIKU. 'Shibata Zeshin,' *Taiyō*, Vol. 5, No. 1. Tokyo, 1899.

KABURAGI KIYOKATA. 'Shibata Zeshin to Sono Ichimon,' *Koshikata no Ki*. Chuo Kōronsha, Tokyo, 1961.

KAWASAKI SENKŌ. 'Shibata Zeshin Ryaku Nempu,' *Kokka*, No. 97. Tokyo, 1908.

KOSUGI KOJIRŌ. 'Shukoken Mandan,' *Shoga Kottō Zasshi*. Tokyo, January 1932.

KŪKI SHŪZŌ. *Iki no Kōzō*. Iwanami Shoten, Tokyo, 1930.

KUROIWA ICHIRŌ. *Kagawa Kageki no Kenkyū*. Bunkyō Shoin, Kobe, 1957.

MATSUDA GONROKU. *Urushi no Hanashi*. Iwanami Edition, Tokyo, 1964. Mitamura Tobiuo. *Edokko*. Tokyo, 1955.

MITCHELL, C. H. *The Illustrated Books of the Nanga, Maruyama, Shijō and Other Related Schools of Japan (A Biobibliography)*. Los Angeles, 1972.

MIZOGUCHI SABURŌ. 'Edo no Shikko,' *Nihon Bunka-zai*, No. 19. Tokyo, November 1956.

MOORE, CHARLES A. *The Japanese Mind: Essentials of Japanese Philosophy and Culture*. University of Hawaii, Honolulu, 1967.

MORI TAIKYO. 'Meishō Shibata Zeshin,' *Shoga Kottō Zasshi*. March 1915.

MORI TAIKYO. 'Shibata Zeshin-Ō,' *Shin Shosetsu*, Vol. 10, Nos. 7–8. Tokyo, 1905.

MOTOYAMA TEKISHŪ. 'Shibata Zeshin,' *Meijin Kijn*. Tokyo, 1971.

MURAMATSU SHŌFŪ. 'Shibata Zeshin,' *Honchō Gajin-Den*, Vol. 4. Chuo Kōronsha, Tokyo, 1976.

NISHIYAMA MATSUNOSUKE. 'Edokko,' *Edo Chōnin no Kenkyū*, Vol. II. Tokyo, 1972.

NISHIZAWA TEKISE. 'Zeshin no Gyoryū-zu,' *Tōei*, Vol. 12, No. 2. Tokyo, February 1936.

ŌTA NORIKAZU. 'Shibata Zeshin Den,' *Chawan*, No. 76. Tokyo, 1937.

SAWAGUCHI GOICHI. *Nihon Shikkō no Kenkyū*. Maruzen, Tokyo, 1933.

SEKI CHIYO. 'Kōkyo Sugito-e ni Tsuite,' *Bijutsu Kenkyū*, No. 264. Tokyo, July 1969.

SHELDON, CHARLES DAVID. *The Rise of the Merchant Class in Tokugawa Japan*. New York, 1958.

SHIBATA REISAI. 'Senkō Shibata Zeshin,' *Shoga Kottō Zasshi*. August 1912.

SHIBATA ZESHIN. 'Maki-e Shi Koma-shi no Ryakkei,' *Kokka*, Vol. 5. Kokka-sha, Tokyo, 1890.

SHŌJI CHIKUSHIN. 'Monjin Toshite Shirareru Zeshin-Ō,' *Shoga Kottō Zasshi*, Tokyo, August 1912

SOEDA TATSUMINE. 'Shibata Zeshin-Ō no Kotodomo,' *Tōei*, Vol. 16, No. 9. Tokyo, 1940.

TAJIMA SHIICHI. *Maruyama-ha Gashū*. Tokyo, 1909.

TAJIMA SHIICHI. *Maruyama Shijō Gakkan*. Tokyo, 1915.

TAKAHASHI JIN. 'Zeshin no Higami,' *Atelier*, Vols. I, II, III. Tokyo, 1936.

TAKEUCHI BAISHŌ. 'Meiji Hogaden no Ken'i: Shibata Zeshin,' *Shoga Kottō Zasshi*, No. 368. Tokyo, February 1939.

TAKEUCHI BAISHŌ. 'Tairyūkyo Zeshin ni Tsuite,' *Shoga Kottō Zasshi*. Tokyo, October 1921.

TOMITA KOJIRO. 'Lacquer Pictures of Shibata Zeshin,' *Bulletin of The Museum of Fine Arts, Boston*, XXVII. Boston, 1929.

TONOMURA KICHINOSUKE. 'Shokunin Katagi: The Spirit of the Artisan,' *The East*, Vol. XII, No. 4. Tokyo, May 1976.

URUSAKI EISHAKU. *Nihon Kindai Bijutsu Hattatsu-shi (Meiji-Era)*. Bijutsu Publications, Tokyo, 1974.

WAKITA HIDETARŌ. 'Okamoto Toyohiko Den no Kenkyū,' *Kokka*, Vol. 57, No. 6. Kokka-sha, Tokyo, June 1948.

YADA SOUN. 'Asakusa,' *Edo Kara Tokyo-e*, Vols. II and III. Chūkō Bunko, Tokyo, 1975.

YASUDA, KENNETH. *The Japanese Haiku*. Tuttle, Tokyo, 1975.

YOKOI HARUYA. 'Shibata Zeshin,' *Teikoku Min*. Tokyo, April 1920.

Zeshin, An Exhibition of Prints, Paintings and Lacquer by Shibata Zeshin (catalogue), June 25–July 9, 1976. Milne Henderson, London, 1976.